Conversations
with a
Painting

A MEMOIR

Donald E. Grayston

tellwell

Tellwell Talent
www.tellwell.ca

ISBN
978-0-2288-1140-4 (Paperback)
978-0-2288-1141-1 (eBook)

Table of Contents

For Dave

FOREWORD

For those who knew him, Donald Grayston was an inimitable and rare character. Having served as an Anglican minister, peace activist and professor for most of his life, Don enjoyed a wide circle of friends and colleagues, who all appreciated his grace and charm. As a gregarious socialite, he would delight the dance floor with happy capers; as a serious scholar, he would silence a seminar room with provocative questions. Despite his talent and charm, Don carried no air of conceit. He laughed and giggled as easily as he sighed over the state of the world. For those who had the pleasure of his friendship, Don was special indeed.

In the spring of 2014, Don started to use an oxygen tank to help him breathe. However, his declining lung capacity did not dim his social and intellectual vibrancy. With a metal tank in tow, he continued to meet friends and even traveled to Seattle to launch a book he had just published. In the fall of 2016, his health took a serious turn for the worse. After a period in the hospital, Don knew he didn't have much time left. He faced his death the way he lived his life: with grace, generosity, and humour. In the year leading to his death, though bound to his oxygen tank and confined to his apartment, he entertained visitors and re-connected with friends. His gregarious persona did not wane even as his health declined. Those who were touched by his kindness would come to nurse him with alacrity. A schedule was drawn and a cohort of sitters volunteered to accompany Don in his final days. They helped him to the bathroom, massaged his muscles, shared laughter and savoured precious moments together. For his part, Don continued to show interest in his friends. "What's going on in your life?" he would ask—and they all shared their stories. His love of people was undiminished. In this way, he remained a minister and a teacher to the end.

I visited Don regularly during the year before he passed. We had many conversations about death, regrets, and the perspective of one who saw life in retrospect. With characteristic candour, Don said that he endured brief episodes of self-pity, but they didn't last long. By the time the first visitor came to see him, his spirits were up again. He relayed stories of his youth and his walking trip across England, his travels across Asia. He held back nothing—it was as if in his journey toward death, he made of himself a teaching on the art of dying. It is this generosity of spirit, an openness that embraces all, including the misery of an ailing body, that made Don such a remarkable man.

And in this very same spirit of generosity and openness, Don has left us a memoir of his life; one in which the transformation of his person and the development of his perspective was shaped by his relationship with a painting. Most lives can be plotted along a narrative line marked by salient events, but the inner life is harder to map, riddled as it is with conflicting desires, unacknowledged needs, and varied aspirations. Tracing the tenure of the spirit can be a difficult task for both author and reader alike. It comes as a treat for readers that Don's inner life should find such a steady anchor in a visible symbol of wisdom and poise. Over the years, the painting became his source of inspiration and reflection, a manifestation of Don's own aspiration to be a beautiful man, the culmination of his own unfulfilled relationship with his own father, an icon that held him to account for the life he lived. His conversation with the painting was his engagement with his consciousness. Through the painting we see the exchange between the child and the father, the seeker and the sage, the man and his God. With candour and charm Don shares his struggles and triumphs; despite life's tumult, the painting remained for him a symbol, of deep and enduring wisdom, a source of unfailing guidance. Thus, in piecing together a map of Don Grayston's life, we see a man's inner growth exteriorized in a symbol of personal authenticity and the quest for self-actualization.

For those who knew Don personally, the words in this book will lift from the page and resound as if uttered from Don's own lips. Each phrase is indelibly imbued with a unique charm that is at once witty, sensitive, humorous, and thoughtful. Reading his words, we glimpse the light in his eyes when he ponders the spiritual import of *Eros*, the seriousness of his concentration when he warns against the dire threat of nuclear war. The text not only inscribes Don's life story, it exudes an immediacy that is

evident in the best oral traditions, wherein speaker and listener fuse in an act of textual union. He remains very much alive in these printed words; those who did not know Don personally can trust that the text presents the man in all his vivacious charisma.

Because his character shimmers through the words of the page, both his strengths and quirks come through in clear light. Readers will notice the tangential manner in which he conveys a story. A description of his work as Anglican minister will meander into an extended critique of the institutional church; likewise, his consideration of an important life-decision can suddenly leap to commentary on the geo-political troubles that cast a pall on global peace. This too is an honest delivery of the man, for Don Grayston was a Christian, a minster, a son, a father, and a scholar all at the same time. He conducted conversations over coffee in much the same way. An anecdote will stray into musings on a recent newspaper article, or a quote from Shakespeare. Don the story-teller is never far from Don the intellectual. When the digression has gone on long enough, Don would catch himself and muse: "where was I?" In like manner, Don reveals all aspects of himself in this memoir, even as one domain of his life bleeds into another in ways that might bewilder the reader. I suggest going along for the ride. Consider each excursus a tour through the remote corners of a brilliant mind. Let him lead you through the land, and you'll find yourself better acquainted with the man.

Another quirk that may niggle the reader: Don's tendency to leap backwards and forwards in time, following one episode in the distant past with a story from a more recent encounter. These leaps can jar the reader who expects a seamless journey through chronological time. In my view, because Don wrote this book in the last three years of his life, his pen traced the insights that unfolded in retrospection. As one nears death's door, a larger context emerges—life is nearly complete and all the supplements that inform a final summation are at hand. What had once seemed a devastating failure finds redemption in the subsequent blossoms that grow from the mire. Old wounds heal and grievances subside. In his story, Don draws together the loops of happenstance, the vagaries of relationships, and finds redress in later life. These resolutions are conveyed with leaps in chronology; they also demonstrate the perspective of one whose life comes to integration, in the fullness of acceptance and understanding.

Don's struggles with his marriage and his subsequent affair are perhaps among the most difficult and painful parts of the book. The women in his life loomed large on his path—even in his last days, he continued to discern the meaning of love, and worked to settle the waves that *Eros* leaves in its wake. His own acuity as a spiritual seeker, and even his sense of masculinity, seemed inextricably bound to these relationships—so much of his inner transformation came as a result of love and heartbreak. As editors and as Don's friends, we read Don's story with shared sorrow. At the same time, because we had the privileged of witnessing the depth of the man's character, we saw how he tried to make peace with his past. Every relationship comprises more than one perspective, and we recognize that Don's memoir presents a partial account of a difficult time for all the principals involved. Yet, Don's life is his to tell, and the painful passages in his story cannot be easily excised without compromising the integrity of the memoir and the authenticity of his voice. Given the balance of considerations, the editors elected to preserve the bulk of Don's manuscript, applying light editorial interventions while keeping the spirit of his narrative. In the end, the man speaks for himself; the book is his message. Let the reader judge Don's account and the wisdom of his experience.

I would like to thank Angus Stuart and Doug Christie for their tireless work in publishing this book. Their labour of love has brought this memoir to life. We hope the reader will discover the story of a man who strove to become himself, who despite storm and sorrow, sought to become what he calls "a beautiful old man". He made of his life an *opus*, and offered himself to God. In his conversations with his painting, we catch a glimpse of his persistent inner work, which includes an examination of his relationship with his parents, a review of his relationship with women, a survey of inspiring, older men who represented for him the best human possibilities. In sharing his memoir with us, Don has provided an exemplar of a life well-lived. Following this account, we are called as readers to reflect on a source of wisdom in our lives. Whether this wisdom appears in a painting or elsewhere, may we nevertheless find our own light.

David Chang
2018

INTRODUCTION

This is a book about my "conversations" over more than four decades with a painting which I purchased in 1972. It is an extended reflection on my relationship with that painting, a particular kind of memoir, certainly not an autobiography. It does contain autobiographical material, but only as much as is needed to provide context for the main line of the reflection. Thus there is very little in it about my children, or the greater part of my marriage, my relationships and friendships, most of my education or my work or political interests.

Something of which I was completely unaware until I started working on this book is that since the 1990s there has been an ongoing phenomenon called by some the memoir boom. Many commentators have linked its continuing rise to the publication and popularity of Frank McCourt's *Angela's Ashes* in 1999. The memoir surge has also come in for criticism. Is it just narcissism or egotism? Is it just literary Kardashianism? Is it just part of the flood of self-presentation and self-representation of which Facebook is the most notable instance? Is it, as the kids say, TMI?

I find these critiques unconvincing. From childhood, we want to hear stories. As adults, we are interested in the stories of others and of their meanings, particularly as we age, and look for patterns of meaning in our own lives. The ageing of the North American population is without doubt a major factor here. With the millions of people in our society over 50 (an important age in my story), there is an increasing cohort of people looking for these patterns and these meanings for themselves. So this is my story, told to the best of my ability. As Touchstone says toward the end of *As You Like It*, "A poor . . . thing, sir, but mine own" (V.iv.60). Yes, "mine

own," good, poor or otherwise. I am also willing to acknowledge that if my former wife or my children had written this story it would have turned out very differently! Such are the limits and also the value of anyone telling his or her own story.

In its inmost dimension, it is an account of the journey of one man toward self-understanding and maturity of spirit. You will get what I am trying to say here if you follow the book's two golden threads, the double-helix of the narrative: my journey home to myself as a man, as a male, and the illumination I received on that journey from my great painting. If you find yourself wondering why I am including what may seem like detours in the narrative, stick with me, and you will soon enough find yourself once again with the narrative's twofold main line. If you find the early chapters slow, have faith, keep reading, and prepare yourself for the revelations which the great painting will offer to you as the book moves forward.

An advance reader questioned the importance of the painting, which after all, addresses me only twice, in 1975 and 1990. I make an analogy here with God. God doesn't usually say very much directly to most of us most of the time, but is nonetheless *there* all the time. And so it is with my painting. For many years I was content with its simple presence; now I connect with it on a daily basis. But it was the steadiness of its presence that brought me to the place of connectedness with it from which I now benefit.

Let me offer here a few words about how I see myself, and how I came to see more of myself in the process of writing the book. I grew up on the west side of Vancouver, where the rich folks live now; but when I lived there, it was middle-middle class. Education: lots, not all of it useful, in Canada, England, the US, and Switzerland. After 25 years spent in parish work, specialized ministry and peace education, I taught Religious Studies at Simon Fraser University here in Vancouver, beginning in 1989, and retired from there in 2004.

I am a cradle Anglican, although I have frequently gone swimming in other ponds. I was ordained in 1963 and regard myself as a post-denominational Anglican and an interfaith-oriented Christian. My watchword here comes from philosopher Ken Wilber: *include* and *transcend*. I *include* my original religious tradition, and I *transcend* its limitations in transcultural and transreligious ways.

I affirm, as you will read in the book, that within this framework Jesus remains The Man—the archetypal man of the west, as Jung says, and the prime resource of the church as it morphs from fortress church to pilgrim church, from church stuck to church on the move. I also affirm that Thomas Merton, whose centenary we celebrated in 2015, a year in which I wrote much of this book, is the contemporary spiritual guide best equipped to lead us into the ways of compassion, justice and peace (cf. Luke 1:79, "to give light to those who sit in darkness and in the shadow of death, to guide our feet into the way of peace.").

A word here about the biblical quotations which you will find from time to time in the book: don't be put off by these. I am not laying a religious trip on you by citing them. They are there because they connect for me with particular experiences or insights. The Bible remains, for good or ill, and whether we grant it authority or not, the foundational document of western culture.

I first thought about writing this book in about 2007; a major part of it was written in the summer of 2010, when I was a volunteer chaplain at the House of the Redeemer in Manhattan. A number of years before that I had read Henri Nouwen's beautiful book, *The Return of the Prodigal Son: A Story of Homecoming,* and years before that, Oscar Wilde's *The Picture of Dorian Gray.* I didn't think about either of these books until perhaps two years after conceiving the idea of this one, and I haven't modeled this book on either of them. To these two I could add the Harry Potter books, with their talking portraits. In 2010 I re-read both the Nouwen and the Wilde books, and although I do see some slight overlap, in that each of the books is focused, as is this one, on a particular painting, I see this book as markedly different from each of them. Nouwen's book takes off from his reflections on Rembrandt's painting, the name of which he gave to his book. His book explores the three characters of Jesus's parable (Luke 15:11-32)—the loving (indeed, prodigally loving) father, the prodigal or wasteful son, and the angry elder brother. The parable is immortal, and Nouwen does it honorable service. (You will encounter it in two of the chapters of this book.) It does concern a father-son relationship (something fraught in Nouwen's own life), and in that regard overlaps with this book; but the painting itself did not belong to Nouwen, and he moved on from writing that book to other concerns. The Wilde book has in common with this book that the painting

belonged to the title character of the book; but the trajectory of the story, and its ghastly finale, is very different.

This account describes a series of epiphanies or moments of truth (you can decide if they meet the bar of mystical experience: one of my advance readers says it does), all in some way related to the painting and to the personal journey it eventually sent me on, the search for the father—my own father—and for the deeper truths of my own masculinity. The unrealized character of my relationship with my father was not revealed to me until I was 62; and his connection with the painting not until I was 70. May readers of this book do better than I did in regard to their understanding of their relationships with their parents! You will certainly be able to live more consciously than I did if you take full heed of the saying of Jesus from the Gospel of Thomas which you will find quoted later in this book.

My relationship with the painting and the rest of my life is of course all one thing—each of us has only "One Life to Live," as the old soap opera title put it. I look back over the decades, and all through those years I am aware of the quiet accompaniment which the painting has provided to me—a touchstone for everything else, for all the other issues and elements and happenings in my life. So let me ask you, my readers: is there anything equivalent in your life? A painting, a book, a piece of music, any form of art, a special place? Something which speaks to you, something with which you are in ongoing convearsation? I can imagine some of you thinking of a relationship with another person as your touchstone, or even your relationship with God, if you have one. My relationship with the painting doesn't deny or contradict or devalue the importance of any other such relationships for me. What it does is help me integrate them into the ongoing challenge of living daily into and out of the True Self.

Wordsworth says that "the Child is father of the Man" ("My heart leaps up")—and the truth of this has come home to me very powerfully *once again for the first time*, to quote Marcus Borg. A memory from a trip to Spain some years ago supports Wordsworth's intuition. I was walking one day along a quiet street in a Spanish town when I came into an open space, something less than a plaza, in which there was a small boy wearing glasses, and playing on his own with a soccer ball. What Buddhists refer to as the illusory character of the ego became my experience at that moment: I was and am that small boy wearing glasses—there was and is no separation

between us. That solitary boy, on his way to becoming a man, lives within me still, and is one of the writers of this book. Another of the book's writers is the prodigal son; and another yet may even be the retired professor as Dave Chang sees him in the poem in the last chapter.

Towards the end of the time, in the spring of 2015, when I was writing much of this book, I read a profound passage in one of Franciscan priest Richard Rohr's daily emailed meditations. (You will find it in Chapter 9, which deals with Assisi and St. Francis.) In that meditation, reflecting on Francis's own experience, he says this:

> We all learn the mystery of ourselves at the price of our own innocence. Francis did not try to remain "innocent" (the word means "unwounded"). He did not run from life's wounding, because he saw that in Jesus it became the way to resurrection and universal life.

Yes, the price of one's own innocence. In this book I tell the story of how I went very deep into the mystery of my own soul at the price of my own innocence, my own naïveté. Rohr's etymological comment is very significant. To be innocent, he says, is to be unwounded: to be wounded, then, is to move, or be moved, beyond innocence into experience. In placing those terms side by side, I am thinking both of Blake's "Songs of Innocence and Experience" and also of how the Desert Fathers taught a three-fold paradigm of the spiritual journey which begins with the first innocence and then moves through life experience to the second innocence. Before the events central to this narrative took place, I was indeed running away from life's wounding. As those events did take place, and the mystery of my own woundedness was revealed to me in the ending of my first innocence, I began to move consciously through the experience phase in the direction of the second innocence. This is not a linear process I am describing; it's much more of a spiral, in which one re-lives each of these phases of the journey many times over.

As the gospel recounts (cf. John 20:24-29 where the risen Jesus appears to the disciples), Jesus after the resurrection continued to bear and show the wounds of his crucifixion. He carried his wounds with him into the life of resurrection, where they no longer caused him pain. This is a spiritual

reality open to any of us as we carry our own wounds, no longer letting them dominate us or absorb all our attention or energy, but moving with them in the peace that comes after pain into the second innocence, in resurrection. In the most basic and imperfect and paradoxical sense this is what happened to me, and is still happening.

After completing a first draft of this memoir, I re-read a book I had read 25 years ago—*Iron John: A Book about Men*, by Robert Bly (hereinafter IJ). I am so glad that I did, because this enriched version of my story is far more pertinent to my actual life journey than the first version. From many pages of *Iron John,* Bly's insights leapt out at me with the force of fireworks; and I have incorporated a number of them in this current, and, I trust, final version.

I am aware that in writing this memoir and entrusting it to you I have made myself vulnerable, woundable; and so I offer you two lines from W. B. Yeats as a plea for your tenderness in response: "I have spread my dreams under your feet; tread softly because you tread on my dreams" ("Aedh Wishes for the Cloths of Heaven," ll. 7-8).

Donald E. Grayston
Vancouver / June 28, 2017

CHAPTER ONE

THE PAINTING APPEARS
AND BEGINS ITS WORK

When I saw the painting, I knew I had to buy it. I had no choice.

I had never before had such an impulse, nor have I had one since. I have over the years seen paintings that I liked, thought about buying them, and then bought or not bought them according to various practical consider-ations. This was different. I *had* to buy this painting, no matter how much it cost. When in 1975 and 1990 the figure in the painting spoke to me—yes, you heard that right—I knew more about why I had had to buy it. And after I noticed that he was holding a scroll in his hand, and after I re-read Robert Bly's *Iron John*, I began to understand why it was that I had been *compelled* to buy the painting.

I saw it for the first time at an art show in Trail, a small city on the Columbia River, in south-eastern British Columbia; I wasn't close enough to it to see its price. The time was mid-June of 1972. It was a Saturday, and the upcoming move my wife and I were preparing to make at the end of the month to Toronto was the most pressing matter in my life. We were going to Toronto so that I could go to grad school. She, we expected, would find work of her own to do, and so she did.

The previous summer we had gone to Toronto so that I could start a Master's in English at the University of Toronto. The plan was that I would continue with this degree in the summer of 1972, and then start

on a Master's in Theology that fall, finishing up the English thesis concurrently. To pay for the theological segment of this project, I had applied to a particular endowment administered through the Vancouver School of Theology, a fund from which I didn't have the slightest doubt that I would receive the amount for which I had applied. So it was an unhappy shock to receive a letter from VST earlier that week rejecting my application. The committee's reasoning: that in working on two master's degrees at the same time, I was overloading myself, and would very likely fail at one, perhaps at both. I immediately knew what they were thinking: "no man can serve two masters" (Matthew 6:24)!

So it was in the immediate aftermath of receiving this unhappy news that I distracted myself on that particular Saturday by going to an art show, something I had done seldom before that, although something I have done fairly often since. I went into the exhibition hall, and wandered among the paintings in a desultory mood, not looking for anything in particular. Then I turned—to my left, I remember—and found myself at the end of a kind of corridor, perhaps six or seven metres in length. On each side of this corridor was a row of standing room-dividers, each bearing its own painting, with the painting about which I am writing hanging on the wall at the end of this corridor, facing me, with an overhead light shining on it. As I say, I had no idea of what its cost would be. I have frequently thought since that given the intensity of my response, if the price had been, say, $10,000, I would simply have gone to a bank, taken out a loan, and bought it. My feeling was akin, I later reflected, to that of the biblical merchant in search of fine pearls who, "finding one pearl of great value, ... went and sold all that he had and bought it" (Matthew 13:45-46, New Revised Standard Version). I have to say that I prefer the King James translation, which refers to it as the "pearl of great price"—a little archaic, I know, but more evocative.

So I was much relieved, coming close enough to the painting to see the price on the ticket, and to learn that it was for sale for only $130. I decided immediately that I would buy it in a spirit of defiance, since I didn't have a line in my budget for paintings, as a kind of pledge to myself, or perhaps as a nudge to God, in regard to the appeal which I planned to write to the bursary committee. Buy the painting, get the money. Still pondering why it was that I *had* to buy this particular painting—only for this purpose, or

was there something more happening?—but knowing beyond any such wonderings that I *did* have to buy it, I went immediately to the organizers of the show, paid the $130, took it off the wall and took it home.

When I had come close enough to the painting to see how much it cost, I also learned its name—*The Holy Man*—and the name of its creator, Czech-Canadian artist Stanislava ("Velenka") Fanderlik (1914-1980). Velenka (she followed the old Czech custom of using the feminine form of the name of her husband, Velen, also an artist) was a lovely and elegant woman. Just before the outbreak of World War II, she and her husband had been, young as they were, the national leaders respectively of the Girl Guides and Boy Scouts in what was then Czechoslovakia, and personal friends of Lord Baden-Powell, founder of the scouting movements, and his wife, Olave. In 1946, Velen, by that time a lawyer, represented Czechoslovakia at the Nuremberg trials of Nazi war criminals. Sometime later, they came to Canada, and to Trail, where Velen taught Latin and other subjects at J. Lloyd Crowe Secondary School, and Velenka pursued her art. I had met them socially, and found both of them intelligent and charming. I regretted later that because of the press of our imminent departure for Toronto I did not think to contact Velenka to ask her about the painting; and when I did think of this some years afterward was saddened to learn that she had died. I would have wanted to ask her why she painted it, who the model was, how she had felt about it while she was painting it and when it was finished, what it meant to her, and why she was willing to sell it. A missed opportunity, and these are things that now I will never know.

At the time, we were living about six miles up a winding road from Trail in the mountain town of Rossland, the kind of small town in which, at least in those days, strangers would greet one another on the street. It was a skiing community which because of its altitude often enjoyed sunshine at times when Trail was enveloped in fog from the river. We had moved there in 1970 when I was appointed to a half-time position as priest at St George's Anglican Church; for the other half—more like three-quarters: two half-time jobs almost always take up more time than one full-time job—I taught English at Selkirk College in nearby Castlegar, where I also served as chaplain for the Anglican and United Churches. This was in the days of high ecumenical hopes and co-operation.

What then did I see as I looked that first time and look now at the painting, as someone who is not an art critic? The central feature of the painting is an elderly man, seated in a garden, with a bouquet of tall marguerites on his lap, his body visible only from the knees upward. He is wearing a robe or habit which, curiously, I long thought of as white. But as I look at it now, I see that like most of the rest of the painting it is painted in different shades of yellow, orange and green. In the upper left-hand corner there is an evocation of a building, or perhaps a city, falling, burning or decaying—it makes me think of John Bunyan's "city of this world" in *Pilgrim's Progress*. In the upper right-hand corner there is a burst of bright yellow. The man's hands are folded over the marguerites, the right hand being noticeably darker than the left; and in his hands he holds a scroll—something I didn't notice during the first eighteen years in which I owned the painting. A large painting, measuring 32 x 48 inches, it was painted in 1965 in acrylic on masonite. It was featured in the art column of the ecumenical American journal *Christian Century*, in the issue of March 9, 2010. However, the caption which my friend Lois Huey-Heck (artist, spiritual director, and at that time a regular contributor to the art column) wrote, with some input from me, was substantially shortened by the journal's art editor. Here then is what we originally wrote:

> This is a large semi-abstract portrait which states little but implies much. It sits at the threshold between the didactic/representative and the interpretive/imagined and felt. Since 1972, it has been an icon—a gateway to God—for its owner, Don Grayston. He recalls an instant recognition on first seeing *The Holy Man*—that he simply had to buy it. Decades later, it continues to offer him truth and insight. As with all icons, the image-viewer dialogue is very personal. Revelation is rarely gained in a passing glance; rather it comes from time spent in prayerful communion … from *imaginatio divina*.

More recently, another friend, Vancouver artist Brooke Anderson (sbandersonart.com) has sent me this marvellous account of her first encounter with the painting:

This lovely painting invites me in. The colours are beautifully rich, vibrant and full of life. Placing these complementary colours in *juxta* position (as the Impressionists did) allows the colours to vibrate. Yellow/Orange as the dominant colour of the background suggests life, excitement, adventure and energy ... i.e., the world.

In peace and deep silence sits a self-contained and grounded holy man. The figure dominates, even exceeds the boundaries of the canvas, both above and below. The robe he wears echoes the patterns of the structure directly behind him and these patterns/lines actually continue onto his robe suggesting a connection between the two. Yet with the application of the ethereal blue, reminiscent of the sky, the figure has the illusion of transparency. He is there, yet not only there. He straddles two worlds ...

The hands are beautifully rendered. Are they holding a bouquet of flowers? I cannot tell what is on his forehead between his eyes. It looks like a skull—and is there above the skull a crown? If the artist has placed a skull on the forehead of the holy man, it may represent an opening or portal to the divine.

My own eye is drawn to the holy man's lap . . . it seems inviting. If I were a child, I would want to climb up onto that lap. This comes as a surprise to me.

Her comment that the holy man "straddles two worlds" hits the mark for me; and yes, he is indeed self-contained and grounded. As one friend said, "The painting has presence." The holy man is both of this world and not of this world; history and eternity come together in him. You will read a number of things later in this book which will testify to this duality. Her reference to the mark on his forehead is another telling comment. Some have called it a scarab, sacred to the ancient Egyptians; others have wondered if it represents the third eye. For me it is a mark that points inward, enhancing the inward direction of his attention. And her statement that if she were a child she would want to climb up onto his lap is a recognition of the way the painting carries the archetype of the father, among others.

★

Having taken the painting home, I hung it on the north wall of the living room. The next morning, Sunday, I got up around 5:00 a.m., prepared for my churchly responsibilities, and then settled into a comfortable chair at the other end of the living room, facing the painting directly. Of course at 5:00 a.m. the house was quiet; and for the first little while, I simply sat there, gazing at the painting. Then I began to hear things, things I had never heard before, although I had by then lived in the house for almost two years.

The first thing I heard was the sound of the clock in the living room itself. Some minutes later I heard the sound of the refrigerator, from the kitchen. Finally, I heard the sound of the furnace, from the basement. I could have heard any of these sounds at any time while living in the house; but I hadn't sat still long enough, or collected myself enough, to pay attention to the sounds around me. In plain words, I hadn't shut up and sat down long enough to take in these simple evidences of my sonic environment. At a later time in my life, working in programs for the training of spiritual directors, I came to honour and use such words as *contemplative, evocative* and *spacious,* words which refer to qualities which were almost completely lacking in my life at that time. It was just such an experience that I was having as I gazed (not just looked, *gazed*) at the painting. Years later, reading about the enlightenment of the historical Buddha, I learned that, according to Buddhist tradition, he became aware, during the last twenty-four hours of his momentous sit under the bo tree in Bodh Gaya, of all the dimensions of time, space and sound in the universe. In the most minimal sense, I reflected, I had had an analogous experience. According to the classic accounts, the Buddha sat unmoving on the ground under the bo tree for seven days: I sat, probably moving around a certain amount in my comfortable chair, for perhaps an hour. I hope the dimensions of this experience—the clock, the refrigerator, the furnace—are mundane enough not to raise in the mind of any reader of this book that I am comparing myself to the Buddha. What these small awarenesses do represent, however, is the beginning of a relationship with the painting through which new learnings, some with the force of revelation, have continued to come to me.

And having said this much, let me seize the occasion to say that I am also not comparing myself either to Jesus or to Thomas Merton (1915-1968),

on whom I wrote my doctoral dissertation, and who, like the man in the painting, has also been a constant companion since 1972. When I turned thirty-four a year later, it occurred to me that although I had by then lived a little longer than Jesus, this offered no basis whatever for comparison. As for Thomas Merton, and my older daughter Megan's teasing about this to the contrary ("Dad, are you trying to be Thomas Merton?"), I have never been tempted to compare myself with him—a man who got up at 2:00 a.m. every day for twenty-seven years, and published a hundred titles—some sixty before he died and some forty since his death (the latter, *bien sur*, with a little help from his friends). I also received a salutary reminder of my standing in relation to Thomas Merton when in December 2000 in India I had a brief audience with a Tibetan high lama, Chatral Rinpoche. Merton had spent two hours with him in 1968 in substantial conversation, as recorded for us in *The Asian Journal of Thomas Merton*. My interview with Chatral was finished and I was in tears after ten minutes, clearly indicating that I was only one-twelfth as realized as Merton!

I think of the painting, and have in fact described it on my website as "my great painting." Is it then in art-crit terms really a great painting? I don't know, nor do I care, although I honour what others have told me it evokes for them. It is *my* great painting, and that's what I do know and care about. Recently I read Donna Tartt's magnificent (and massive) novel, *The Goldfinch*. The protagonist is Theo, a young man who loses his mother in a criminal explosion in a museum, and in a mysterious way ends up living with the business partner of an elderly man whom he comforted as he was dying after the explosion. The partner, James Hobart—Hobie—takes him into his home and into his antique furniture business; and Theo after some years becomes his new working partner. Hundreds of pages after this beginning tell Theo's story; and toward the end of the book, he and Hobie are having a meaning-of-life-what's-it-all-about kind of conversation, in the course of which Hobie says this:

> Great paintings—people flock to see them, they draw crowds,
> they're reproduced endlessly on coffee mugs and mouse pads
> and anything-you-like. And, I count myself in the following,
> you can have a lifetime of perfectly sincere museum-going
> where you traipse around enjoying everything and then go

out and have some lunch. But … if a painting really works down in your heart and changes the way you see, and think, and feel, you don't think, "oh, I love this picture because it's universal." "I love this painting because it speaks to all mankind." That's not the reason anyone loves a piece of art. It's a secret whisper from an alleyway. *Psst, you. Hey kid. Yes, you.* … An individual heart-shock. Your dream, Welty's dream [Welty: the partner who died], Vermeer's dream. You see one painting, I see another, the art book puts it at another remove still, the lady buying the greeting card at the museum gift shop sees something else entirely, and that's not even to mention the people separated from us by time—four hundred years before us, four hundred years after we're gone—it'll never strike anybody the same way and the great majority of people it'll never strike in any deep way at all but—a really great painting is fluid enough to work its way into the mind and heart through all kinds of different angles, in ways that are unique and very particular. *Yours, yours. I was painted for you* (p.758).

That's it. That's exactly what happened to me and for me. The painting told me that the holy man and I were meant to be together. And in one of the meditations which he sends out daily from his Center for Action and Contemplation, Richard Rohr addresses the power of art for spiritual awakening:

> … I think good art is absolutely essential for good religion. … Sometimes you don't know what you're experiencing in a logical, rational way, but you can't take your eyes off a picture or a piece of art. You're drawn to it because the epiphany is happening as the unconscious is being ferried across to your conscious mind—but unconsciously! … [Good art] is less informational than transformational. And it largely happens beneath your conscious awareness that it is even happening. You only see the fruits later (from his meditation of October 13, 2015).

And again, so it was for me.

<div align="center">★</div>

Who were we then, my wife and I? We were both thirty-two, very naïve and childless, although we hoped to have children. I sometimes look at young folk in their thirties and wonder if they are as naïve as we were, or at least, as I was. My general sense is that members of the present generation are far more what?—sophisticated? worldly-wise?—than I was at thirty-two. My wife was American by birth (her mother was scandalized when she became a Canadian citizen and pledged allegiance to the Queen), a teacher, with degrees in music and theology, of Anglo-Saxon and German stock going back several generations in the US. I am Canadian by birth, my paternal grandfather having arrived in Canada from England in 1896 and my English grandmother in 1910. My maternal grandparents were both born in the 1880s in Ontario, of Irish, Scottish and Dutch stock. My degrees were in English and theology; I had been ordained in 1963. I was fortunate enough, immediately after ordination, to work in an experimental parish under a visionary rector; and my later posting in Rossland was part of that experimental parish.

My wife and I had met in Switzerland, in Geneva, where, having done a degree in theology after her undergraduate degree in music education, she was working in a parish, and I was studying at the Ecumenical Institute at Bossey, a joint project of the University of Geneva and the World Council of Churches. I wandered into her church one Saturday afternoon, wondering about part-time work there, heard the sound of a typewriter, and followed it to her office. We got talking, and discovered we knew one person in common, a friend from Vancouver who had gone to the same seminary as she had; and this sufficed to assure both of us of our *bona fides*. Like most young people of my time and my acculturation, I thought that marriage involved finding "the one." I now realize that, as Shakespeare says, "Ripeness is all" (King Lear V.ii.9). Both of us were ripe to meet, if not "the one," then "someone"—I won't go so far as to say "anyone"! So when part-way through our initial conversation I heard an inner voice say "This is she," I paid close attention. You may smile at this, but it rang true for me because it was grammatically correct. If the voice had said "This is her," I would

have disregarded it. Years later, after our separation, I challenged the voice: "I thought you said "This is she!"" "Well, yes, I did," the voice replied, "but I didn't mean you would be together forever. I just meant that this is the woman with whom you would have your children." Isn't this how the Delphic Oracle used to work? The Oracle would make what sounded like a flat and simple statement, which would almost invariably turn out to mean something *just a little different* from what its hearers thought it to mean at first. As to the character or identity of the voice, I leave that to the reader to decide after reading the rest of this book. The courtship was a speedy one—we were both 29 and, as I later realized, unconsciously invested in being wed before we were 30. This was, after all, the time when "Don't trust anybody over 30" was one of the watchwords of the progressive set.

She lived in a marvellous old apartment on rue des Granges, in the old city of Geneva. The building had formerly housed the civil guard which protected the Hôtel de Ville, which was next door. Our courtship was romantic in the extreme, which made our separation all the sadder. Our first date was to the Musée Rath, for an exhibition of Russian icons. We had a picnic at the Col de la Faucille. We ate raclette at the Cave Valaisanne. We drank Swiss and Luxembourgeois wine. We spent a Christmas holiday in Kitzbühl, in Austria: she skied, and I did a chaplaincy for the Colonial and Continental Church Society, a Victorian name if ever there was one. My main responsibility was visiting English-speaking skiers with broken legs in the hospital. The Roman Catholic diocese kindly lent us one of their churches, St. Catherine's, which was so cold that the holy water was frozen in the stoups, and I had to keep my duffel coat on under my alb and wear gloves except at the time of consecration in the Eucharist, and the time of communion. We met in September, I proposed in October, she accepted in December and we were married, civilly, in the Hôtel de Ville in May.

All weddings are memorable, and this one was no exception. As a surprise for her, I rented a *fiacre,* a horse-drawn carriage, what in Québec is called a *calèche,* to take us the very short distance from her apartment to the Hôtel de Ville. My witness for the civil wedding, who was flying from Zürich on standby, couldn't get a seat, and we had to find another witness pronto. Another guest, a Roman Catholic priest who had worked with my wife in youth ministry for English-speaking teens, was recruited. About a year later we smiled to learn that he had married her successor at the church at

which she had worked, and was on his way to being recycled as a Methodist minister. After our civil wedding, we had a brief honeymoon in the Chalet Minnehaha, in the mountains near Berne. We needed to be close to Berne, where on the presentation of our marriage certificate we were to pick up her immigration documents from the Canadian Embassy. When we went in to get them, the clerk, with the look of utter boredom that most of us will have seen in some bureaucratic context or other, said that she couldn't find the file. Since we had imminent reservations for our sea voyage from France to England, I was alarmed. With all the authority of a husband of two days' standing, I slammed my hand on the counter and said "We will be back in exactly one hour and that file will be on this counter." We made careful note of the time, exactly one hour later walked back into the immigration office, and lo! there it was on the counter; the lost had been found. These documents described her as a "settler," a term which we found amusingly archaic, but which has now regained currency as many of the First Nations of Canada are engaged in negotiations to reclaim something of the land which previous "settlers" commandeered without so much as a by-your-leave.

At the church wedding, in Cambridge, Massachusetts, in July, the officiant, a friend and former teacher of my wife's, and a great wit, pretended to puzzle over what it meant for him to "marry" us when we had already had a wedding in Switzerland. His solution: he would say "*I pronounce you man and wife*" There is no such phrasing in the Anglican/Episcopal wedding rite, but he was making his little joke. The beginning of our honeymoon was a weekend at his getaway place on Cape Cod, a great old house dating from 1755. My recollection is that we spent a lot of our time eating a great number of local mussels. We also had fun with his kids, whom my wife had babysat when she was a student. Because at that time she had had a carpet-bag, the kids called her "Mary Poppins," which led to my being designated "Mr. Pop."

So the honeymoon began well, but then deteriorated seriously. Our plan was to drive from Cape Cod to Vancouver. The car didn't have a radio, and my wife wanted to have one installed, something about which I was indifferent. This took place in a hurry; and as we drove away we realized the radio wasn't working. I didn't realize until later that she wanted the radio because she was afraid that on such a long trip we wouldn't find enough to

talk about. Then on a long straight stretch of I-90 in Montana we ran out of gas. Our response was to jump out of the car in simultaneous and mutual irritation with each other, blame one another, and lock the doors, with the keys dangling visibly and infuriatingly from the ignition. A highway patrol officer came by, told us we were committing an offense—running out of gas on a freeway in Montana was the charge—but given that we were on our honeymoon, gave us a break, and drove us to a gas station where we bought a container of gas, and soon we were once more on our way, barely speaking to each other—we did need the radio!

Another Montana adventure was to come. At 7:00 the next morning, on the main street of Bozeman, the engine block cracked (we were pulling a U-Haul containing all our wedding presents). VWs were not common in those days, and came supplied with a directory of all VW garages in the US and Canada. I flipped through the directory to find Montana, and immediately saw that there was only one VW garage in the whole state—in Bozeman, as it turned out, and about a block from where we had broken down. A few hours, a number of cups of coffee, and we were on our way.

A couple of days later we visited in Tacoma, Washington, a school friend of my wife's and her husband, a major just back from Vietnam. We had planned to stay overnight with them; but I had a visceral reaction—irrational, I know, in the larger scheme of things—at staying in the same house with someone who had been involved in the obscenity of the war in Vietnam. We made feeble excuses—correction: I made feeble excuses—and we left, and found a motel a few blocks away. By the time we got to Vancouver, and presented ourselves at the beautiful reception my parents had planned for us, we were once again talking to each other, but just.

Post-reception, and storage of some of the wedding presents, we drove up to Sorrento, the location of an Anglican continuing education centre in the Shuswap country of British Columbia's interior. We spent a mostly happy year there, with me working at the centre, subbing for a friend on sabbatical, and my wife subbing as a teacher in the local high schools. What kept it from being entirely happy was a dispute in the spring between my wife and myself about my next job. I was invited to be an assistant to the dean of the Anglican cathedral in Vancouver, a man I much admired, and still admire, Herbert O'Driscoll, a wonderful teacher, preacher and writer. I was, frankly, thrilled with this invitation, but my wife was anything

but. "If we move to Vancouver, your family will eat me alive," was her comment. I do have a lot of relatives in the Vancouver area, but seldom see most of them. She was making a statement about her own insecurity, not a statement about the reality of the situation. We didn't speak for three days, even though we were living in the same house, and sleeping in the same bed. We communicated by leaving notes at the front desk of the Centre. Somehow this passed, and life carried on; but it points ahead to two comparable moments of resistance on her part to what I also saw as wonderful possibilities.

From there, we went to Rossland, where we were living when I bought the painting, a town of about 4000. We had a happy time there. My most memorable moment there (apart from buying the painting) came when I was asked to chair a public meeting called to discuss the prospect of the high school being closed. A good thousand people came out to protest, and as chair, I was given an actual hammer, not just a gavel, with which to keep order, high and strong feelings being anticipated. Order was maintained, motions were passed, the crowd dispersed, and the high school, yes, was saved, and to my knowledge is still open.

<div align="center">★</div>

The last two weeks of June 1972, the short time before our departure from Rossland, passed quickly. I contacted two friends of mine, prominent Anglicans, asked them to write letters of reference to the bursary committee, sent in my own letter of appeal, and stopped thinking about it. We prepared the house for friends of ours who were going to be moving into it during the summer, and deposited whatever we weren't taking to Toronto in my Aunt Kathleen's basement in Vancouver. We had decided that we would only take to Toronto what we could fit into our VW Squareback Sedan; orange in colour, we called it "the Pumpkin." Fortunately, when the back seats were down, there was just enough room on the flat surface in the back for the painting, protected by a sheet of plywood, with the rest of our possessions piled on top of it.

After my early-morning time of self-exposure to the painting, to its presence and meaning, I didn't immediately give any notable time to thinking about it, what it meant or what it would mean, apart from my somewhat

whimsical decision to use it as a talisman, a source of sympathetic magic that would tilt the universe in my favour in financial terms. I smile now at my own willingness to engage in this kind of folk-religious, semi-magical attempt to bend reality in my preferred direction. At the same time, I had no doubt that the painting had to come with us, so that we would have at least one thing of real beauty in whatever grungy little flat we would find in which to live in Toronto.

CHAPTER TWO

TORONTO, THAT GREAT CITY

So we did find our little flat, a two-bedroom apartment on Summerhill Avenue, in what I used to call jokingly "the slums of Rosedale," the neighbourhood where many of the rich and beautiful of Toronto live. The great houses of that beautiful and leafy suburb began right across the street; but on the north side of Summerhill—ah yes, here's the reason: just south of the railway tracks—there were three little red-brick apartment blocks. We were shown the apartment by Mike, the manager, who apologized for its smell of fresh paint. We didn't think this needed any apology, since the place felt fresh, not grungy as I had anticipated, and the price was right. We moved in, and transferred our worldly possessions, the painting included, from the VW to our new domain. The hanging of the painting was always my special care; and so I hung it on the east end of our living-room, where it presided in its usual peaceful way. After all this, we collapsed into bed; and a couple of hours after falling asleep were suddenly awakened by the reason for the apartment's low rent—the train that went by, screechingly announcing its presence at about 2:00 a.m., perhaps six inches from our window, or so it seemed. But we quickly got used to this, and by our third or fourth night there, we were successfully sleeping through.

Then what about the bursary money? Was my appeal successful? Yes, it was. The money came in; I took my English courses in the summer—one from an authority on novels, Walter Allen, the other on Canadian literature, with Milton Wilson, a name to be conjured with in English studies in those

days; and life carried on. This was Toronto in the seventies, when David Crombie was its "tiny perfect mayor," and the city cheerfully accepted the label of "New York run by the Swiss." These were simple, happy times for us, and for the city. So yes, I got the money: but what about the earlier concern of the bursary committee that I might be in danger of overloading myself? Did I in fact finish both master's degrees? No, I didn't: I did finish the Th.M., not the M.A. in English. So then was the committee right, and had I, in my grandiose manner, overreached myself? Again, in all objectivity, no. What happened was this. Having completed the course work, I had settled on the thought of doing for my thesis a reading of Malcolm Lowry's *Under the Volcano* via the archetypal theories of Carl Jung (1875-1961), founder of Analytical Psychology. The Lowry book is a classic Canadian novel, full of archetypal material; and it seemed to me then, and still does, to be a natural subject to explore with the assistance of Jung's theories. I went to see Robertson Davies (1913-95), author, journalist and noted wit, then Master of Massey College in the University of Toronto, because I knew that he was deeply interested in Jung. Alas, he professed no knowledge of Lowry, and declined to supervise my thesis. Nor could he suggest anyone else in the English Department who, to his knowledge, had an interest in Lowry. I remain convinced that if he had responded positively to my request, I would have finished the M.A.

But too much else happened just around this time. It was early fall, and my own graduate theological studies were commencing. I was also working as a teaching-assistant for a University of Toronto course in Jung; I had been arbitrarily assigned a Th.M. thesis director with whom I didn't connect comfortably; and our daughter-by-adoption Megan arrived, in all her four-month-old and bright-eyed beauty, and turned our lives inside out for many months. We also took in an old friend of mine from BC, who was waiting for his admission to Donwood, the addiction treatment centre in North Toronto. He did two four-week stretches with Donwood, and then returned to us for another month or so before finding his own place. He later had a successful career as an addictions counselor, and died some time in the nineties; his time with us will surface again later in this chapter. I take this opportunity now to say, peace be with him.

I tell another story about him here to atone, so far as I can, for the naïveté that the story demonstrates. Our diocese was having an episcopal

election, and in a straw vote, my friend had come out at the head of the list. At about the same time, a young guy whom I had met at Sorrento Centre told me that this friend was cross-addicted to drugs and alcohol, and was also involved sexually with a number of young folk of both sexes. Hearing this, I decided to act. I phoned him, told him what I had been told, and asked him if what I had been told was true. "Yes," he said, "it's true." I said to him that we needed to talk, and we agreed to meet on the highway between his city and mine, a completely deserted spot, as it turned out. He protested—classic for addicts—that if he were elected, he would change. I told him that I would expect a call from him within 24 hours, telling me that he had withdrawn his name from the list of candidates, got back in my car, and drove home. He did call me, did withdraw, and a couple of weeks later—the priest's nightmare—collapsed in the pulpit.

Some years later, it suddenly occurred to me that in that deserted place he could have killed me. Don't take this for melodrama: both then and later I realized he was in a real sense crazy, and the episcopal dignity is something that Anglican clergy can crazily lust after with no regard to their competence or suitability ("This is a true saying, if a man desire the office of a bishop, he desireth a good work"—1 Timothy 3:1 KJV). I have wondered, in fact, what would have happened if I had extended the conversation by even fifteen minutes. By the time he came to stay with us, however, he was well on his way to sanity once again.

At some point in the fall, before Megan arrived on December 1 (International Megan Day, as it came to be known in the family), Phil Jefferson, a longtime staffer with the Anglican national office, came for dinner. He asked about the painting, as most people did; and I told him the story of how I had bought it as an attempt to nudge the universe in my direction. "So did you get the money?" he asked. "Yes, I did." "So it worked—the painting did its job for you?" "Yes, it did!" An "Aha!" moment. Until that conversation, amazingly it now seems to me, I had not made the connection. When the letter with the cheque arrived, I had accepted it with a sense of entitlement, and with some satisfaction that the committee had seen the error of its ways. But I had completely forgotten the deal I had made with the painting: I find it hard now to understand why that was so. I thanked "the guy in the painting," as I had come to think of the calm, robed figure which the painting offers to its viewers, and

apologized to him for not having thanked him immediately after receiving the results of his … what?—intercession? magic? talismanic influence? In his usual peaceful way, he made no sign indicating either that he had been insulted by my lack of immediate gratitude or that he was gratified by my somewhat dilatory thanks.

The following summer, we left Rosedale to move to a much larger apartment in Parkdale, then a slightly decayed neighbourhood, now very hip; our building was on Tyndall Avenue, just south of Queen Street. It was a remarkably spacious place, with a large separate dining room, a study, and a working fireplace. The apartment had been built in 1898, and in the 75 years of its existence up to that point, had had only two sets of renters, we ourselves being the third. Here I confess to a lapse of memory. The painting must have hung either in the living room or the dining room, but I can't remember exactly where. We were there for two years, during which time I finished my Th.M., and continued to teaching-assist in the Department of Religious Studies of the University and tutor in the Faculty of Divinity at Trinity College. I also filled in at the office of the Anglican Diocese of Toronto, working as a consultant in marriage and family life education during the sabbatical of the incumbent, Graham Cotter, a brilliant, socially-concerned, humorous and charming man, who was also the rector of the parish of which we were members, St Mark's, Parkdale.

A very particular memory from this time comes to mind here. The friend we had taken into our first little apartment, as I've indicated, was a priest of my diocese. The bishop had taken his name off the clergy mailing list, and was not responding to his letters. This concerned me, and I wrote from our new apartment a polite letter to the bishop about our friend's situation. In return I received what I felt was an unsatisfactory reply, in essence telling me to mind my own damn business. This offended me, and I wrote a stronger letter back, saying that I believed that the fact that he was living in my home entitled me to ask what I was asking. In response I received a letter saying to me, in so many words, that he was the bishop and I wasn't. I wrote back, agreeing that indeed he was the bishop and that I was not, but asking whether he was also a Christian (!)—ah, the brashness of (comparative) youth! The correspondence went downhill rapidly from there, but I didn't let go. Then one day, having received another letter from him, I stood with my wife in the dining room, waved the letter in the air, and exclaimed,

"Another stupid letter from the bishop!" Her reply was brilliant: "Why are you trying to force the bishop to be your father?" Later you will read how I came to understand this comment. The oblique angle at which it came into the discussion completely disarmed me. I decided immediately that I *would* let go, that I would *not* reply. Two or three months later I received another letter from the bishop. This one said that not having heard from me for a while, he wondered how I was doing; and knowing that money is always welcome to grad students, was happy to be able to enclose a cheque for $200—roughly the equivalent of $1000 today. I wrote him a brief and grateful letter, and so our correspondence ended.

<p style="text-align:center">★</p>

In March 1975 our second daughter, Rebekah, appeared among us as her tiny and beautiful self (less than five pounds), full of promise. This moved us to think of finding a larger place; and eventually we decided, together with another couple, to buy a house in another part of Parkdale. These were different days, a time when two relatively impecunious couples could afford to buy a house in Toronto. We found a place on Beaty Avenue, a little farther west, and closer to Roncesvalles Avenue, the major western artery of the neighbourhood. It was a solid brick house, of classic early-twentieth century middle-class-Toronto design, with four stories, a beautiful back yard for our children and their friends, and wide stairwells. I mention the stairwells, because I decided to hang the painting on the left-hand (i.e., western) wall of the first rank of stairs in the stairwell going from the ground floor to the floor above. There it seemed to settle in and to have found a place both of honour and of peace. One day, as I was walking upstairs, and just as I was passing the painting—not looking at the painting, just passing it as I climbed—the figure in the painting spoke to me. Of course I was startled, and wondered if my ears had actually heard the words he had spoken or if the whole thing was taking place in my sensate imagination. (As Thomas Merton would say, this there is no need to decide.) I looked carefully at him, as always seeing no change in his expression, and wondered what was happening. What then had he said? He had simply said, "Look at me"—which of course I did; and when I did, I realized immediately what (I conjectured) he wanted me to recognize—that the painting was

an archetypal one, and that he, the figure in the painting, carried at least three archetypes: the archetype of God, the archetype of the True Self and the archetype of the Wise Old Man. Later I was to discern in it a fourth, and later still a fifth.

A word here about archetypes, the fundamental building-blocks of psychic life. An archetype is a collectively-generated and inherited unconscious pattern of thought, or image, universally present in individual psyches. The archetype of the Wise Old Man, for example, exists potentially in all males, but as a kind of waiting mold which will be filled in differently in each man according to his life experience. According to Jung, when an archetype of the collective unconscious manifests itself in one's life, it comes as a catalyst for transformation, as a call to a new level of wakefulness. As Vancouver therapist Devorah Peterson says, speaking of the Stranger archetype, "we know intuitively that if we allow him or her into our lives, our identity will change in some essential way." I believe that I did have some intuition, below the level of consciousness, which kicked into action when I saw the painting for the first time, was non-verbally addressed by its archetypal character, and allowed the Stranger into my life by buying it. I am ready now, having read what Devorah Peterson has written about the Stranger archetype, to add it to the list of archetypes I first saw represented in the painting. (Later I would add a fifth, the archetype of the Father.)

She begins her paper on this archetype with a reference to "the stranger" who in the old western films would ride into town and initiate a series of changes after which nothing and no-one would ever be the same again.

> You have read or watched it before, or something similar …: the stranger arrives, riding his horse along the main street of town. An old man shades his eyes with his hand. Others stop what they are doing and turn, squinting, toward the road. The stranger's steed knowingly comes to a halt, without him tugging the reins. All is still except for the dust the horse has kicked up, and the only sound is the animal's whinny and blow. Then everything falls silent. Nothing (and no-one) is the same again.

And at Christmas 2009, I heard a song on the radio which said "Come to the manger; meet the little stranger"—and Jesus will of course change the

life of anyone who encounters him at any depth. Certainly I recognize the truth of this dynamic in my own life: that when I bought the painting my life took a decisive turn the implications of which are still unfolding and being unfolded. On this motif of the stranger, a motif which he applied to himself in his magnificent "Day of a Stranger," Thomas Merton has this to add, in his article "From Pilgrimage to Crusade":

> ... if we can voyage to the ends of the earth and find *ourselves* in the aborigine who most differs from ourselves, we will have made a fruitful pilgrimage. That is why pilgrimage is necessary, in some shape or other. Mere sitting at home meditating on the divine presence is not enough. We have to come to the end of a long journey and see that the stranger we meet there is no other than ourselves—which is the same as saying we find Christ in him. ... the stranger who is Christ, our fellow pilgrim and brother (p.112).

How sad that the European settlers in North America could not have taken Merton's perspective into their encounters with the indigenous peoples of the land: that in meeting them they were meeting Christ, and meeting themselves. We would not then have had the sorrow and shame of the residential schools and the theft of land by the settlers. Here, then, in Merton's words, we see the archetypes coming together: in meeting the stranger who is oneself, and recognizing Christ in that person, we have encountered once again the True and Divine Self. And in meeting ourselves as strangers (for on the inner journey, if intentionally pursued, we will always find aspects of ourselves which remain mysterious and strange to us), and at the same time encountering the True Self/God, we also encounter God as stranger. Thomas Merton again, in his great prose-poem, "Hagia Sophia":

> A vagrant, a destitute wanderer with dusty feet, finds his way down a new road. A homeless God, lost in the night, without papers, without identification, without even a number, a frail expendable exile lies down in desolation under the sweet stars of the world and entrusts Himself to sleep (p.371).

Merton here does not use the word "stranger" for God: but his near-syn-onyms—vagrant, wanderer, homeless one, exile—evoke very much the same resonances. He is not speaking in the terms of systematic or dogmatic theology, but in personal, mystical and social terms, characterizing how we as individuals can sometimes experience God, and also describing the cultural marginalization of God which we regularly encounter in our twenty-first century consumerist and post-Christian society. Those of us who have set out as Christians on the interior path will co-experience this with God, knowing ourselves as well, in various ways, to be "strangers and pilgrims on the earth" (Hebrews 11:13, KJV).

Back then to my encounter with the archetypal figure in the painting. It was as if he was saying something like this to me. "Now that you have been studying Jung, you are in a position to recognize the archetypal realities which I carry, and because of which you bought the painting." And so it was. Jung says that the archetypes of God and of the True Self (of which the archetype of the Wise Old Man is a variant) are "empiri-cally indistinguishable." You can't tell, in other words, which of these two archetypes is at play without reference to the context. Is the painting, then, a representation of the True Self, or is it a representation of God? It *can't* be a representation of God according to the western religious traditions of Judaism, Christianity and Islam—which, whether we follow them or give them credence or not, continue to influence our culture—in which it is considered impossible if not blasphemous to try to depict the invisible God (cf. John 1:18). Most memorably, any such attempt is explicitly forbidden by the second commandment (Exodus 20:4). Beyond this it is impossible to make a representation of God in a way which all its viewers would accept as valid—although here I can't prevent myself from telling the story of the little boy who was painting one day. His mother asked him what he was painting, and he replied that he was painting a picture of God. "But nobody knows what God looks like," his mother said. "They will when I'm finished," the boy replied.

So then, hanging in my stairwell, I had at least a painting of the True Self, and, with all the provisos I have given, a painting of God, or better perhaps, "God." What I mean by the quotation marks is this. God with no quotation marks refers (I used to tell my students) to God in Godself, as God is known to Godself; this is God (if there is a God: I told them

that our university had no official position on this question!) beyond any human knowing. With the quotation marks, the reference is to human cultural commentary, verbal or visual (I think here of Michelangelo's God the Father in the ceiling of the Sistine Chapel at the Vatican). It refers to whatever we choose to say, rather than keep silence, about God. On this understanding, the painting points to "God," God as human beings think or write about or try to paint the ineffable God. The painting, as I say, was archetypal, symbolic: and a true symbol both points to the reality of which it is a symbol and in some sense participates in and conveys a sense of that reality, but is certainly not the reality in its fullness. Another way of saying this is to call it an icon, in the sense in which the Eastern Orthodox Christian tradition uses that term, and this is how I have now come to regard it myself. The icon draws the viewer into and through itself to the reality archetypally symbolized. The figure is not a realistic human figure; it is impressionistic rather than photographically accurate, and isn't intended to be a realistic painting of an actual human being, let alone of God. Another way of saying this is to say that it is clearly not a realistic portrait. But it simultaneously points to a certain way of *construing* what it is to be human, and at the same time points to the reality of God. It is thus both a pointer towards proximate, finite reality—the human, and towards transcendent and ultimate reality—the divine. It is the finger pointing to the moon. If it makes it any clearer, I might say, paradoxically and in no sense literally, and in the spirit of Zen, that it is both a painting of "God" and *not* a painting of God. It is worth adding here that just as no figurative work of art can adequately represent God, neither can words, all words about God being finally inadequate if not potentially idolatrous. This takes us to the spiritual truism put forward by St. Augustine in his *Confessions*, and by Thomas Merton in almost everything he wrote: to find God, find yourself; to find God, look into your own soul. The ground for this in the western tradition is found in Genesis 1:26-27, which speaks of God creating humankind, both male and female, in the divine image. I stress here that female as well as male is made in the divine image, since this is something about which our lingeringly patriarchal culture is not always entirely clear.

<div align="center">★</div>

Buying the house was a good decision financially, although we soon found ourselves in a difficult situation with the other couple. We had not known them for long before we launched into being co-owners of our house; and in retrospect, we would have been well-advised to wait until we knew them better. But the housing market was favourable, and neither couple could have bought alone; but we liked them, so we took the plunge. Then in the last year we were there together (1976-77), open conflict. The woman in the other couple was at home with three little children; and at that particular time, I was doing a lot of traveling and speaking. The contrast between what she perceived as my careless freedom and by contrast her imprisonment on Beaty Avenue became too much for her. At the high point of the conflict, she told me that I was nothing but a disembodied head. (Remember this when you read the story of the "click" in Chapter 6). I was not happy to hear this, and resisted to the best of my ability, while simultaneously recognizing her comment as at least partially valid. The previous year, Rebekah, then five months old, got meningitis, and was in hospital for ten days. My wife spent every day in the hospital, nursing Rebekah, and expressed milk which the nurses would give her during the night. I am convinced that this is what saved Rebekah's life (another child in the hospital had just died of meningitis), and also spared her from its dreadful side-effects: blindness, deafness and paralysis. The woman in the other couple looked after Megan during these ten days, enabling my wife to spend every day at the hospital. This time of bonding was probably the only thing that enabled us to be civil to each other in that later time of conflict. We continue to be grateful to them.

And a coda to this. Five years later, I was again in Toronto, for my Ph.D. defense. I had just had dinner with my supervisor at a Chinese restaurant (I hesitated to open the fortune cookie, but when I did, I was grateful to read "Your business [the defense!] will prosper," and so it did, the next day.) After dinner, I was walking back to my hotel when I saw the couple of this story walking toward me. I was apprehensive; but as they approached, the woman put out her hand in my direction. We shook hands—no words were spoken—but I knew that we had all let go of the unhappy time of three years earlier.

<div align="center">★</div>

We stayed in Toronto until the summer of 1977, when we drove west *en famille* in the same Squareback sedan—and however did we manage to pack all our stuff, plus two children and their stuff, into the same vehicle in which the two of us had driven east childlessly five years before! Once again, the painting was on the flat deck of the sedan, protected by the same sheet of plywood that we had used for this purpose on our way east, and which in the interim had served me as a mattress stiffener for the sore back which afflicted me in those days.

CHAPTER THREE

BACK TO THE WEST

And so we came west again, to the Vancouver suburb of Burnaby, arriving there at the beginning of August in 1977. I had been appointed rector of the middle-sized, middle-income, middle-of-the-road parish of All Saints, Royal Oak, located on the crest of the South Slope, which takes Burnaby down to the Fraser River and to the astonishingly fertile Chinese gardens in its so-called Big Bend. The rectory was a smallish, undistinguished, stucco suburban bungalow. I hung the painting in my downstairs study, where it kept me company for the eight years that we remained there. After his first statement ("Look at me"), the figure in the painting had said nothing for the rest of our time in Toronto; nor did he say anything during the time we lived in the rectory. This was the home to which our third and last child, Jonathan, came in his male and red-haired glory when he was born in January 1978 in the same hospital in which I had been born, Vancouver General.

There were more happy moments in my eight years at All Saints than unhappy ones. I think particularly of the defusing of the lingering anger between the congregation and a previous rector, a resolution which took us about three years to bring about. I think also of the founding of the Marriage Project, which flourished for more than twenty years in the provision of marriage preparation for engaged couples and for couples re-marrying after divorce, as well as other support services for married couples. These were also the years of high nuclear anxiety, which generated strong response from

the parish in the form of support for peace demonstrations (115,000 people walked across the Burrard Bridge in Vancouver in April 1982 to protest the very existence of nuclear weapons). It was also a time of active ecumenical co-operation among three local mainline congregations—Grace Lutheran, South Burnaby United and All Saints; and even occasional interchange with a large local evangelical congregation, Burnaby Christian Fellowship. This kind of interchange was still possible because the fissures which have since opened between conservative evangelicals and the mainline non-Roman churches over such issues as same-sex relations had not yet manifested themselves. There were also, of course, the usual irritations and worries which disfigure parish life, and which give its negative connotation to the word "parochial." Let them remain in the dustbin of memory!

When I arrived in the parish of All Saints, Burnaby, I had just turned thirty-eight, meaning that I was solidly launched into that mid-life phase in which men in particular (is this still true?) strive to accomplish what they can before it is too late. (Will I ever go higher than second deputy assistant vice-president or is this it?) Given the size of the parish, and the fact that I was the only priest there full-time (although I valued the contributions of the honorary clergy who worked with me from time to time), I recognize now that it was at that time that I succumbed notably to my tendency to workaholism. It is not an exaggeration to say that my normal work week was one of around sixty hours, with weeks of eighty and ninety hours not being uncommon. So how did I justify this, if I thought about it at all? Frankly, I didn't even try. In the first place, I enjoyed what I was doing, and I was reasonably good at it. There were many opportunities for me to use my pastoral gifts, and a lot of appreciation came my way, which of course served to maintain me in my workaholic style. In the second place, I believed in what I was doing. It still at that time appeared possible that the institutional church in its traditional form could flourish and provide a nourishing and challenging experience of belonging, to spiritual seekers as well as to longtime parishioners. In the third place, I was not yet at this time aware of the profound meaning of the blessed word *boundaries*. Fourthly, life at home was not always happy, and so I was not inclined to spend much time there. And finally, when I compared myself to my *father's* workaholism, I gave myself, by comparison, a glowing self-evaluation. In spite of what I have just said about not spending time at home, I calculated that I spent

twenty hours with my children for every hour my father had spent with me when I was growing up; and this excused me from acknowledging any sense of my own behavior as workaholic. Understandably, my wife didn't share this assessment.

Thinking here for a moment about my comments in the previous paragraph on the potential of the institutional church and parish, I am sad to acknowledge that for the most part, with a few outstanding exceptions, this is no longer the case. The institutional mainline church is in serious decline, and much in need of new approaches to ministry. I have come to the conclusion, particularly after filling in on Sunday mornings at a large number of parishes, in some cases for months at a time, that the model of church life which was normative when I was ordained in 1963—the territorial parish with a single pastor—can no longer adequately and everywhere serve the Christian cause as it did for so many centuries. Here therefore I take as my own some words of American theological educator Paul E. Capetz, in *The Embrace of Eros*:

> ... my roots are planted too deeply in the church's heritage for me to uproot myself completely [he had resigned the exercise of his orders over his church's decision not to authorize or bless same-sex relationships for its pastors]. I know in my gut that even if I tried to sever my ties to the church, it would never let go of me. I am so deeply grasped by its religious and moral substance that I remain in the church, even committed to it in a measured sort of way, albeit with a heavy heart (p.116).

Is this then a tragedy? No, not ultimately, although it is an occasion for sorrow at the church's failure to realize its capacities in rapidly changing times. I think here of Wordsworth's lines from his poem "On the extinction of the Venetian Republic":

> [Men] are we, and must grieve when even the Shade Of that which once was great is pass'd away (ll. 13-14).

The parish, as we know it, is not in fact the essential form of Christian community. England, for example, a country with which the churches of

the Anglican tradition have a special link, was only organized into parishes in the ninth century. Somehow our Christian ancestors found other ways in previous centuries of celebrating their belonging to each other: in the catacombs, in house churches, around the great basilicas, around the monasteries of the Celtic tradition, on pilgrimages, with and without priests, and so on. There is no reason why the Christians of our time cannot with sufficient imagination find new ways of belonging to each other, ways more suited to the dynamics of our contemporary culture, ways which will need to be simultaneously counter-cultural and pro-cultural. Such a way was recently exemplified for me when I had coffee with a newly-minted minister who works out of a café from which she ministers to the small congregation based there, and at the same time reaches out very imaginatively to the spiritual seekers who frequent the café (trinity-united.ca). My own conviction, which I shared with her in that conversation, is that the way forward lies in the development of *small intentional communities of spiritual practice,* some of which will take their rise from existing parishes, of course. This is the same impulse as the one behind the founding of religious orders and congregations in previous centuries. Time will tell how true this is. In the meantime, I intend to follow up on this line of thinking to whatever degree I can.

Yet as the mainline church has declined numerically and in terms of its influence in the culture, the person of Jesus stands taller than ever. When I was ordained, I didn't think about Jesus all that much, except as I encountered him in the liturgy. He presided peacefully from stained-glass windows over a church the busy social life of which was for most of its members its sufficient justification. We experienced Jesus in those days much more as the Christ of Faith, the distant Divine Son, or the Second Person of the Trinity, rather than the Son of Man, the "human one," or the animator of a movement of peasant resistance to imperial Rome. But the great advances in Jesus-scholarship in recent years—the work of Marcus Borg, John Dominic Crossan, Rex Weyler and others, all in various ways descendants of Albert Schweitzer in his classic work, *The Quest of the Historical Jesus*—have brought the human Jesus, the peasant Jesus, the citizen-of-an-occupied-land Jesus, the often-uncomfortable-to-listen-to Jesus, much closer to our awareness. The brilliant title of one of Borg's books—*Meeting Jesus Again for the First Time*—epitomizes this shift exactly.

He's picking up, of course, on T. S. Eliot's famous lines: "the end of all our exploring / Will be to arrive where we started / And know the place for the first time" ("Little Gidding," ll. 240-42).

Certainly the Christian movement as such began with the spiritual energy of Jesus (even if, as many claim, it was Paul who is primarily responsible for the institutional church), and yes, we are seeing him again—if not for the first time, at least with a more focused gaze. We are looking at the man Jesus these days with new eyes, and listening to him more attentively with the ears of our hearts. Beyond any decline that the institutional church has suffered or will suffer, Jesus remains, in Jung's term, the archetypal man of the west. He is active not only in the Christian community, where one might expect and hope his influence to be exercised, but also in other faith-traditions (notably Buddhism, Islam and the indigenous spiritualities of North America), as well as in the culture at large. "There's flies on you, and there's flies on me, but there ain't no flies on Jesus!" (old revival-meeting song).

And a fascinating final comment here from Jung's closest colleague, Marie-Louise von Franz. She once remarked to Robert Bly that she had noticed in recent decades (she died in 1998) in the dreams of both men and women, a spiritual figure covered with hair, a sort of hairy Christ. She took this as an indication that the contemporary psyche was asking for a new image of Christ, one in manifestly closer touch with sexuality and the earth than the images of him traditionally transmitted by the church (*Iron John*, p.249).

CHAPTER FOUR

JUSTICE AND PEACE

We had come to Burnaby in 1977; I had not yet finished my Ph.D. So I arranged for a three-month study leave in 1979, to push the project over the top. On a typewriter, as it was called, that ancient instrument for the production of print, I typed the last page of my dissertation on January 31, 1980, Thomas Merton's 65th birthday. I pulled it out of the typewriter, waved it in the air, and called out to him, in whichever of the seven heavens he finds himself: "Tom! Happy birthday! You're sixty-five today. You have eaten up the last eight years of my life, and as of today I am retiring you. Goodbye, and happy retirement." But Thomas Merton being Thomas Merton and me being myself, he wouldn't stay retired, nor would I let him. Some years after this, I realized that he had been a kind of spiritual director *in absentia* for me, and indeed, he still is. I regard him as the greatest Christian spiritual writer of the twentieth century. When he died in 1968, it seems to me, he was thinking and writing out of some future time, let's say 2050—meaning that it will be decades yet before we catch up with him. I sense in fact a connection—not one that I can define—between his ongoing companionship and that of the mysterious figure in the painting.

Having finished my Ph.D., I had a kind of surfacing experience, to use Margaret Atwood's term. It was as if I had been working under water for years and months, in the parish and on my Ph.D., taking very little notice of what was going on above me in the culture at large. Thus, in early 1980, awakening at least to a certain level, I discovered to my horror that Ronald

Reagan seemed alarmingly likely to be elected president of the United States. My first thought was that we would not survive his presidency; that someone who could talk as he glibly did about "limited nuclear war," or of "surviving nuclear war" was simply not clear on the concept. But as leader of one of the two nuclear superpowers, he was in a position either to move the planet towards destruction or away from it; and my bleak sense of things was that the former option was the more likely.

Not long after this unhappy realization, I learned that the periodic international assembly of the World Council of Churches in Vancouver was to take place in Vancouver, at the University of British Columbia, in August of 1983. The local organizing committee was asking for volunteers; and this moved me to wonder if there was a volunteer cohort that would be working to save the world from Ronald Reagan, or, more prosaically, that would be focused on ecumenical efforts for justice and peace. Yes, there was a reference to this on the contact list: call Kathleen Wallace-Deering, Vancouver coordinator of Project Ploughshares (www.ploughshares.org), the arms-control-monitoring arm of the Canadian Council of Churches.

I met Kathleen, and volunteered through her to work at the Justice and Peace Coffee House which was planned for the WCC assembly. I salute her here, gratefully, as my godmother in the peace movement. Then came the advertisement for a local site co-ordinator for the assembly, someone who would work locally with the organizing committee in Geneva. Surely, I told myself, this was something for which I was qualified. I had met a number of WCC folk during my time in Switzerland; I was an experienced ecumenist; and I spoke French. Again my wife refused to countenance this. She told me that I had not been in the parish long enough, and that it would be irresponsible for me to take on this work. (In the event, the person appointed took a two-year leave of absence from his parish, and returned to it after the assembly.) I now see this not as a statement coming from insecurity, as had been her response to the invitation I had had to work at the cathedral in Vancouver. Rather, it now seems to me that this was an expression of the anger which was building in her about what she named as my grandiosity. I also see a parallel here between this feeling on her part and the feeling of my housemate in Toronto. There was another dimension to her anger as well. Early in our marriage she had made a unilateral decision, something I did not learn about until forty-one years later, to take a back seat in the

marriage, and let me occupy "centre stage." As the years went by, so she told me after 41 years, she felt smaller and smaller and angrier and angrier, something which mystified me, since she had not told me about her unfortunate decision. So again, this second time, I yielded.

Soon I met many other people who had the same concern about the nuclear threat that I did. While the assembly was in session, I spent every evening and many days as a floating chaplain at the justice-and-peace coffee house, ready to engage anyone who wanted to talk about what the nuclear threat really involved, and what justice-and-peace ministry might mean for individual Christians and the churches. I met people from many nations, a few famous (Desmond Tutu and Coretta Scott King), most not so. On one of those days during the assembly, I found myself at home alone, and decided that I would use that un-spoken-for time to reflect on my future. I was on the edge of turning 44, and was having one of those mid-life moments of which Jung regularly speaks. His image is that having climbed the first side of life's mountain during the "morning" of life, one finds oneself at the "noon" of life at the top of the mountain, and is thus able for a brief time to look down both sides of it, the "morning" side and the "afternoon" side. As one climbs the morning side, the afternoon side is not visible; and once one has begun to descend the afternoon side, the morning side fades from view. But at the moment of noon, both sides are visible—there is a wide overview possible then, although neither before nor after. I remember sitting in a chair in the living room of the rectory, not moving for about two hours, thinking such thoughts. I had entered the mid-life passage.

My dilemma was this: should I go to Zürich and train as a Jungian analyst? Or should I become a fulltime peace activist? The pull of Jung and Zürich was very strong; but by the end of the two hours I had concluded that although this was a wonderful thought, that given the geopolitical situation, with the planet and the wellbeing of all my loved ones under terrible threat, I needed to choose the second option. At a different historical moment, I would with a clear conscience have taken the first option; but at *this* historical moment I could only choose the second option. I link this now to Gandalf's response in *The Lord of the Rings* to Frodo's question about why responsibility for the destruction of the ring of power had come upon him. "There is no answer to that question," said Gandalf. "But come it has,

and your challenge is to decide what your response will be"—or words to that effect. Only recently have I realized that, although I had then decided on the activist option, the impulse behind the option-not-then-chosen later found a way to express itself, in my launching (with my friend and colleague, Episcopal priest Jack Gorsuch) of the program in spiritual formation and spiritual direction now called Jubilee (pacificjubilee.ca).

So, the decision made, I began to plan the creation of an organization which would present the demands of justice-and-peace ministry to upcoming generations of clergy through an outreach to the theological schools in which they were being educated. Its name—The Shalom Institute—had come to me out of thin air some years before; at the time I didn't know to what it might some day refer. After my WCC experience, however, it did become clear: it was to be the name of the organization which I would put together to promote the ecumenical ideals and challenges in regard to justice and peace which I had encountered at the assembly. In early 1985 I applied for and received seed money from the national level of the Anglican Church, after which I concluded my time at All Saints, with the Institute beginning its work in September of the same year. At first our office was sheltered by the Burnaby home of Jean Vanier's L'Arche Community; and then within a few months, we were invited to be part of the Centre for Justice and Peace housed at St Paul's United Church, also in Burnaby. In the first two years of its life, I visited 40 out of the then-total of 48 theological schools in Canada, schools of all stripes: Roman Catholic and Anglican, United and Baptist, Lutheran, Evangelical and Orthodox. I taught courses, organized seminars, promoted demonstrations, wrote appeals to church leaders, and so on. After the founding grant, donations from groups and individuals supported the Institute's work. And did I accomplish anything of my original intention? Nothing that I can weigh or measure. But I take a cosmic view of this, believing that every righteous action, every *mitzvah*, as the Jews say, contributes to a tipping point after which eventually the universe tilts in a positive direction. The details of this I leave to God.

And was I right or wrong about Ronald Reagan? The fact that I have written this and that you are reading it is sufficient evidence that I was wrong. In the paradoxical way in which US politics sometimes works (Nixon in China is another good example), there was probably no-one better placed than Reagan both politically and in the affections of the

American people to come to an agreement with the Soviet Union without being accused of being "soft on Communism." Thus in December 1987, the Soviets and the Americans signed the INF (Intermediate Nuclear Force) Agreement, the first agreement in history which committed both sides to the reduction of the number of their nuclear weapons—a great tipping point. Another such agreement, Start II, has been ratified by the American Congress and the Russian Duma; and the Canadian Parliament, in both its houses, voted unanimously in 2010 to commit Canadian foreign policy to the complete abolition of nuclear weapons. But we still have miles to go before we can sleep in post-nuclear peace. Canada in May 2015, under the Harper government, colluded with the US and the UK to sabotage the hope of consensus at the quinquennial review of the Non-Proliferation Treaty on the issue of a conference to discuss making the Middle East, tinderbox that it is, into a nuclear-weapons-free zone. This was in order to "protect"—an Orwellian use of the term—Israel from pressure to admit what all the other parties to the NPT already know, that it possesses nuclear weapons. Given the 2010 parliamentary vote, this is contradictory and discouraging. Since then, mercifully, there has been a quantum shift in Canadian politics, with the ideologically-driven and mean-spirited Stephen Harper sent into political retirement, and a new and apparently more pragmatic and progressive government elected, with Justin Trudeau as Prime Minister. Since the election, however, the House of Commons has passed a resolution condemning the non-violent program called BDS—boycott, divestment and sanctions, regarding it, wrongly, as anti-semitic. Here I salute the NDP and the Bloc Québecois, which voted against it, recognizing that it infringed on the right of free speech. This is an issue which I am sure will be revisited. Certainly the supporters of BDS, myself among them, have no intention of ending our participation in the campaign. More positively, the deal reached in July 2015 between Iran and the consortium of western nations headed by the US also offers great hope for a move in the right direction; and since then, the Egyptian government has announced that it will make another attempt to set up a nuclear-weapons-free zone in the Middle East. The Iran agreement was approved by the Security Council of the UN, and even in the face of furious opposition was accepted by the US Congress, however since the rise of the Trump administration, the United States has withdrawn from the agreement.

Immediately after the signing of the INF Agreement there was a great wave of ill-founded relief which swept through Canada and other western countries. I remember in particular the party organized by the Vancouver-based organization called End the Arms Race, of which I had become vice-president, at Heritage Hall, on Main Street in Vancouver, to celebrate the announcement of the agreement. Those of us active in the peace movement knew, of course, that this was only a first step, and that many steps remained between this agreement and a state of affairs worthy of the name of "peace" (cf. Jeremiah 6:14 KJV—"peace, peace—when there is no peace"). However, the population at large jumped to the conclusion that "peace" had been attained; and in consequence, contributions to peace-action and peace-education organizations fell off sharply. We managed to keep the Institute going for a while, but by the spring of 1988 it was necessary for me to apply for EI (employment insurance) benefits (or UI, unemployment insurance, as it was then called). I remember shaking my head at this, asking myself how it was that someone with my education and qualifications should—even could—be on UI. However, as attacks of grandiosity go, this was a brief one; I quickly realized that with 1.1 million of my fellow Canadians unemployed at the same time, who was I to expect that I should be exempt? And so I registered for work under the heading of "director of an ecumenical peace-education organization," and carried on the work of the Institute as a volunteer. I note here that I have continued since that time on justice issues, chiefly the issues raised by the Israeli-Palestinian conflict, which has gone on in one form or another since 1947.

<p style="text-align:center">★</p>

Since my re-reading of *Iron John*, I have been moved to reflect once again on what it meant for me to go on Unemployment Insurance, to be technically one of the unemployed, even though I was spending all my working days on the needs of the Institute. I now see it as an instance of what Robert Bly calls *katabasis*—"the Drop through the Floor, the Descent, the humiliation" (*Iron John*, p. 69), or what might more prosaically be called hitting bottom. This experience echoes the words of Jesus that "unless a grain of wheat falls into the earth and dies, it remains just a single grain; but if it dies, it bears much fruit" (John 12:24). In the summer, I had met the

woman I will be telling you about in Chapter 5; I now realize that I had met her at a vulnerable moment, a low moment in my life measured in terms of "success," something of which Thomas Merton was very scornful. According to Bly, an experience of *katabasis* brings the one experiencing it into unavoidable awareness of those problematic aspects of his life to which insufficient attention has previously been given. I knew that I was unhappy in my marriage, as did my wife, and I had thought of separation. Now my time of Descent was taking me to a new psychic location, one in which hard decisions would have to be made.

<div align="center">★</div>

The end of my time at All Saints, August 1985, meant that we had to leave the rectory and find another place to live. We found an old rabbit-warren of a house to rent on McKee Street, on the South Slope, and we lived there until 1988. In this house the painting hung in what we called the music room, because it contained the piano. This small room was between the dining room and the living room; and when people walked through this room after a meal, many of them would stop to look at the painting. Their standard question was, "Who is that in the painting?" Of course, not having discussed it with the painter, I knew no more than what the painting's title, *The Holy Man*, told me. But often people without waiting for a response to the first question would go on to a second question: "Is it your father?"—a question which at the time I found very curious. Of course I answered, "No," and they would typically go on to ask: "Then who is it?" Simply to deflect the further asking of questions to which I had no answer, I would reply, "It's me, when I'm seventy-five"—intended as a joke, and received as such. But the holy man in the painting heard me say this, and, as you will read in Chapter 6, made profound use of my comment.

It was in the house on McKee Street that there occurred, or perhaps more to the point didn't occur, something which tilted the marriage strongly toward its end. I had been invited by the president of the University of Strasbourg, whom I had met at the Vancouver School of Theology, ironically through my wife's work there, to come to Strasbourg for a year as a visiting professor. I very much wanted to accept this offer; its symbol in my memory remains the street map of Strasbourg that I pinned up in the dining room,

and very sadly took down when the decision was made not to go. The children would have come back fluently bilingual, and a year in Europe, I argued, would be a great experience for both my wife and myself. "What would I do?" she asked. "You would *find* something to do," I replied, "just as you did when we went to Toronto." Nothing I could say could change her mind. So again I yielded. This was the third time that she had forestalled what seemed to me to be a wonderful possibility. Isn't that what the fairy tales tell us? Three wishes, three sons or daughters, three tasks—so many threes. Something has to happen three times before a breakthrough or dénouement. I decided after this that it would be the last such time.

Let me take this unhappy moment to reflect on the word "accommodating." This was a word that applied in my case, I now recognize, culturally as well as personally. William A. Macdonald is a consultant on government relations and economic policy who has written extensively on this Canadian cultural characteristic. Here is what he says in a recent article in *The Globe and Mail.*

> . . . mutual accommodation . . . helps to get things done by making room for others. It is often about compromise, and always requires an understanding of what each side needs. Inclusion is the key driver. Mutual accommodation may be about shared purposes, values, interests and beliefs; it may simply make room for different approaches; or it may just make a particular goal possible. . . . Although mutual accommodation is big and its reach inexhaustible, it does not always work, and force may be needed along the way (*Globe and Mail*, August 28, 2015 "Time to Reconsider the Nature of Life, Liberty and the Pursuit of Happiness").

The title of his article is an ironic one, because the formulation is an American one, the Canadian equivalent being "peace, order and good government." His concluding point in this excerpt is the catch. Yes, sometimes mutual accommodation fails, and then forcefulness, if not force, is needed. Macdonald says later in the article that "letting one's spouse have her or his way is not really that hard most of the time." Most of the time, perhaps; but there are moments when disagreement is the healthiest long-term option,

and the Strasbourg moment was, in retrospect, manifestly one of these. Robert Bly uses the word "fierce," which he characterizes as Dionysian energy, not a desire to dominate, but in fact an expression of self-respect. If former Prime Minister Mackenzie King, culturally a quintessential Canadian, had been asked to comment on this, he would very likely have said "Accommodation if necessary, but not necessarily accommodation."

It was a value that I feel I had over-learned.

★

Then in what was to be the last year of the marriage, we moved once again, because of the decision of our landlords to sell the McKee Street house, to a wretched little house on Brooks Street in south Vancouver. I find it telling that although the painting must have come with us and would have been mounted on a wall as in every previous place we had lived, again I cannot remember where I placed it. I attribute this to the fact that this was a time of disorientation, confusion and increasing misery in what was left of the marriage, both for my wife and for myself.

CHAPTER FIVE

AMOUR FOU

I come now to the sad necessity of reporting what was happening in this last year of our marriage. I have no desire whatever to blame or criticize my former wife, and I will not, I hope, offer anything but a factual description of how and when the marriage died—which it had, I later realized, at about the fifteen year mark, sometime around 1984, four years before the time I am now describing. It's often been said that nobody knows in any depth the inside of someone else's marriage. Suffice it here to cite Tolstoy in *Anna Karenina*: "All happy families are alike; each unhappy family is unhappy in its own way."

And so it was with us: we were unhappy in our own way. My former wife is the adult child of an alcoholic father and a highly critical mother, and I am the adult child of a workaholic, an unhappy combination of personal factors, and something the implications of which we were completely unaware when we met and married. We had three times previously gone for marriage counseling; and in the last year that we were together, 1988-89, we went for the last time, this time to a psychiatrist. He was the only one of all these counselors to have an illuminating take on our situation. Contrary to my previous unrecognized assumption that I was just fine, and that I was married to someone with an alcoholic parent (she weak, I strong; she sick, I healthy), he asked us to consider the combined effects of parental alcoholism and workaholism on our marriage. This made it clear to me for the first time that I had to accept equal responsibility for the decline of our

relationship. It was a sad and sobering time. A major aspect of my sadness was the realization that I no longer wanted to tell the beautiful stories of our meeting and courting, or show the beautiful photos of our wedding. (Very symbolically, the wedding photos were lost in a house fire in the house into which she and the children moved after the separation.) Soon after our time with the psychiatrist, we separated, and were divorced in 1992. Then in 2012, twenty-three years after the separation, and deeply moved by a sermon she had heard around the theme of "why carry this stuff around with you for the rest of your life?" my former wife called me to apologize for her share in the failure of the marriage, something which I very much appreciated. I asked her if I needed to apologize about anything: she replied that I had apologized sufficiently at the time the marriage ended, which I was glad to hear. And so we reached a place of peace.

<p style="text-align:center">★</p>

The separation took place in July of 1989. Nine months earlier I had begun an affair, although that term doesn't begin to describe what happened. I won't expose my lover's identity in a public context such as this book. She was and is a highly intelligent and accomplished woman, who when we met was also struggling with some profound family-related challenges to her own happiness, self-esteem and peace of mind. Given the attention paid by this book to my relationship with my father, it's apropos to mention that her relationship with her father was a fraught one. Both of us were miserable, and in our common misery we found each other. The old adage that "misery loves company" was never more true than in our relationship.

I met her at a conference: and Robert Bly's description of this kind of meeting is so exact that I am wondering now if he was standing in a corner at the conference taking notes.

> What does it mean when a man falls in love with a radiant face across the room? It may mean that he has some soul work to do. His soul is the issue. Instead of pursuing the woman ..., he needs to go alone himself, perhaps to a mountain cabin, for three months, write poetry, canoe down a river and dream (*Iron John*, p.137).

Yes: my soul was indeed the issue; and perhaps I would have been more prudent to take his advice—something I had not read at the time—and find a mountain cabin to retreat to. Even Bly's canoe will appear later in this narrative! In the event, I did my soul work in the furnace of the relationship. I did see her "across a crowded room," as the song says, and asked someone nearby—I remember my words exactly: "Who is that beautiful creature?" When he told me, I realized that she had left me a phone message two days earlier, asking for information about a program the Shalom Institute was offering; so I had a sense of who she was. The next morning she deliberately partnered with my son as a preliminary to coming into an intergenerational group with me—the attraction, unspoken, was mutual from day one.

In 2005, I heard Leonard Cohen's great song, "Hallelujah" for the first time —the greatest song ever written in Canada, according to a *Globe and Mail* survey in 2002. Bono very simply says, "It might be the most perfect song in the world." One of its verses brought me immediately to tears, because it so vividly described what had happened in my relationship with my lover.

> She tied you to her kitchen chair,
> And broke your throne and cut your hair,
> And from your lips she drew the Hallelujah

Yes, she did tie me "to her kitchen chair": I had a sense of helplessness or inevitability about the relationship. And she "broke my throne" (the reference there is to David and Bathsheba in the Hebrew Bible (2 Samuel 11:1-12:25), a phrase I apply to the shattering of my self-image as a respectable middle-aged cleric. And she "cut my hair" (the reference there is to the story of Samson in Judges 13-16: when Delilah cut his hair he became weak), and the metaphorical cutting of my hair, so to speak, made me weak, swept along, although this "weakness" was combined with a paradoxical sense of strength and energy. And from my lips "she drew the Hallelujah." I experienced the relationship as nothing less than life-giving, life-changing, life-restoring—Hallelujah! Another line from the same song also resonated strongly with me: "Her beauty and the moonlight overthrew you." Beauty, of course, because the lover is always beautiful at the beginning of an affair, sometimes not at the end, although she was. And as for the moonlight, it

was during this time, when I was with her one cloudless night on Burnaby Mountain, that I consciously and intentionally looked at the moon, recognized that I hadn't even glanced at it or even *thought* about it for perhaps 25 years, and saw afresh at that moment what is there for all of us to see at any time should we care to look ("... the moon, the abiding witness in the sky"—Psalm 89:37). I was seeing the moon *again—for the first time.* I look back on that moment as representing an awakening after years of comparative spiritual somnolence.

I recognize this relationship these many years later as an instance of what the French call *amour fou*—"crazy love." So was I crazy? Yes, from the pain, at that point not fully acknowledged, of having repressed the realization that my marriage—in its relational dimension, not yet of course in its legal dimension—was stone dead. I name it also as an encounter with Eros. The ancient Greeks, with their many different words for love, thought of Eros, the unpredictable son of Aphrodite, goddess of love, as the bestower of a kind of divine madness on certain people at certain times. Its bestowal resulted, typically, in a sudden and overwhelming leap/dive into an unexpected and all-consuming intimate relationship. The Greeks were clear that this kind of love differs both from *agape*, unconditional and other-directed love, and from *epithymia*, simple sexual desire or lust. It is an experience which is life-changing, as this experience was for me. I recognize here that Eros is not a universal category, that there are cultures which do not structure their understanding of love and sexuality through its lens. Sexual attraction and bonding occurs in all cultures, of course, however it is socially or conceptually constructed. Even so, the notion of Eros is part of *my* culture, and so I use it here as part of my attempt to understand myself contextually, in a larger-than-individual way. I would also agree with American poet Audre Lorde that Eros is not equivalent to sexuality, as many in our society conceive it when they equate the erotic with the sexual. Rather, it is the power—surely a divine power, mad or not—of connectedness, of bonding which expresses itself in sexual relationships as in other erotic vehicles. On this understanding, sexuality is simply one expression of Eros, which can also include such dimensions as political or parental commitment; but to be erotic in the full sense, they need to be commitments which cut to the centre of the soul. The arrival in the core of one's being of the arrow associated with Eros (or with his Roman counterpart, Cupid—in popular

art an infantilized and sentimentalized version of the Greek original, who is a powerful figure of ecstasy and terror, as in the myth of Eros and Psyche) represents the unexpected character of its happening and the depth of the experience it brings. What had been a delightful friendship (I almost wrote "a simple friendship," but I later recognized that it was subtextually much more), erupted, with no warning, into carnality and tears. Indeed it did cut to the centre of my soul.

On the evening of this eruption, every other member of my family had other plans, and I found myself with a free evening. My friend and lover-to-be and I decided to go to a film: it was "Baghdad Café." As we sat in the cinema beside each other, not touching, I became aware of a strange sense of connection with her, and of tension in my body, which only later I identified as sexual. Returning to her car after the film, she surprised me with the gift of a single red rose. If the meaning of this gift is not clear to you, dear reader, I invite you to google the symbolism of flowers, where you will find the traditional understanding of this gesture. We followed this with a drink at a bar, and then at her invitation—"the night is young!"—went to her place for a cup of tea. Because she didn't have two chairs in her little garret apartment, we sat on the floor, and (again at her suggestion) took our shoes off. It will give the reader something of the measure of my naïveté when I assert that I still had no conscious expectation of what was about to happen. Then, something curious: I saw a hand reaching out for a foot. It was only when I saw *my* hand touch *her* foot that I realized to whom hand and foot belonged.

Our love-making was soul-sex; our conversations were soul-conversations; our confusion was soul-confusion; our pain was soul-pain. The tears we both regularly shed had been anticipated by Rumi centuries earlier: "Let the tears come; they water the soul." They were soul-tears. I think here of the many poems about soul-tears written by St. Ephrem the Syrian (306-73). For Ephrem, the shedding of tears was focused on the passion of Christ, for which he held each human being co-responsible. Those tears were tears of sorrow and repentance—as often were ours. And then, beginning that evening, something amazing and unexpected: I discovered that I could suddenly hear *the music inside the music,* and *the poetry inside the poetry, perhaps even shed the tears inside the tears.* Life had switched from black-and-white to technicolour.

I mention poetry. A raft of poems issued forth from me in the heat of the relationship. I kept them, and here is one which carries the intensity and foolishness of the time.

Paradise Left

The day I had to leave
I thought I should take,
Take with me, take
A good look:
I could (memory beside)
Take nothing else.

In Paradise, then, there was a fridge
 (usually almost empty),
A stove
 (we left the burner on once),
A sink
 (where I could brush my teeth),
A chair
 (sometimes I put my clothes there),
A table
 (for your mementoes and great thoughts),
A floor and a futon
 (where you, Eve, and I would lie).

Weeks before, you gave me a *billet,*
And on it these words *doux*
From Christina Rossetti:

"Tread softly! all the earth is holy ground.
 It may be, could we look with seeing eyes,
 This spot we stand on is a paradise"

(That's it / I see it now /
Paradise / a paradise.)

This gave me hope
For each of us,
As eastward from Eden
I took my solitary way.

January 17, 1989

Adding this poem to the narrative, I decided to check the wording and punctuation of the Rossetti quotation, and found how the poem continues:

… a paradise
Where dead have come to life and lost been found, ….
Where fools have foiled the wisdom of the wise ….

Each of those phrases also echoes some aspect of our time together. I am most struck these many years later by the reference to the fools foiling "the wisdom of the wise." Wisdom and foolishness, bless ye the Lord!

★

It is clear to me now that I seriously overestimated the role of conscious decision-making in this situation, that the forces of the unconscious were far more potent in me than the resources of consciousness. Among these over-estimations was the conventional idea that the male is the initiator at such moments, at least the prime initiator if not the only initiator. My lover, however, at least at the beginning of our relationship, saw me far more clearly than I saw her, and was as much of an initiator in the moment as I was (hey, who was it who invited me back to her place for tea and suggested that we take our shoes off?!). The image that came to me about this some years later was that, in my unhappiness, I was like a ripe pear. Those of you who have seen my pear collection will know why I choose that fruit from among other possible choices to make my point; an apple or a cherry, both of which carry erotic resonances that pears usually don't, would be just as apropos. I was ready to be plucked—or, better, ready to

fall. In this scenario, my lover just had to hold her little hand underneath this very ripe fruit, which then simply fell into her hand.

And perhaps this is the moment to give the background to the origin of my pear collection. On one occasion, my lover and I were sitting beside each other at a round table, with four others, sharing a bag lunch. In her bag lunch she had a pear. She asked me nonchalantly if I wanted part of her pear, and I replied with equal nonchalance that I did. The nonchalance, *bien sur*, was for the benefit of the other people sitting at the table, who didn't know about our relationship, although one of them intuited it during this incident. So she cut it in half, and gave me half. I cut that half in half, and returned the quarter to her. She cut that in half, and so on, until the last piece was just a little bit of pear-mush. (Laughter all round.) Meanwhile, our knees were pressed together under the table so tightly that I expected to hear a bone snap at any moment. Then about ten years later, I was visiting a friend on Salt Spring Island who is a potter, and who was creating a series of large ceramic fruits. Among them was a big pear, and that moment came back to me. I bought it from her as a memento, and she gave me another pear, a smaller one, "to keep it company," as she said. So then I had two pears, a pair of pears; and after that (since I *need* nothing), friends started giving me pears for my "collection."

Again in reference to consciousness and unconsciousness, when all this happened I didn't at first give any particular attention to the fact that I was forty-nine, almost fifty, or to the developmental currents that often run strong and deep at that age, although later the Jubilee motif fixed it firmly in my memory. A long article in the *Guardian Weekly*, "Countdown to Big Birthdays" (December 12, 2014, pp.26-29) discusses what it calls "nine-enders," people whose ages end in a nine: the article highlights all the "nine-years" from twenty-nine to sixty-nine. It cites studies which show "how profoundly we're affected when we sense these milestones approaching and experience a 'crisis of meaning'" (p.26). The statistics for affairs, job changes, suicide and the search for challenge (example: running a marathon) all peak around these ages. The feeling "By the time I'm thirty (or forty, or in my case fifty) …" becomes an emotional refrain, a now-or-never feeling. If there are any cracks in the substructures of one's life, these soon-to-arrive round-number ages exert a notable pressure. I have mixed feelings about the fact that affairs peak at such times, given that I experienced my time

with my lover as unique in history, perhaps in the universe (I know, I know: naïve, naïve). Yet I was perfectly aware that we human beings in this and other respects move in schools or herds or cohorts, unconsciously moving forward with others like ourselves, simultaneously convinced that we are acting consciously and individually.

And after forty-nine, fifty. While I was in Manhattan in the summer of 2010, spending a month as volunteer chaplain at the House of the Redeemer, the Episcopal retreat house on the upper east side, I ran across a brief item in *The New York Times* which offers these thoughts about age fifty as also an important transitional moment, one which marks important shifts for thousands if not millions among those who pass through that particular portal of the years, and here it is.

> Prime Number: 50 …
>
> … the age at which people start feeling better about themselves after years and years of feeling steadily worse, according to a new study published online in the Proceedings of the National [i.e., US] Academy of Sciences. The study was based on the results of a 2008 Gallup poll of 340,000 people nationwide [i.e., in the US]. People start out at age 18 feeling pretty good about themselves, the study found, but then feel worse and worse until they hit 50. At that point there is a sharp reversal, and people keep getting happier. By the time they are 85, they are even more satisfied with themselves that they were at 18.

This has been empirically confirmed by the Harvard study, currently directed by psychiatrist Robert Waldinger, which since 1938 has studied male development, seeking to identify the factor or factors which most significantly contribute to health and happiness. It notes that at or around fifty, if men have taken intentional steps to set aside their young-male dreams of fame and fortune and to focus on the quality of their personal relationships, they have set themselves firmly on the path to second-half-of-life wellbeing.

Absolutely true, in my case, at any rate. Before the relationship—and not just the relationship, but the transition within which it was central—I had been feeling steadily worse about myself, my marriage and the world in

general. From November until March in the year prior to the separation, I wept in the shower every morning. Then one day in March, no more tears. I was wept out. I had done the major part of my grieving in anticipation of the separation, rather than afterwards. After the transition, I started to feel better about myself, as the article says. In fact, I think of my life, with its many chapters, as essentially divided into two phases, which I privately call A and B: A before the transition, B since. There was something in me, some dimension of the élan vital which had been blocked, or dammed up, probably since my adolescence, and which had not found release in my marriage. Am I saying, then, that the affair was a spiritual event, opening me to an experience of spiritual as well as carnal intimacy? Yes, I am. The flow and power of Niagara Falls comes to mind here, as an image to suggest something of my sense of the power or overwhelming character of what was happening to me and in me as the outward form of the marriage disintegrated. The Twelve Step folk say that "Having experienced a spiritual awakening …," or words to that effect, and so it was with me. Richard Rohr acknowledges the possibility of this in one of his daily meditations.

> Once you've experienced any true union (perhaps at times of peace, acceptance, surrender, prayer, intimate sex, all authentic love), you know that is what you were created for (March 8, 2016, "Unitive consciousness"—part of his series on Paul).

But this wasn't *just* about me—and I say this with no desire to justify myself or diminish my responsibility for what I did. I did it, and I own that I did it. It was also in a major way about something that happens to many people—men especially—around this age. Rather than take into consideration the nudges of the unconscious, nor what typically happens to people as they approach and then hit a round-number age, as discussed in the *Guardian Weekly* article, I over-personalized and over-individualized what-was-happening-to-me-and-what-I-was-causing-to-happen, rather than seeing it in this larger context. I thought of separation and divorce as primarily a wound in the personal lives of those involved, and only secondarily in the social fabric, as indeed it is. My experience of separation and divorce was of course unique; but so is everybody else's. It is a very common human experience, in the West at least, a "cohort" experience.

I can now hear about the divorces of others without a sense of ultimate tragedy, which is how I tended to respond at the time of my own divorce. I had been increasingly miserable as my forties proceeded, even as I was doing something through peace education which I felt was making a small yet real contribution to what Jews call *tikkun olam*, the healing of the world. I was working at the healing of the world *and* not paying sufficient attention to my own need, and my family's need, for healing. I say this not to avoid responsibility for my actions, but to attempt to understand them. And as I again write here the word "responsibility," more than a quarter-century later, I shake my head in continuing astonishment as I reflect once again on the explosion of Eros that erupted in me at this time. In the person of my lover, the archetype of the Stranger again manifested itself in my life, initiating a series of changes that set in motion a process of transformation (not too strong a word) which continues to this day. I am well aware that middle-aged men who are brave enough or foolish enough to attempt to describe in print how they dealt with their own misery by having an affair are usually ready to offer extenuating circumstances to justify or try to justify their actions. This, however, I am resisting to the best of my ability, and I can only leave it to any reader of this memoir to decide to what extent I have succeeded. Gail Sheehy says in her *New Passages* that the average North American male doesn't wake up until his first divorce (ouch! may there not be a second). She also says, in *Understanding Men's Passages*, that in the mid-lives of many heterosexual men, a "transformative woman" will regularly appear, manifest herself to a man at the midlife moment, and have a permanent effect on him. My lover was manifestly for me this transformative woman. I have heard it said that to link an affair and a transformative awakening has become a cliché. But what is a cliché, if not an oft-repeated truth? Cliché or not, I found myself transformed.

Let me here deal briefly with the wretched word "cheating." What is cheating? In its typical and judgmental use, it is used to mean having sex, or an emotional involvement, while married, with someone other than one's spouse. I grant that this is an accurate use of the word if there is indeed a *living* marriage which is placed in jeopardy by an extra-marital relationship. And if, existentially, there *is* no living marriage? What then? As I have reflected over the years on the course of my marriage, I have come to recognize that my former wife had resigned emotionally from

the marriage about the fifteen-year mark—and it takes two for a marriage to exist. After that point, she just wasn't there. My affair occurred at the nineteen-year mark, when the marriage had been dead for at least four years. If the extra-marital connection is to be called cheating, then must abandonment of the marriage also be so called. I had in fact before the affair started to take steps to bring the *legal* marriage to an end; but these were not sufficiently advanced when it erupted into my life in so unexpected a way. I say all this not to derogate from personal responsibility, but simply to encourage any reader of this reflection to apply existential as well as legal considerations to the use of the term "cheating" than is usually the case.

<p style="text-align:center">★</p>

I had never met anyone like my lover before—brilliant, sensual, fragile, intense, volatile, and angry about injustice—something which carries its own attraction—and I am very conscious that in saying this I am once again revealing the naïveté and inexperience which were mine at that time, not least my tendency to "rescuing." In more ways than this (in my academic career, for example, which didn't take off until I was fifty, and in my political understanding), I have been a late bloomer. This mention of the political brings to mind a conversation I had at Cambridge in 1967 with a Swiss friend. He asked me what I thought about the American presence in Vietnam. I said I thought it was wonderful that the Americans were over there defending democracy [*sic*]. He asked me if I had fifteen minutes right then. I said I did; and in that fifteen minutes, with the help of his alternative view, the scales fell from my eyes. In him, as in my lover, the Stranger spoke. I was twenty-eight. Two decades later I was on the cusp of an even more far-reaching awakening. I was forty-nine, about to be fifty, and, though consciously unaware of the prospect, more than ready for the sharp reversal of which the *New York Times* item speaks. (I did ask a therapist in Toronto once if I was simply being an old fool, and was reassured by his comment that I wasn't old enough to be an old fool! I am now, of course!)

The relationship was tumultuous, on again and off again: we "broke up" and "got back together" at least eight or nine times in the course of that year. Both of us were afflicted at different times by surges of conscience, prudence, anxiety, sorrow or confusion. After the time given to making

love, and conversation, the next activity to which we gave the most time was weeping—sometimes alone, sometimes together: St. Ephrem, pray for us!

By the spring of 1989, it was completely and finally clear to me that I had to face the reality of the death of my marriage. As I write this, I think of one of the sayings of Jesus recorded in the Gospel of Thomas, a quasi-scriptural text not part of the New Testament and only recovered from the Egyptian desert in the twentieth century.

> Know what is in front of your face, and what is hidden from you will be disclosed; for there is nothing hidden that will not be revealed (Gospel of Thomas, Saying 5).

Yes, know what is in front of your face—if you can. Turn your eyes neither to the left or the right, to the past or the future, but face the present reality in the present moment: try to be one who "sees life steadily and sees it whole" (Matthew Arnold's "To a friend," line 12). My eyes had not been open wide enough to look steadily at the whole reality of my marriage; if they had been, I would have had to acknowledge long before that it had died. If I had known what was *in front of my face*, the death of the marriage would have been disclosed to me, and I would/should/could have taken quiet, discreet and respectful steps to lay to rest the remains of the marriage in some other way than by having an affair.) Again, if I had known what was in front of my face in regard to my relationship with my lover (I refused for a couple of years even to call it an "affair," a word which in my mind sullied the transformative, even mystical character of the relationship), I would have seen that it had no potential for a marital relationship in the long term, something which for a while I unrealistically entertained. Writing this, of course I have to ask myself if I know what is in front of my face *right now* and whether or not I will be able to be present to and aware of what is in front of my face in all the succeeding moments that remain to me. To work at knowing what is in front of one's face must become habitual if one is to stay sane and present.

When I was teaching at Simon Fraser University, where I began working in the fall of 1989, two months after the end of the marriage, I regularly used to say to my students, whenever the phrase "falling in love" came into the conversation, and since most of them were young adults it inevitably did, that

falling in love was essentially a form of mental illness. The roar of laughter which invariably greeted this comment attested to their recognition of its truth. So in falling in love with my lover, as twenty years earlier I had with my wife, I had, I acknowledge, succumbed to a temporary form of mental illness, *amour fou*. Since then, I have come to understand "falling in love" in another and more positive sense, as the intuition that oneself and one's partner at the time of discernment have the potential of sharing a common future; and again I recognize that had I faced the reality of our relationship, I would have known that no shared future was in practical terms possible. To name only one factor: she wanted children, and I knew that I did not want any more children than the three beautiful children I already had, to say nothing of my vasectomy. At the same time, I have to say that I think that this erotic connection, or something like it, something as powerful, was necessary to wake me up, to shake me up, break me open, open my eyes to the death of the marriage, to say nothing of a fuller awakening about my life—about life itself—in general. In *Private Lies: Infidelity and the Betrayal of Intimacy,* author Frank Pittman says that one of the major reasons people have affairs is because they feel weak in themselves (Samson again), that they are in need of a "helper," a role which the partner in the affair then fulfills. Certainly I did feel weak, as did, I now realize, my lover, in spite of her many presenting strengths. Sex researcher and therapist Lori Brotto says that sometimes "people seek extramarital affairs not to find another, but to find themselves" ("Fairy-tale romance gets a reality check," *The Globe and Mail*, December 14, 2015, L4). Yes: I was looking for my self, my true self, something the next chapter will explore. However, in my weakness, and in the tumult of the affair, I was unable to initiate the kind of responsible change in my own life that might have brought the marriage to an end co-operatively and respectfully. Yet, paradoxically, I also have to wonder whether had I taken a prudent and socially acceptable route I would have found the spiritual awakening that came to me in the course of this relationship.

<div align="center">★</div>

I record here now an experience which I will always associate with this crazy, tumultuous, contradictory time in my life, and which later I will

connect with the painting. It happened one Sunday morning in the spring of 1989 in the church at which I was the honorary assistant priest, and my wife the organist—an uncomfortable situation, particularly as the time of our separation was approaching. It was the Fourth Sunday in Lent, and I was not preaching that day. That being so, I had not needed to read the Sunday readings in advance, even though that was and is my normal custom—but very little in my life was normal at this time. As the assisting priest, it fell to me to read the gospel. In this church, it was the custom for the server to carry a large book of the gospels down to the middle of the church, turn around, and hold it up to be read. As he did so, a quick glance told me that the gospel reading of the day was the story of the prodigal son, his loving father and his angry older brother (Luke 15:11-32). Instantly I felt a full-body *frisson*, which began in my feet, flashed to the top of my head, and returned to my feet in a split second. Only by digging my nails into my palms was I able to prevent myself from bursting into tears; but I managed to contain myself, and I don't think anyone in the congregation noticed anything—no-one said anything to me, at any rate. And with the *frisson* came this prayer: "Thank you, God, thank you, thank you, thank you—that I have lived long enough to become the prodigal son." Once again my body was speaking directly to my soul.

Around this time, and as a result of my experience of the affair and of the end of my marriage, I developed a paradigm of mid-life spiritual journeying, with these phases in it:

- Being sound asleep
- Waking up
- Going crazy (with the pain, when you begin to see what is in front of your face)
- Becoming sane

I continue to find this valuable, although as the years proceeded, I have found it essential to add a fifth (and, I think, final) phase:

- Staying sane

This paradigm is something like the stages of response to terminal diagnoses set out by Elisabeth Kübler-Ross: D-A-B-D-A—Denial, Anger, Bargaining, Depression, Acceptance. Set forth in a linear fashion, it in fact operates in a spiral way, with people going back and forth between anger and bargaining, between depression and acceptance, and so on. So one commits to staying sane, but will find oneself from time to time slipping back into craziness of one kind or another. When this happens, the commitment to staying sane must be renewed and acted on. I am stating the obvious here.

I have mentioned pain. In the spiritual journey, pain of some kind is essential for the awakening that the journey ultimately requires; and the place of pain turns out eventually to be the place of resolution and growth. Robert Bly again: "where a man's wound is, that is where his genius will be" (*Iron John*, 42). I have often described the expression on the face of the holy man in the painting as one of "peace after pain." Such was to be my own experience as the pain of the marital breakdown faded and healed. Richard Rohr speaks powerfully to the place of pain as the place of growth in another of his daily meditations, this one for December 4, 2015.

> The real authority that changes the world is an inner authority that comes from people who have lost, let go, and are re-found on a new level. These are the people who can heal, reconcile, understand, and change others. The pattern for this new kind of authority was taught by Jesus when he said, "Simon [Peter], you must be sifted like wheat and I will pray that you will not fail; and once you have *recovered*, you in turn can strengthen the brothers [and sisters]" (Luke 22:31-32, [italics Richard Rohr's]). This sifting and then recovering is Peter's real and life-changing authority, as it is for anyone. Unless a bishop, teacher, or minister has, on some level, walked through suffering, failure, or humiliation, his or her words will tend to be fine but superficial, okay but harmless, heard by the ears but unable to touch the soul. It is interesting to me that Twelve-Step programs have come to be called the "Recovery" movement. They are onto something!

And here is another of Richard Rohr's powerful meditations on the same subject.

> Pain teaches a most counterintuitive thing: we must go down before we even know what up is. In terms of the ego, most religions teach in some way that all must "die before they die." Suffering of some sort seems to be the only thing strong enough to both destabilize and reveal our arrogance, our separateness, and our lack of compassion. I define suffering very simply as "whenever you are not in control." Suffering is the most effective way whereby humans learn to trust, allow, and give up control to Another Source. I wish there were a different answer, but Jesus reveals on the cross both the path and the price of full transformation into the divine (Daily Meditation, February 26, 2016).

Richard Rohr mentions the Twelve-Step programs. They speak of the necessity of a spiritual awakening; and such was my experience at this juncture. It was an awakening that called me out of sleep into painful awareness, then through the crazy dimension of the pain into clarity, and then into the relatively calm waters of the sanity which comes after the craziness. The final and continuing stage: staying sane, my task for all the years that remain to me. (Although a friend has recently said to me that remaining sane needs to include some craziness.) Here is another set of images, a mini-narrative of salvation by water (cf. 1 Peter 3:20–21), through which I tried to make sense of what had come upon me in this affair, which began, as I have said, unexpectedly and without conscious planning on my part. It concretizes what I mean when I have said to certain friends that the affair saved my life.

> *I am drowning. I am going down for the third time. My lover comes along in her canoe, hauls me into the canoe, hands me a paddle, and says "Paddle like hell!" We do paddle together for a time until, without warning, she jumps out of the canoe, swims to shore, and waves sweetly to me from the riverbank. At this point I look ahead and see that the canoe and I are about to go through the rapids. I manage*

this successfully, somehow, and then find myself in a quiet pool below the rapids.

This scenario must have come to me some time after the day of my formal departure from my marriage, because her leaping out of the canoe represents the suddenness of what happened the day she and I also parted. I moved out of the marital home on the morning of July 10, 1989, took my things to the home of a friend who was taking me in for a time, called my lover, and arranged to have supper with her that evening. Early in that meal, she reached across the table, put her hand on my arm, and very quietly told me that our time together was over. She had felt safe (another new learning for me, women's feelings about "safety") in having an affair with a married man, but not with a newly-single and available—and thereby dangerous—man. With my separation, reality had set in for her. (An ironic thought here. If I had successfully brought the legal marriage to an end before meeting her, we would never have had our affair, given her attitude about "safety." Given the impact of this relationship on my life, I am glad in retrospect that things worked out as they did.) In other words, I separated from the two most important women in my life on the same day. I went back to my friend's house, poured myself a stiffer drink than I had drunk before or have drunk since, and tried to come to grips with my situation. The next morning, telling myself that this was the first day of the rest of my life (true: but so is it true of every day), and that I would be married again within two years (false: more naïveté), I had breakfast the next morning in a local restaurant in the neighbourhood of Kerrisdale in Vancouver. What attracted me on the menu was something called the Hangtown Fry, which included both steak and oysters. It was the name of the dish which prompted my decision to order it. I had woven enough rope to hang myself with, and then used it for that purpose. Or, to riff on the second part of the name, I had found myself in a frying-pan of my own choosing, and now needed to jump from there into the fires of resolution.

What then did I learn from this relationship? Many things, some welcome, some painful. I learned that my prime responsibility before God, others and myself (cf. what I say about the three *rakus* in Chapter 13) is to take responsibility for myself, to remain in possession of my own soul, to know what is in front of my face. I learned that the highest/deepest

levels of sexual exchange are inescapably spiritual, that in peak experience, spirituality and sexuality are one. There is, gloriously, such a thing as carnal spirituality: "This is my body, which is given for you. And this is *my* body, which is given for *you*." When Nina Simone says "Come on, Daddy, save my soul" (in her great song "I want a little sugar in my bowl"), this is the salvation she is talking about—there is no separation. I learned that in sexual exchange, as in all other dimensions of ordinary daily life, my task, my calling, my invitation, my opportunity is to be present to the other, that sexual relationship without mutual presence is miserable (both partners have to be *there*), and to be fled from. I also found in myself in a new way the capacity for what I call erotic friendship. By this I mean a friendship in which I appreciate and honour my friends who are women and in which they appreciate and honour me as a man, with no intention on either side to genitalize the friendship. These friendships are sexual, yes, because all human interactions from birth to death have a sexual meaning or implication; but there is no engagement in intimate physicality. In a different but still erotic way, as I have come to develop my understanding of Eros, this has also renewed my capacity for friendship with other men.

I also learned the deep truth of something that was illuminated by a word that came to me some years later in a dream. A deep voice asked me what I had learned in my life up to that point, and I replied immediately that I had learned three things:

* that life is not tidy;
* that things usually take longer than you think they are going to take;
* and that when you are cooking, you can never use too much garlic.

(A therapist/spiritual director friend told me that this was a Zen dream—because of the dazzling absurdity of the third learning.) So yes: life is not tidy, and that became abundantly clear to me in this year with my lover. I acknowledge here that I am not the first to come to the conclusion that there can be spiritual benefit in moral untidiness. There is a mediaeval Christmas carol which makes this point, that there is such a thing as a *felix culpa*, a happy fault. This is a concept very familiar to our Christian ancestors, who in the Middle Ages represented—ironically, paradoxically, realistically, and gratefully—the Fall of Adam and Eve as something to be celebrated

rather than mourned. Had not Adam and Eve eaten the forbidden fruit, then it would not have been necessary, they held, for the cosmic Word of God (see on this the first chapter of John's Gospel) to come among us in the flesh; nor then would Christians have had access to the prayers of Mary, the Incarnate Word's mother, understood in the Catholic Middle Ages as Queen of Heaven and prime intercessor with her divine Son, our Judge. And here is the carol.

Adam lay ybounden / Anonymous, 15th Century

Adam lay ybounden
Bounden in a bond;
Four thousand winter,
Thought he not too long.
And all was for an apple
An apple that he took.
As clerkes finden,
Written in their book.

Ne had the apple taken been
The apple taken been,
Ne had never our ladie,
Abeen heav'ne queen.

Blessed be the time
That apple taken was,
Therefore we moun singen.
Deo gracias!

Yes: had the apple not been taken, Mary would not have been Queen of Heaven; and had my lover and I not met and embraced, I would not have been released from that with which I was *ybounden,* and been liberated to live, in the fullest sense of the word, erotically, as I now try to do—connected rather than disconnected. Untidy, paradoxical, unexpected, illicit, whatever! The affair woke me up, seized me by the lapels, shook me by the shoulders, kicked me in the pants, tied me to my kitchen chair, broke my

throne and cut my hair, and launched me into a life of greater awareness and capacity for truth and love. Here are Parker Palmer's thoughts about this paradox, in *The Active Life*.

> I treasure that early Christian theologian who railed against the notion that the fall of Adam and Eve was pure and simple sin. Instead, he called it *felix culpa*, the happy sin, since without it we would still be living in the boredom of dreaming innocence and the great adventure of human history would never have gotten underway. The fall gave us the "gifts" of doubt, ambiguity, alienation. These do not feel like gifts when we first experience them. To know them as the gifts they are, we must enter into the struggles they pose for us. Once inside, we have a chance to find the self that remains hidden when we feel confident and secure, the seeking self that draws us into the human adventure (p.21).

I wasn't living in "the boredom of dreaming innocence," but without my own experience of the *felix culpa,* or something equally powerful, I believe that I would have continued to live in a combination of pain, numbness and disconnectedness; and yes, I did receive the paradoxical gifts of ambiguity and alienation, to say nothing of guilt, shame and confusion. But they pushed me forward on the spiritual journey, the journey of the "seeking self" that continues to this day. Here is how Julian of Norwich thought about this: "First the fall, and then the recovery from the fall, and both are the mercy of God."

Finally, I learned that although an intimate relationship at its most intense seems to constitute the permanent centre of existence, it isn't. Looking back on it, I realize that rather than it continuing as such a centre for me, it cleared the psychic and spiritual decks of my life, and prepared me to hear the call to the True Self, about which I write in the next chapter.

★

In March 1990, I got a call from my lover, whom I had not seen since a brief and bittersweet moment of reconnection in October, and we met

for coffee. I told her that the holy man had spoken to me again (as recorded in Chapter 6). She was mock-irritated that I had had such an experience whereas she had experienced nothing equivalent. (I told her I would pass on her irritation to God or to whomever facilitates such experiences.) Even so, since she was going away in September, she suggested that we become lovers again—"just for the summer." As I write this, I can hear her say this again, and see her sitting there in the coffee shop in all her beauty and desirability. But I had, in a new and undeniable way, come into possession of my own soul; and knowing that she wanted children, and that another intimate time with her would come to an end, with its attendant pain, I declined. Some friends I have told this to said I was crazy—in a different sense than earlier—not to accept her invitation. Certainly she was surprised at and unhappy with my response. But having come into possession of my own soul, I knew that if I had accepted her offer, I would have once again plunged both of us into *amour fou,* and betrayed myself at a profound level. However, we continued to hang out, and see each other every so often. Wanting to switch careers, she went to the US for a further experience of grad. school—for which I wrote her some mischievous letters of reference containing a number of *double-entendres.* She still lives in the US, where I had dinner with her in 2003. Then in 2009, I sent out a note to my e-lists (I had kept her on my US e-list) to mark Anne Frank's birthday. At that time she happened to be re-reading Anne Frank's diary, and wrote me a response. Email exchange continued for some time, and I learned she was coming to Vancouver. On August 19, the twenty-first anniversary of the day I had first heard her voice in a voicemail, and the eighteenth anniversary of the day she moved to the US, we met for breakfast. At the time and for many years after, I thought this was probably the last time I would see her; it was for me a luminous experience. But in March 2017, she came to see me, attached as I was to the end of a 32-foot length of oxygen tubing. We had an altered-state-of-consciousness time together. I quoted to her the lines from Leonard Cohen's "Hallelujah" which I have quoted earlier—and to my astonishment, she told me she had never heard the song. I put it on the stereo, in k.d. lang's version, and after listening to it for 30 seconds, she said, "Let's dance!" And we did. (We had never danced before.) If I never see her again, the energy from that moment will have to suffice—and it will. I will love her and be grateful to her forever.

★

Here I switch gears to pay my respects to Thomas Merton and his late-life lover, Margie. I have written a few pages about them in my *Thomas Merton and the Noonday Demon: The Camaldoli Correspondence* (pp.267-79), under the same title I chose for this chapter, *amour fou*. Of Merton and Margie's relationship I knew nothing when in 1974 I began my doctoral work on him. Yet I can't help feeling that, at some unconscious level, part of what drew me to Merton (he and I also both dropped out of Cambridge, incidentally) was what I would years later discover about the visit that Eros paid him in the spring of 1966, when he was fifty-one, two years older than I was at the time my affair began. At first glance, Merton and Margie's connection seems to have come out of nowhere; but the careful reader of Merton's journals will notice a number of erotic foreshadowings pointing to the likelihood of a forthcoming major visit—a dynamic which, as I look back on the years immediately preceding my visit from Eros, was also discernible in my life, mostly in terms of marital dissatisfaction.

Merton and Margie met at the end of March 1966 in the hospital in Louisville where he had just had a serious back operation. She was his nurse, had for a time belonged to a religious community, and had read some of his books. So she knew who he was, and the erotic connection was immediate. There was a significant age difference between them, she twenty-four and he fifty-one. But it is typical of the craziness of *amour fou* that the lovers will dismiss any such potential impediment as irrelevant. For any woman, of any age, to enter into an intimate relationship with Thomas Merton, she would have had to be a woman of formidable intelligence and ego-strength—as was my lover. Some commentators have conjectured that Merton took advantage of his young sweetheart, something I find unconvincing. Merton's diaries testify that she was as active as he was in moving the relationship forward. In other words, she was as *folle* about him as he was *fou* about her; and again, this was my experience. Neither, in fact, was free to enter into an intimate relationship: Merton was vowed to the celibate life of the monastery, and Margie was engaged; her fiancé (later they separated, not surprisingly) was in Vietnam. Whatever were their scruples about these commitments, the craziness of love prevailed. I am trusting that should Dante ever produce a revision of the *Divine Comedy*, I hope he would be kind enough to place

Merton and Margie in the *Purgatorio* and not the *Inferno*, where perhaps my lover and I can keep them company.

For Merton (we don't know about Margie: we don't have her letters, which Merton burnt in 1968 to the everlasting regret of Merton scholars, although I have heard rumours of a deeply-embargoed manuscript that she has written, and a recorded interview again deeply-embargoed), there was a clear resolution that faced with the choice between marriage and the solitude of the hermit life he could only choose solitude. But he makes it clear that it was a choice between solitude and *marriage*, not between solitude and *love*. (He had not yet met Chatral Rinpoche, married *and* a hermit; nor, to my knowledge, did he ever learn that this was Chatral's situation.) Biographer Michael Mott's summary comment about Merton and Margie I could virtually take as my own: "He loved greatly and was greatly loved. He was overwhelmed by the experience and it changed him forever" (*The Seven Mountains of Thomas Merton*, p.348).

CHAPTER SIX

THE PAINTING SPEAKS AGAIN

Having found refuge at my friend's house after the separation in July 1989, I then found a garden-level apartment on East 15th Avenue. (This was the moment at which I became aware of the distinction between a garden-level apartment and a basement suite—something long known to my students.) Then in September I started teaching Religious Studies at Simon Fraser University in Vancouver. This new career was a major factor in Part B of my life being so different from Part A. I take a moment here to thank Charles Paris, who phoned me to ask if I would be interested in applying for the single Religious Studies course he had been teaching, and of course I was; to thank Christine Prisland, the manager of the Humanities Department, who fostered my teaching career in many caring ways; and to thank Jerry Zaslove, department chair, for his support and mentoring, first by upgrading my status from sessional instructor to adjunct professor, and then at a later time, for facilitating my succeeding him as director of the Institute for the Humanities. My fifteen years at SFU, which ended only with what was then mandatory retirement, were a happy and productive time. Would I have retired if I hadn't had to? (Mandatory retirement was abolished about two years later.) No, I wouldn't have. But having retired, I realized I was ready for the freedom which is a major dimension of retirement.

In my new residence the painting hung on the south wall of the living room, which made it immediately noticeable to anyone coming in the front door. It was not my deliberate choice that the painting should be so

immediately visible; the south wall was simply the only wall wide enough to receive a painting of that size. Trying in many ways to put my life together again—unlike Humpty Dumpty, human beings can do that—I began to practise once again the form of meditation I had learned a few years earlier from Benedictine teacher John Main (wccm.org). I did this in the morning after I had showered but before I dressed, and got into the habit of wearing during my meditation time a brown velvet dressing-gown/bathrobe of a faintly Asian character. There was a futon directly across from the painting, and I found it convenient to sit cross-legged on the futon while meditating. Somehow I got into the habit of bowing in the direction of the painting at the beginning and end of my meditation time—not bowing *to* the painting or to *the figure* in the painting, but "just bowing" and thereby demarcating the boundaries of my meditation time. During the meditation I kept my eyes half-closed, and didn't look or gaze at the painting at all. This carried on through the fall, during which Megan came to live with me—on the same day my lover reappeared for a bittersweet 48-hour reunion (is there no-one out there scheduling these things?!). Christmas came and went, a particularly miserable one, and soon we were into the new year, 1990.

Then one morning, while meditating, perhaps in January or February, I felt a strong drawing from the painting to open my eyes and look at it. As I did, the figure in the painting spoke for a second time, and this, verbatim, is what he said.

> I am your True Self. When you are 75, you will look at me, and you will say one of two things. Either you will say, "This is who I have become—thanks be to God." Or you will say, "This is who I *could* have become—Lord, have mercy."

It is too simple to say that this unexpected address staggered me. I felt a strong bodily *frisson,* equal in strength to my experience when reading the gospel story of the prodigal son in church. As I looked intently at the painting, many things happened simultaneously. I had always taken the figure as a representation of an occidental male; now for a time I became uncertain whether the figure was masculine or feminine, occidental or oriental. I had always taken the blaze of light in the upper-right quadrant of the painting as coming from outside, shining on the figure. I now saw it as

shining out *from* the figure. I also saw something I had never noticed before, a boundary line of light which limned the outline of the figure. Everything I am describing here took place, not successively, but simultaneously and instantly. After a while, however, my sense of the figure settled. For me, it's clearly a masculine and occidental image, and I have come to see that the light in the painting *both* shines upon the figure *and* shines out from the figure. My conclusion that it was a masculine image I will discuss later in this book. And looking at the painting now, I do not see the boundary line of light that I saw then—it just isn't there. But my sense of the figure's androgynous and transcultural qualities remains with me. This experience of dualities within the unity of the painting does point in its own way to Zen; and I think of it now as having strongly encouraged me in the direction of spiritual integration.

Did this electric moment have anything to do with the affair? Of course it did. The holy man was asking me to make a fresh start in my life, to live as my True Self. Arguably, I had not been acting as such, first, when I failed to recognize that my marriage had died, and taken the appropriate personal and legal steps accordingly; and second, it can also be argued that any affair, no matter how life-giving, is at another level untrue to the self and the other. At some points I wondered if by our relationship I was simply getting in my lover's way as she tried to engage her personal challenges, although it does not seem to have done her any permanent damage, or indeed any damage at all. I also cannot deny that the relationship re-oriented my life in the *direction* of the True Self. So, paradox: *felix culpa*. I have given up trying to rationalize or explain this. I have to be content to live with its ambiguity and paradoxicality: thanks be to God / Lord, have mercy.

A short time later—some days, a week or two—I was sitting in the same room and reading the biblical story of the patriarch of monotheism, Abram/Abraham/Ibrahim, honoured by Jews and Muslims as well as by Christians. The story begins in Genesis 11. The part of the story of particular interest to me here comes in Genesis 12:4. Abram, later in the narrative called Abraham, has heard a call from God to move from Haran to the land of Canaan; and then the story says, "So Abram went, as the Lord had told him: …. Abram was seventy-five years old when he departed from Haran." Seventy-five years old, and what had he done worthy of note before that? He had been born (11:26), married (11:29) and traveled with his father,

Terah, from Ur of the Chaldees to Haran (11:31). But he had not done or said anything in the view of the biblical writer or editor that was unique, notable or revelatory *before* he was seventy-five. The saga of Abraham and his family, full of incident and intrigue, beginning here and continuing until Genesis 25, tells us that he died a hundred years later, at the age of a hundred and seventy-five (25:7). I recognize that the Bible uses numbers as they pertain to the years of one's age in a different way than we more precisely do nowadays. In other words, I take the figure of seventy-five as intended to suggest that Abraham was old when he was called—oldish at least; and the figure of a hundred and seventy-five to suggest that he lived for a good long while after his departure from Haran. And certainly in this good long while he did many things worthy of record in the view of the biblical writers—but only *after* he had turned seventy-five.

For years, as I have mentioned, I had been brushing off the questions of people who when they saw the painting wanted to know who the figure in the painting was, with a joking response: that it was a portrait of myself at age seventy-five. On sober second thought, this implies that it had been painted somehow from the future—a literal (but not a mystical) impossibility. It evokes for me now Jung's telling comment that the future casts its shadow on the present. Whatever the truth in my response, recalling, as the old proverb says, that many a true word is spoken in jest, what I took from this reading of Genesis 11-12 was that for Abraham, *seventy-five was a beginning, not an end.* Up to this point, in regard to my own life, I had had a mental image of two lines converging on one another and coming to a point together representing my reaching the age of departure, whenever that might be. I *now* saw these two lines, yes, converging on the point representing seventy-five, the figure from my joke picked up by the holy man, but then continuing, each in its original direction, so that after seventy-five, they crossed over each other and opened up more and more, opened up, in fact, into infinity and eternity. The understanding that came to me was one of the possibility, even perhaps the inevitability, of what early theologian Gregory of Nyssa (c. 332 – 395) called *epektasis,* the process he posited of infinite spiritual growth after death in the infinity and eternity of God.

Of course this completely changed my feeling about what it meant to be seventy-five. When the figure in the painting told me when I was fifty

that I would look at him when I was seventy-five and utter one or other of the two stark life-assessments he had offered me, I didn't take him as suggesting that I would die at that age, and so far, I haven't, being as I write seventy-seven. Quite apart from my age at death, whenever that occurs, what he was holding before me was a kind of spiritual *terminus ad quem* after which I could not in good conscience continue to think of myself in any moral sense as a person still in process, someone for whom excuses could be kindly made, not essentially a finished product. Age seventy-five, in other words, would be a moment of solemn accountability, for which his comment, twenty-five years before that moment—fair warning, indeed—was preparing me, and towards which it was calling me. It was a call to let go of my longstanding tendency to excuse myself for my failings, a classic characteristic of "Sevens" in the Enneagram.

Another reframing of my sense of time had occurred not long after I had moved into my little apartment a few weeks before my fiftieth birthday. One day, a down day as I recall it, I started thinking about the biblical concept of Jubilee (described in Leviticus 25). It is a year in which four things are supposed to happen: debts are forgiven, slaves are freed, the land has sacred rest, and all return to their ancestral home (www. donaldgrayston.ca/jubilee.html). Thinking of this, I said to myself, "Well, here you are at probably the lowest point of your life. But soon you will be fifty, and that will be the Year of Jubilee, when things will *have* to be better than they are right now." This was my third and last major moment of *katabasis,* going on UI being the first, separating from my wife and the prospect of divorce being the second—another appearance of the number three in its archetypal dimension. So a moment of *katabasis,* but a very brief one, because immediately I caught my error, and speaking again to myself, said: "No, wait: the Year of Jubilee is not the year one (or one's society) is fifty, it's *the fiftieth year*—*it's right now!* Down here in the pits, if I am going to celebrate it at all, is when I have to celebrate the Jubilee." This realization caused a one hundred and eighty degree shift in my feelings. I still had a few weeks in which to live the Jubilee—to forgive myself my moral and spiritual debts, to let go of my addictions, to honour my body—my sacred land—and to move intentionally in the direction of home, that is, of my own heart and the heart of God. Some years later I wrote this little song during one of the Jubilee Program residencies.

It brings together for me both the themes of Jubilee and the Abrahamic revelation of which I have just spoken:

> I am here, in the heart of God,
> I walk the path the saints have trod.
> As I step forth, Mercy takes my hand,
> And leads me to the Promised Land.

And of course my references to the Jubilee Program also call for context. In 1991, the Shalom Institute, much reduced for financial reasons, amalgamated with a sister organization, the Anawim Community. A new name was needed for the amalgamated group. I suggested Jubilee (without sharing the personal meaning that it had for me), and the name was accepted. This is why and how the spiritual direction training program which had been started in the time of the Shalom Institute, in co-operation with the Vancouver School of Theology, a relationship which lasted until 2006, and which continues today under the magnificent leadership of Lois Huey-Heck and her team, came to bear the name of Jubilee.

<div align="center">★</div>

I am writing now when I am seventy-seven, adding to the previous paragraphs, mostly written in 2010, the thoughts that came to me when I did turn seventy-five, in 2014. Here, first (slightly edited), is what I wrote on my website (donaldgrayston.ca) in July 2014, the month before my seventy-fifth birthday:

> For some years now, the first thing I have done and continue to do when I get up in the morning is to offer a modest bow in the direction of the painting. . . . My intention is simply to acknowledge every day the iconic and archetypal character of the painting which points me to God and to accountability (cf. Matthew 25:31-46). I now have less than two months to go; and at the moment I think my chances of being able to say "Thanks be to God!" are fairly good. But for the remainder, I am also going to be ready to say "Lord, have mercy."

Then two months later, on my seventy-fifth birthday—the "very day," as my mother used to say, I wrote this:

So now I am seventy-five, the age which the holy man held out to me twenty-five years ago as a solemn moment of accountability, and the age of the patriarch Abraham at the time of his call; a third of my life to date has passed since then. I have wrinkles and liver spots that I didn't have ten years ago. (Leonard Cohen has a great line about this in "The Tower of Song": "Well, my friends are gone, and my hair is grey. I ache in the places where I used to play." Mercifully, many of my friends are still with me, but indeed my hair is grey, and he got the ache part right.) As Aristotle and St. Thomas Aquinas might say, the "accidents" speak of age, but the "substance" inside still feels youthful. Is this immaturity? Am I just trying to hang on to what's left of my youth—not that easy with arthritis and my need for oxygen (as of March 2014)? Am I, heaven forfend, a *puer aeternus* ["eternal boy"], a Peter Pan, the boy who never grew up? Let these questions drain away into the sand before anyone answers them in the affirmative!

So what am I saying today? Is it "Thanks be to God!" or is it "Lord, have mercy"? Earlier this week I had a conversation with a friend in Ontario, fifty years a Roman Catholic sister, a redoubtable and marvellous woman. I told her about this and asked her what she thought I should say today (she knows me pretty well). "Both, of course!"

Ergo, and in the best Anglican fashion, both/and, not either/or: Thanks be to God! (let's say79%—a high second class mark when I was an undergraduate), and Lord, have mercy! (let's say 21%). All right, I *could* say that, but in the larger sense, I need/want to say 100% in regard to both. If I am presiding in church, and if we are praying the Kyrie in Greek ("*Kyrie, eleison*"—"Lord, have mercy") I translate it for people as "The Lord, the merciful one, is with us." It's from that perspective that I want to say 100% in regard to "Lord, have mercy!" And come to think of it, I don't want to stint on "Thanks be

to God!" either. Thus, revised percentages: "Thanks be to God!" – 100%; "Lord, have mercy!" – 100%. (Not that we can quantify such things with percentages!)

So was the holy man misleading me when he offered me the stark alternative which he did rather than intimating the possibility of his two perspectives being held together? I don't think so. He was simply laying out the cardinal directions in which I or anyone might *without intentionality* find ourselves going. I dare to trust that he is satisfied with my self-assessment here—at least I have had no word from him to the contrary! His presence in my life is a non-judgmental one.

Not long after the day on which I read about Abraham, another electric moment. Once again I was meditating in the living room, in the presence of the painting, but without thinking about or looking at the painting. With no warning, I heard an audible click, which came from the area of my sternum, the place in the rib-structure where the ribs of both sides of the chest come together, and which protects the heart. (Recently I have heard the sternum called the Vishnu Point in Hindu spiritual theory, a point of revelation.) My sense of the click was that it was so loud that if another person had been in the room, he or she would have said, "What was that sound?" Of course it was an intra-psychic event, and if I am accessing my rational mind for a moment, no actual sound was made that anyone else would have heard—and doubtless this applies equally to the two occasions on which the figure in the painting spoke to me. The meaning of this was immediately clear to me: *my body and my soul had come back together again* into the unity for which they are intended, after a separation of some forty-five years. By this I mean that I had gone through a lopsidedly-rationalistic educational system, starting around the age of five, in which my education had separated body and soul from mind and from each other. My time as a disembodied head was over. In order to do well in school, which I wanted to do and which I was encouraged to do, I had to prevent my body from moving, since I knew that the teachers wanted us to sit still and concentrate. Beyond this, the physical education curriculum of any school that I went to was either feeble or biased. My classic memory of physical ed. from elementary school is this one, an experience repeated numerous times. The teacher would choose the two most athletic boys in the class,

give each one of them a baseball bat, and tell them to pick teams. My regular experience: being the last one to be picked. And a further level of humiliation: in the case of even numbers, the two captains arguing with each other: "You take him!" "No, you take him!" I know now that this was the experience of many, in no way unique to myself. But that later recognition offers no solace to the eight-or-nine-year-old kid still alive in me who was always picked last. Then in the high school years, there was the practice of the teachers using the phys. ed. periods to train the members of school teams, while the rest of us non-athletic types were tossed a ball and bat and told to amuse ourselves in a corner of the schoolyard and not get in the way of the teams. My father, as a young man, had been a fine athlete. However, his absence from home, and his concern for—indeed, his anxiety about—his job meant that we spent very little time together in any athletic activity. I remember only two very precious shared moments from my childhood, one afternoon in which we played catch in the back yard, and another occasion when he took me and a school friend fishing in the Cariboo (because there was a dock strike, which meant he couldn't work—he was a ship chandler). But as I moved into my teen years, and demonstrated intellectual ability, I only received encouragement at school to give time and energy to intellectual and cultural pursuits and no similar encouragement to engage with my body.

Of course, as a teenager, I couldn't help but be confronted with the reality of sexuality. However, as an active member of the church of that time, and as someone heading for ordination, I received no messages from the church about the beauty and spirituality of sexuality, but rather messages, mostly unspoken, to the effect that sexuality was essentially a source of danger rather than pleasure and growth and connection. And so I understandably came to the conclusion that I must reserve any sexual exchange until after my wedding, if indeed I ever did get married. I went to school dances and had girls as friends, but not as girlfriends. These were the late-fifties, the last years before the pill came into general use in 1960; and as had been the case forever, sexual intercourse still ran the risk of pregnancy and the attendant loss of career. This dynamic also was a major factor in the long separation of my body from my soul. The positive re-evaluation of sexuality, in particular from a spiritual viewpoint, the shaking off of the centuries-long and baleful influence of St. Augustine, is one of the great

cultural gains of the last half-century, which is not to deny the sexual chaos which characterizes so much of our culture. More work remains to be done in this critically important area. I have in this memoir described myself as naïve about sexuality, and so I was. I would have benefited from a whole and healthy formation in sexual matters, freely offered by church or society. In the event, as here described, I had to seize it for myself. The time of the hairy Christ of whom Marie-Louise von Franz speaks had not yet come, indeed has not yet come in its fullness.

At this point, having realized after the end of the marriage, and after experiencing the "audible" click indicating that my body and soul had come together again, I also realized that for the first time in my life I was in possession of my own soul, my own deepest self, in charge of myself, responsible for myself. But then who had had possession of my soul in my earlier years? Certainly I believe that as Wordsworth says, "Trailing clouds of glory do we come from God, who is our home" ("Intimations of Immortality"), and that for the infant, body and soul are one. From the beginning, my mother took my soul into her care, and cared for it, cared for me, to the best of her ability. Then when I had my religious awakening as a teenager, I took my soul away from my mother, without feeling any need to tell her (although that was simply the beginning of a process, as it is for many of us, which took decades to complete) and gave it, as I thought, to God. In fact, I gave it to the church. It took me many years after this to realize that God and the church are different realities, something well-known to any secularist, whether or not he/she acknowledges the reality of God. (The consensus on this subject among my students at Simon Fraser University may be simply stated: Jesus good, church bad.) Again, when I married, at the age of twenty-nine, I took my soul away from the church, which I had already begun to perceive as an imperfect institution ("The church is a lousy mother," as John Harris memorably says in *Stress, Power and Ministry*), and gave it to my wife. Then in my late forties, I took my soul back from my wife, without telling her *nor realizing it myself*, since this part of the journey was an unconscious process. In fact, I was looking for someone else to give it to, someone *other than myself* who would care for my soul. When my lover and I found each other, we gave each other our souls, and looked after each other's souls very tenderly, chiefly by the tenderness with which we cared for each other's bodies. When the affair ended, she

asked for her soul back, and it was with great regret that I returned her soul to her and very reluctantly received my own soul back from her. In fact, between the time of our separation and the day the holy man spoke again, I was walking around with my soul in my hands (for some reason, I visualized it as a golden ball), looking for someone *else* to give it to.

The golden ball, yes! In the folk-tale of *Iron John*, the golden ball belonging to the boy who is the protagonist in the story represents his soul. It is a sphere—a perfect shape, and made of gold—seen through the ages as the most precious of metals. "The golden ball," Robert Bly tells us, "reminds us of that unity of personality we had as children. . . . The ball is golden, as the sun is, and round. Like the sun, it gives off a radiant energy from the inside" (*Iron John* p.7). So did I get the idea of the golden ball from reading *Iron John*? No, because the image came to me in 1989 and I didn't read *Iron John* until the early nineties. Had I read about it in another folk-tale which I had read as a child? Perhaps. More likely, I conclude, it came to me from the same source as the golden ball in the Iron John story, the collective unconscious.

But after that staggering statement from the figure in the painting, after my reconstruing of what it meant to be fifty and might mean to be seventy-five, and after the mysterious experience of the click marking the reunion of body and soul, I realized that I was in a new place spiritually. With body and soul together once again, I began to realize that I must take responsibility for my own soul. I realized that we can *share* our souls, but we must never, as adults, ask anyone else to *take responsibility* for them; and since then, with brief lapses which I readily acknowledge, I have tried to take full responsibility for the health and well-being of my soul, *both* sharing it with others *and* retaining it in my own possession.

So at that point in my journey I was fifty, two-thirds of the way to seventy-five; and I had been given completely new perspectives on what it means to be fifty and what it could mean to be seventy-five. During my forties, I had been feeling older and older, worse and worse about myself, as the *New York Times* piece says. After this mighty shifting of gears in my fiftieth and fifty-first years, that feeling left me completely. As Bob Dylan says: "Ah, but I was so much older then; I'm younger than that now" (the refrain from "My back pages," 1963). But even that wry comment doesn't completely capture what I'm talking about. I had a new sense that age was,

if not quite immaterial, then certainly secondary; not that I was ageless, because of course I noticed and felt the ageing of my body, but that once again I was going with the flow of my life and the flow of the universe in a way that relativizes age in its numerical or determinative character. I was beginning to learn to be present to myself as I was in the now, and thereby present to God, to others and to the world. My body and my soul had come together again.

So then, fifty. Yeats gives magnificent expression in his poem, "Vacillation IV," to what that moment meant for him, and indeed for me (quoted in *Iron John*, p.113).

> My fiftieth year had come and gone.
> I sat, a solitary man,
> In a crowded London shop,
> An open book and empty cup
> On the marble table top.
>
> While on the shop and street I gazed
> My body for a moment blazed,
> And twenty minutes, more or less,
> It seemed, so great my happiness,
> That I was blessèd, and could bless.

It was true. My wounds were healing. I was blessed, and could bless. Having become sane, I knew I had to stay sane. I was happy in a way I had never been happy before. With body and soul together again, I was ready to embark on the long journey to seventy-five.

CHAPTER SEVEN

WHAT IS WRITTEN
ON THE SCROLL?

Here I am; in the scroll of the book it is written of me: "I delight
to do your will, O my God; your law is within my heart."
Psalm 40:7-8 (NRSV).

Because Megan had come to live with me, the garden-level apartment
became too small, and I looked for a new place to live, which I found on
Kitchener Street, just east of Nanaimo Street, still in East Vancouver, then
largely the home of the overeducated poor, now experiencing gentrifi-
cation as people move east in search of affordable housing. It was a 1920s
stucco-covered bungalow, uninviting on the outside, in beautiful shape
on the inside. My sense was that yuppies had preceded us in the house;
and although I had no desire to be a yuppy, nor was I any longer qualified
by age, contrary to what I said in the last chapter—age is relevant in *some*
contexts. I was happy to be following yuppies in any house in which they
had lived—they always do a good job.

Perhaps two or three days after I moved into this house, I was standing
in the little dining-room/study, talking to someone on the phone. Many
boxes were still unpacked, and the painting was leaning against the wall
across from me, not yet having been installed in its new place of honour
on the north wall of my bedroom. Suddenly I noticed something in the

painting that I had never noticed before: the holy man was holding a scroll in his hand. His left hand is folded over his right hand, which holds the scroll, supported by the left hand above it. At this point I had owned the painting for eighteen years, and had never noticed the scroll; but I was no longer surprised that new meanings were coming forth from it.

So what is written on the scroll? I asked myself and the universe: and the answer came immediately—*it is the story of the rest of your life.* I didn't take this to mean that in some cosmic file or dossier the remaining years of my life were scripted out, and that I simply had to follow the script. Rather, I understood this as related to what the man in the painting had said some months earlier: that when I hit seventy-five, I would have reached a moment of special accountability, that I would be solemnly accountable for what I had "written on the scroll" in the years that remained to me between my discovery of the scroll and the year I would be seventy-five, should I live that long—although now that I think about it, the holy man's mention of seventy-five was a kind of promise that I would live that long. The painting, in effect, was saying this to me: your next years, your next decades, lie open before you. What you do with those years will be what is written on the scroll, or rather, what you will choose to write on the scroll.

Before there was the *codex*, or, as we now call it, *the book*, there was the scroll. In the epigraph to this chapter, both terms are used, scroll and book: "book" there I take to mean the written content of the scroll. All the scriptures of the Hebrew Bible and the New Testament were originally written on scrolls; and to this day the copy of the Torah which is found in a synagogue is hand-inscribed, following the ancient tradition, on a scroll.

Having then noticed the scroll in the painting, I thought of the two places in the Bible in which a scroll itself figures prominently. The first of these occurs in the book of the prophet Ezekiel, who goes into exile in Babylon with his fellow-Israelites in 597 BCE. He has a number of visions as he sits by the river Chebar, including one (Ezekiel 1:28-3:11) in which he hears God (no painting needed) speaking to him. After speaking of the rebelliousness (i.e., the failure to keep the Law of Moses) of the Israelites, God, according to the text, speaks (God's words are in Roman type, and Ezekiel's responses in italics).

But you, mortal, hear what I say to you; do not be rebellious like that rebellious house; open your mouth and eat what I give you.

I looked, and a hand was stretched out to me, and a written scroll was in it. He spread it before me; it had writing on the front and on the back, and written on it were words of lamentation and mourning and woe. He said to me,

O mortal, eat what is offered to you; eat this scroll, and go, speak to the house of Israel.

So I opened my mouth, and he gave me the scroll to eat. He said to me,

Mortal, eat this scroll that I give you and fill your stomach with it. *Then I ate it; and in my mouth it was sweet as honey*

(Ezekiel 2:8–3:3).

Open your mouth and eat what I give you: take into yourself the experiences that are waiting for you. As your life proceeds, your days and years will indeed be "eaten up" by the voracious appetite of Time, and you must always remain conscious of this. Life is not simply short; it is very short.

Writing on the front and on the back: I will write on my scroll as the years go what is on the front (the external elements of my life observable to others) and on the back (the hidden or private elements of my life), yet all on one single scroll, the scroll of my one life.

Words of lamentation and mourning and woe: yes, sorrow for the failure of my marriage, and for my failure in so many ways to be present to God, self and others, particularly my family.

Eat this scroll that I give you and fill your stomach with it: you must integrate and digest your experience—you must not live an unexamined life.

Then I ate it: and in my mouth it was as sweet as honey. Yes: for undeniably out of my stumbling negotiation of the midlife passage I had a new sense

of freedom, of liberation, of cleansing, of possibility, of newness. Life was bittersweet, but more sweet than bitter.

The other biblical context in which a scroll is mentioned is in the Book of Revelation, chapters 5 and 10. In chapter 5, the writer, John of Patmos, sometimes called John the Divine, or John the Beloved Disciple, sees a scroll, inscribed, like Ezekiel's scroll, on both front and back. An angel calls out for someone who is worthy to open the scroll by the breaking of its seven seals. John is then told that the Lion who is also the Lamb (Revelation 5:5-6) has been found worthy, and will break the seals and reveal the contents of the scroll. Succeeding chapters reveal these contents in cosmic terms relating to the final apocalypse. Then in chapter 10, another angel, with one foot on the land and the other on the sea (an amazing image), gives John another scroll, "the little scroll" (Revelation 10:8-10), with the same instruction that was given to Ezekiel, to eat it. John's experience of the eating of the scroll differs, however, from that of Ezekiel, for whom the scroll was "sweet as honey in [his] mouth," whereas for John, it was yes, sweet as honey in his mouth but then bitter in his stomach.

I offer here the notes to Revelation 5:1-5 written by the editors of the New Revised Standard Version of the Bible in regard to the first scroll, the great scroll with the seven seals.

> The *right hand* is the hand of power and favor The *scroll* represents secret knowledge, and access to a revelation (see Psalm 139:16). Scrolls were ordinarily written only on the *inside* and rarely *on the back;* either there is too much for the scroll to hold or there is a summary on the outside The imagery derives from Ezekiel 2:10 and will be used again in Revelation 10. The *seven seals* signify the perfection of the scroll's contents.

I note here what the psalm reference says: "In your book were written all the days that were formed for me, when none of them yet existed" (Psalm 139:16). This does not mandate a minutely predestined life, but rather one in which the foreknowledge and love of God accompanies us as we make our own decisions. The right hand, yes, is the hand of power: and it is the holy man's right hand in which the scroll is held. Clearly my scroll is neither Ezekiel's scroll nor the great apocalyptic scroll of Revelation 5. I take the

word "perfection" of the scroll's contents as referring to completeness, rather than anything moral or moralistic. Perhaps the little scroll of Revelation 10 is closest to my personal scroll, in that since I noticed it in the painting in 1990, I have had experiences both sweet and bitter. Since that time, I myself have inscribed twenty-five years' worth of living on both the front and the back of the scroll, or, alternatively stated, the great maw of Time has swallowed twenty-five of my years, the third third of my life to date. In a sense, writing this book is taking something from the back of the scroll, the knowledge that has largely been internal and private, and inscribing it in this book. But there is still room on the scroll for me to inscribe whatever happens in the rest of my years, however many of those there may be.

One more scroll-connection with the painting. In classical Orthodox icons, it is common for the holy figure so depicted to be holding a scroll, St. Ephrem the Syrian, for example, the saint of many tears. On the cover of the book devoted to him in the *Classics of Western Spirituality* series, we find him holding a scroll. It bears the inscription "Seriousness mixed with laughter destroys souls easily"—not a thought to which I myself would subscribe: I usually combined seriousness and humour in my sermons. For this to have been chosen by the iconographer as a representative Ephremian saying, Ephrem must have been one serious dude. Even so, his scroll plays a role in relation to him very similar to what I have intuited is the meaning for me of the scroll in my painting: that it refers to my life (or the remainder of it once I had noticed it) in a general sense. Perhaps the comment about seriousness and laughter did represent Ephrem's life stance; certainly how I have lived my life since 1990, when I first noticed the scroll, were it to be inscribed on it, would be representative of my life stance. It seems that holy men and scrolls belong together.

I end this chapter with some Canadian content, from First Nations writer Richard Wagamese, Ojibwa (1955-2017), whom I have heard speak on the CBC. In a web article from 2011 (wagamesewriter.wordpress.com), he speaks about words and books and scrolls. Essentially his ancestors lived in an oral culture, an aliterate culture, one with no need of books. However, sometimes scrolls were created from birch bark.

> They say that at one time in our history we set our stories on
> the skin of birch trees. We etched them there on the bark with

the blunt edge of a burnt stick or pigments formed of earth and rock and plant material that has never faded over time. Sacred scrolls holding stories meant to last forever. I only ever saw a birch bark scroll once. The old man laid it out for me on a plank table top in a cabin tucked far away in the bush and traced the line of history with one arthritic finger, telling it in the Old Talk that I didn't understand. But I could translate his eyes. In those ancient symbols was a world where legends were alive, where an entire belief system was represented in teachings built of principles that were built themselves of rock and leaf and tree, of bird and moose and sky, and Trickster spirits nimble as dreams cajoling my people onto the land, toward themselves, toward him, toward me. This is what I understood from the wet glimmer of his eyes.

He was telling me that words cannot exist without feeling. That a text is only as useful as the truth it holds and that dreams and reality are the same world. This is what I carried away. This is the message I brought to my own storytelling here, to this page, stark in its blankness, waiting like me to be imagined, to be filled.

My heart resonates with what Richard Wagamese says: "words cannot exist without feeling." The "wet glimmer" of the old man's eyes testifies to the felt truth of this. This memoir, I hope it will be clear to any reader, is also full of feeling; and I will be giving ample attention in chapter 11 to the moistening of my own eyes.

CHAPTER EIGHT

CHARLES STREET, EAST 15TH—ASIA!

In 1993, Jonathan came to live with Megan and me; and so, because the beautiful little house on Kitchener Street wasn't big enough for the three of us, we moved to another rented place, faux-Spanish, near the corner of Charles and Lakewood, also in East Vancouver. ("Definitely an upgrade," said one of the summer students I had dragooned with promises of beer and pizza to help me move—exactly the opposite of how I felt, since I had truly loved the little house on Kitchener Street.) Indeed, as I spent the day following the move, which was also my birthday, alone in the Kitchener Street house, cleaning it in readiness for its next occupant, I wept. I did something that day which I had not done before, but which I did again when I left Charles Street; I stood in the centre of each room, recalled what memories it evoked, and gave thanks. I commit myself now to do the same thing with my present apartment if I leave it consciously. It was a deep moment.

I had taken Megan and Jonathan with me as we looked at various places to rent; and it was the fact that as well as three bedrooms there were three bathrooms in the Charles Street house that decided us to move there—one for each of us, no fights in the mornings! I had a big bedroom upstairs, with an ensuite bathroom, enough space for a home office, and a huge walk-in closet; and it was in that bedroom that I hung the painting for the four

years that we lived there. These were very active years for me: teaching at Simon Fraser University, parenting my kids as a single father, exploring possibilities of partnership, and doing Sunday duty as a priest in various parishes. Nothing special happened in regard to the painting that I can recall. It maintained its peaceful presence on the wall of my bedroom, and whenever I looked at it, offered me as always the possibility of grace and peace. Then in 1997, Jonathan graduated from high school, and Megan, by now twenty-five, decided to find her own place and move out. Hearing this, Jonathan immediately said, "Yeah, I'm moving out, too." Translation: I wouldn't be caught dead living here all alone, so to speak, with Dad. So of course I replied that with both of them gone, the house would be too big for me by myself, and that I would move out as well; whereupon Jonathan immediately said, "Well then, I could stay here, find a couple of friends to move in with me, and we could rent it together"—and that is what happened.

I wanted to stay within reach of Commercial Drive, where I felt very much at home, and where I regularly encountered students and other friends, and I ended up renting a unit in a fourplex at 1215 East 15th Avenue. When I looked at it in advance of the advertised open house, I found it so attractive that I told myself—please understand the hyperbolic character of this statement—that I would beg, borrow or steal (probably not kill) to be granted possession of it. When I went to the open house, I discovered that the house was half-owned by an architect whose wife was a former student of mine from UBC, and it was she who was showing the suite. "Ah, my cherished professor!" she said when she saw me. "Dushka!" I replied: "It's been too long!" (Exults to himself: "The place is mine.") When I told my mother my new address, she asked me how close it was to 1219, where she and her family had lived between 1919 and 1921, when she was between the ages of seven and nine. I checked this out, and discovered that it was next door—apple doesn't fall far from tree. I acknowledge that this would invite a Freudian reading if I had *known* that she had lived next door. The suite was big enough for my children to crash there temporarily if they needed to, but too small for them to settle into permanently; and indeed, both Megan and Jonathan took advantage of its crash-pad possibilities on a few occasions. Here I hung the painting in my study, over my desk, and I was regularly conscious, as I worked there, of its presence. I had a sense

as always of being watched over by the figure in the painting, not in a hovering or supervisory sense, but simply in a calm and even caring way. Its presence was companionable; and as time has gone by, I have realized that it has companioned me—for forty-five years as I write—more than twice as long as I was married.

It was while I was living in the fourplex, in the academic year 2000-01, that I had the first and only sabbatical of my time at SFU. It was a glorious time, one which I had never had before and will never have again. So how to use it, how to spend it, how to exercise my stewardship of it? Part of it I spent in Europe, a time which included visits to Auschwitz and to Anne Frank House in Amsterdam in support of my teaching of a course on the Holocaust. (I felt numb at Auschwitz, and sobbed at Anne Frank House. As Stalin once said, "The death of one person is a tragedy; the death of millions is a statistic.") But the single longest time away from home I spent in Asia, retracing the last journey of Thomas Merton. Merton spent most of his time on this journey in India, Sri Lanka and Thailand, with brief stops in Hawaii, Tokyo, Hong Kong and Singapore. He left San Francisco on October 15, 1968, and died in Thailand on December 10, twenty-seven years to the day from the day of his entry into monastic life at Gethsemani.

Merton's record of those weeks, edited after his death by friends, chiefly his publisher, James Laughlin, can be found in his *Asian Journal*. In its pages he records his impressions of Asian life, his reflections on the many books he was reading, and his encounters with people he met—Hindu, Buddhist, Muslim, Jain, Christian and secular. Often when people read that book today, they assume that his most important encounters were with the Dalai Lama, with whom he had three audiences, the first at his own request, the later two at the Dalai Lama's request. But the Dalai Lama at that time was young, only thirty-three; and Merton was a seasoned monk of fifty-three. Not to trivialize Merton's meetings with the Dalai Lama, it seems clear to me that for the most part Merton was the teacher and the Dalai Lama the student in their times together. Almost fifty years later, the Dalai Lama continues to speak warmly of Thomas Merton, and to acknowledge that it was through Merton that he was first able to appreciate Christianity as a spiritual path. Recently, in fact, he has spoken of their relationship as one of father and son, with himself as the son (in Morgan Atkinson's centenary DVD, "The Many Storeys and Last Year of Thomas Merton"). However,

it was Merton's encounter with Chatral Rinpoche that I believe is far more significant, as indeed my encounter with him was significant for me.

I left Vancouver on October 31, 2000, and arrived the next day in Mumbai/Bombay. For the next ten days, I traveled in Kerala, the Indian state with the highest percentage of Christians, with two friends, one Indian, one Canadian. We visited tea plantations and rode on the back of an elephant (a cruel practice—with a chain on one leg, she simply walked around in circles—something I would not do again). We were paddled across a lake by indigenous people on bamboo rafts which rather alarmingly floated just beneath the surface of the water, and visited the delightful "backwaters" of Kerala (large lagoons with houses built on skinny strips of land). In the city of Kochi we attended a performance of a classic Indian play, "Arjuna's Repentance," by Kathakali dancers—my most vivid memory there being of the actor playing Lord Shiva picking a louse out of his beard; and we visited the tomb of Vasco da Gama, whose name I remembered from elementary school. To judge by the length of his gravestone, he was very short, not something we were told in elementary school.

Returning to Mumbai, I undertook a secondary part of my trip, visiting sites connected to Mahatma Gandhi, on whom I was also teaching a course. The first of these was Mani Bhavan, his Mumbai residence and base of operations from 1917 to 1934. From there I took the train to Ahmedabad, his northern base, where I visited Sabarmati Ashram, his longtime home. Remembering his devotion to the Sermon on the Mount (Matthew 5-7), I took the opportunity of a quiet time sitting on a bench in the ashram to read it out loud, just to see how long it would take: fifteen minutes. I'm not suggesting that this is how long Jesus took to speak the Sermon; what we have of it in the New Testament is of course a condensed literary recollection of what he said on many occasions. From Ahmedabad I took the train to Porbandar, Gandhi's birthplace, and from there to New Delhi, where again I visited several Gandhi-related sites, including the place of his assassination, Birla House, and the place of his cremation, Rajghat, in New Delhi. I was surprised to see that most of the Gandhi sites were dust-covered, except for Rajghat. In conversation, I further discovered that Gandhi remains a controversial figure for Indians. Half the population reveres him as the father of the nation; the other half blames him for the bloody partition between India and Pakistan. I also found it curious that

Merton, who had some years before his Asian journey published a small book on Gandhi, was not at all interested, to judge by his *Asian Journal*, in connecting with Gandhi's memory or legacy while in India. But this is not uncharacteristic of Merton: to plunge deeply—for a time—into the study of a person or subject, and then to move on.

From Delhi I traveled to Dharamsala, hoping to have an audience there with the Dalai Lama myself. Merton had traveled by train to Pathankot, and from there by jeep to Dharamsala. My trip from Delhi was not as comfortable: thirteen hours in a bus in a seat which had lost its spring and refused to support my back, and in which the glass in the window by my seat was lacking, a factor with serious effects as we climbed higher into the Himalayas. I had been trying for some weeks to arrange the audience, but with no success. However, I spent an enjoyable few days in Dharamsala, breathing in the atmosphere of recollection which Merton describes, talking to monks (some of whom were very interested in the possibility that, demonstrating by my presence so far from home that I was a rich westerner, I might fund their further education in North America—I don't blame them for trying), and to other western visitors, the most memorable of whom was Marina Illich, niece of the great Ivan.

On the bus back to Delhi, I found myself sitting opposite an elegant Frenchwoman, with whom I took the opportunity, *bien sur*, to practise my French. We asked each other what we were doing in India, as all westerners do, and I told her that I was on my way to Nepal, to visit the Buddhist high lama, Chatral Rinpoche (1913-2015). "Ah," she said, "you won't find him there. He always spends the winter in India. Would you like his phone number?" This I should say was only one of the many "coincidences" that I experienced in India. Since I had already bought an airline ticket, however, I did go first to Nepal, where I met one of Chatral's daughters, who gave me a very useful magazine devoted to her father and his work. Merton, at least from the record of their conversation, did not realize, as I've mentioned, that Chatral was a *married* hermit; according to what I later learned, he had married after his enlightenment, and had become the father of two daughters. I mention this in relation to Merton's humorous comments in his essay, "Day of a Stranger," to the effect that hermits (he himself then being about to enter his own hermitage) were "more unmarried" than monks, and that at a time in Catholic circles when there was "a lot of talk about

a married clergy ... there [had] not been a great deal said about married hermits" (p.219). It is intriguing, given Merton's time two years earlier with Margie, to speculate what Merton might have thought, said, written or done had he realized that Chatral was married—married, *and* a hermit.

Back then to Calcutta/Kolkata, and from there to New Siliguri, the major town near Salabari, where Chatral's Indian base is located. The next day I took a taxi to Salabari, where I met Konchok Tashi, a Canadian student of Chatral's, whose name I had been given before going to India by James George, the Canadian high commissioner to India at the time of Merton's visit, a distinguished Canadian, now in his nineties, whom in 2013 I had the privilege of meeting, in Toronto. I had prepared a list of ten questions about Merton's visit, and I showed them to Konchok (now back to his original name of Steve Brown, living in the US, and working as a lawyer) and asked him if they were appropriate. He said that they were, but that visitors usually asked Chatral *spiritual* questions, since he was a *spiritual* teacher. I asked what this meant, "spiritual" being a notoriously slippery word, and he said that the standard question was, "Do you have a teaching for me?" which I dutifully wrote down at the end of my ten Merton questions. I also asked Konchok what Chatral was like. His response: "To one person he will be very tender. To another, he'll say, 'You're a piece of shit; get out of my sight and never come back!' And whatever he says, that's what they need to hear." OK ... so I've come to India to be told ... well, tomorrow I will know.

That tomorrow—December 13—is a day I have commemorated annually ever since—and here we reconnect with the place of the painting in my life. I came to the compound at 7:00 a.m. Chatral was seated, comfortably cross-legged on a cushion (astonishing to me for someone then eighty-seven), on a dais under a canopy and a big tree—grown, as I later learned, from a cutting made of the current Bo tree at Bodh Gaya, itself the descendant of the tree under which the historical Buddha experienced his enlightenment. I stood in front of him, with Konchok to my left as my interpreter. After some ritual preliminaries, including the ingesting of something that looked like 10/30 motor oil, and a granular substance called *mendrup*, something like Grape-Nuts cereal, which was described to me as "the medicine of immortality," followed by a slap on the cheek to assist my wakefulness, I was granted the privilege of asking my first question: "What do you

remember of your conversation with Thomas Merton?" Chatral spoke for three or four minutes, with Konchok translating. While he was speaking, I suddenly became aware that from the moment our eyes had met, I had been silently weeping. So when he finished his response to my first question, I dumped (le mot juste) the remaining nine Merton questions, and asked the question which Konchok had suggested to me the day before: "Do you have a teaching for me?" "Yes," he said. "Decide for yourself what is the most important thing that Jesus ever said, and then take it as far as you can." At this point my weeping turned to sobbing, and after a ritual parting, Konchok and his fellow student, Heidi Nevin, led me away and gave me tea and Kleenex. "Does this happen very often?" I asked. "All the time," was their reply.

Did he know that I was a Christian? My hunch is that since I am a westerner, and someone interested in Merton, he thought it was likely that I was a Christian, although I am not ruling out the possibility of an exercise of his psychic powers. I decided immediately not to rush into a decision about what—for me—was the most important thing that Jesus ever said, but to make it a subject of long-term discernment. And about three months later, back in Canada, the saying rose up within me: "Let your yes be yes and your no be no" (Matthew 5:37): that at least is how I remembered it—the NRSV translation says "Let your word be 'Yes, Yes,' or 'No, No'"—and yes, I have ever since been trying to take its truth as far as I can. As for the weeping, I later came to recognize, during a conversation with a friend to whom I was relating the story of my meeting with Chatral, that the tears arose from the unrealized character of my relationship with my father. In the ten minutes I was with Chatral, whose gaze was laser-like, and whose presence was also an enfolding and paternal one, I had received a kind of fathering as never before. My sense of Chatral is that he was a Buddhist equivalent of the Desert Fathers of old. In those times, the third and fourth centuries of the present era, Christians would go out from the cities into the deserts of Egypt and Syria to speak with a Desert Father—and there were Desert Mothers as well. Typically, a seeker/pilgrim would say, "Father, give me a word," and the Desert Father would offer the seeker a word of scripture: "Love one another," or "Bear one another's burdens," or "The kingdom of God is within you." The seeker would then take that word back to the city, and use it as a spiritual touchstone for a year at least. So when

I asked Chatral if he had a teaching for me, and he replied with the words I have recorded here, we were having the kind of exchange that the ancient Christians had with the saints and hermits of the desert. It was almost as if my own holy man had stepped out of the painting (cf. Woody Allen's film, *The Purple Rose of Cairo*) to speak to me. My friend Douglas Christie has written about these ancient holy folk in *The Word in the Desert: Scripture and the Quest for Holiness in Early Christian Monasticism*; and Thomas Merton on the same subject published *The Wisdom of the Desert: Sayings from the Desert Fathers of the Fourth Century*.

It is clear to me from the *Asian Journal*, as I have already asserted, that Merton's time with Chatral was significantly more important to him than his time with the Dalai Lama, who was younger than Merton, while Merton and Chatral were close in age. Merton testifies to this by his comment that if he were to "settle down with a Tibetan guru, . . . Chatral would be the one [he would] choose", and by their "parting compact" to do their best to "attain to complete Buddhahood" (*Asian Journal* p.144) in this life, and not some future one. Certainly my brief time with Chatral was the high point of my own Asian journey, the point at which I realized that my journey, as well as being a research trip, was a pilgrimage, a holy journey. When I wrote this account, Chatral was still alive, but, according to my friend David Chang, who also tried to visit him, was no longer seeing Western visitors. The reason for this is that he had become irritated at visitors asking him about Thomas Merton rather than about enlightenment! I was fortunate to visit him before his irritation reached this level. I was sad to learn early in 2016 that he had died in 2015, at the age of a hundred and two. A blessing upon his memory!

In the days following my audience with Chatral, the thought came to me that not only was he a powerful old man, a wise old man, a holy old man, but he was also a *beautiful* old man. And what do I mean by this? I mean that he was an iconic figure, a human being through whom shines an intimation of the transcendent beauty that lies "deep down things," as Gerard Manley Hopkins says (in *"God's Grandeur"*). There was not the slightest doubt that he was one who had walked the walk as well as talked the talk. As I continued to reflect on my audience with him, the desire rose up powerfully in me: *I too want to be a beautiful old man*. Was this grandiose or foolish or even delusional? Is it a reasonable desire/goal for someone in

his sixties (as I then was), or is it too late? Do I in fact have this capacity? Does one become a beautiful old man simply by wanting to? Of course, if I do become a beautiful old man, I will no longer be asking myself these questions. Any male person becomes an old man if he lives long enough; the "beautiful" part is not automatic. But yes: I thought I still had enough time to come to such a place, or come nearer to it ("Nearer, my God, to thee"). It's not that I want to be recognized or hailed as "a beautiful old man": ah, there he goes, Donald Grayston, that beautiful old man. It is simply that for myself, and if I may dare to say so, for God, I want to be a beautiful old man—I think here of the title of Malcolm Muggeridge's book about Mother Teresa: *Something Beautiful for God. Eh bien*, all in good time: at this point no lesser goal appeals to me.

Back to the painting. It is without a doubt a beautiful painting of a beautiful old man, a man of wisdom and egolessness, a man who doesn't worry whether people see him as beautiful or not, a man who has come to peace through pain—a man, incidentally, who looks a lot like Chatral Rinpoche. So for many years the painting has been doing its quiet work, holding before me, in its iconic power, the archetypal representation not merely of a wise old man, but a beautiful old man, an old man who is wise in his beauty and beautiful in his wisdom; in whom, indeed, wisdom is beauty.

<p style="text-align:center">★</p>

From New Siliguri, and my encounter with Chatral, I went to Bagdogra Airport to catch my plane to Kolkata/Calcutta, only to discover that pilots had just that day refused to land their planes there until the massive potholes in the tarmac had been repaired. Five of us, westerners, two young Swedes, a couple from Québec and I conferred and decided to rent a van together to go to Calcutta. We chose the company because the man we understood would be our driver spoke such good English. He drove us into town, leapt out, turned us over to his cousin—who spoke no English, and had never been to Calcutta/Kolkata—and wished us well. We drove through the night along the West Bengal Highway, a fourteen-hour drive, and had the experience once we arrived in the city of having to direct our driver to our hotels by means of the maps in our tourist handbooks. The next morning I went to church at St. Paul's Cathedral, a monument of the time of the

British Raj, now belonging to the Church of North India. At the tea-hour which followed the service, I was asked by an elegant young Indian couple how I had traveled to the city. I told them, and they went pale under their brown skins. It was then that I learned that the West Bengal Highway has one of the worst reputations of any road in India for banditry and murder. What to say, except perhaps "Thanks be to God!"

After my time in India, I visited Sri Lanka, and saw the marvelous statues of the Buddha at Polonnaruwa. (My article about this is on the Merton page on my website, donaldgrayston.ca.) From there I went to Thailand, where Merton died accidentally, at the Red Cross conference centre at Samut Prakan, some 30 km outside Bangkok. I went there with an American friend, who when I asked him to show me the room where Merton had died, took me to the wrong room, something I discovered when I came home and read more carefully the account of his death in the *Asian Journal*. However, I am consoled by having seen on the front door of the cottage where Merton died a decal for Carling's beer; and given Merton's comment about beer—"I love beer, and thereby the world"—I knew that right room or wrong room, I had come to the right place. Then to Japan, which Merton had planned to visit after his time in Thailand. I asked myself what he would have visited, and the answer came immediately: Hiroshima and the Zen temples; and those were the chief markers of my six-day visit. I got home at the end of January 2001, and life carried on, but at a different level, as I continued to meditate, as I still do, on the meaning of the most important thing that—for me—Jesus said.

ASSISI, AND SAINT FRANCIS

In the summer of 2007, on behalf of the Thomas Merton Society of Canada, my friend Judith Hardcastle (its program coordinator) and I went to Rome to prepare for a 2008 Merton pilgrimage to the city in which Merton spent a few critical weeks in 1933, seventy-five years earlier. It took us ten days to complete our preparations; and after that, I went on my own to Siena and Assisi. (It was in the following year, after the Merton program, that I visited the ancient monastery of Camaldoli, and discovered the letters that prompted me to write *Thomas Merton and the Noonday Demon: The Camaldoli Correspondence*.) The name of Assisi, of course, is inseparable from the story of Giovanni Francesco di Bernardone (1182-1226), better known to history as St. Francis. I stayed in St. Anthony's, a Franciscan guesthouse, which overlooks the Basilica of St. Clare (Santa Chiara), which is at the near end of the city as one approaches it from the train station on the plain below.

While I was working on this book, I read a posting about Francis from Richard Rohr's daily mailing from the Center for Action and Contemplation in Albuquerque (cac.org, May 18, 2015). In a few brilliant paragraphs, it epitomizes Francis's "universal appeal," and links it to his spirituality of imperfection or "descent"—*katabasis*—something very close to the themes of this book. Here is what Rohr, himself a Franciscan, says.

Much of Francis' universal appeal is that he took a joyful approach to inner and outer liberation. His entire lifestyle was

a wholesale critique of the way most people live, yet he did not do this in a negative or moralistic way. . . . He felt the only way to get out of the world of violence, competition, and hatred was to live a simple life . . . a life lived in constant presence to what was right in front of him, which was nature itself, an always present doorway to the divine. Seeing what was right in front of him also awakened Francis to the immense amount of suffering in the world. Francis did not shield himself from that suffering or deny the dark, negative side of himself and the world. Instead he did a pre-emptive dive right into "the tears of things," without judgment, rancor, or cynicism. . . .

He first worked with the lepers on the plain below Assisi, and there he "found what was once hateful to [him] became sweetness and life." We all learn the mystery of ourselves at the price of our own innocence. Francis did not try to remain "innocent" (the word means "unwounded"). He did not run from life's wounding, because he saw that in Jesus it became the way to resurrection and universal life.

What Rohr says about Francis' practice of seeing "what was right in front of him" resonates very strongly with me. It's really an echo of Saying 5 from the Gospel of Thomas: "Know what is in front of your face ", which Francis would not have read; but there are texts in the gospels with echoes of what Saying 5 so forcefully states. And the phrase "the tears of things" speaks very powerfully to me, especially in regard to my encounters with the beautiful old men. I am still pondering the meaning of Rohr's very deep statement: "We all learn the mystery of ourselves at the price of our own innocence," with "innocent" understood, etymologically, as "unwounded." Certainly this was my experience as the marriage ended, a time of wounding and being wounded, and a time when the mystery of my fallibility began to become painfully clear for me.

Assisi is a walled city; and every building inside the wall is governed by an architectural code which serves to keep the city as an integral and beautiful testament to the skill and perfect taste of its builders in the twelfth and thirteenth centuries. The Basilica of St. Clare is at what I am calling the near end; and its companion basilica, dedicated to St. Francis, is on the slope

of a hill at the far end. The critical moment in the life of Francis—after his wild youth, his time in the army and as a prisoner of war, and his resistance to the domination of his wealthy father—occurred in 1206 as he was praying in the ruined and roofless church of San Damiano. That church is still, eight hundred years later, to be found only about 300 metres below my guesthouse at the near end of the city, now of course and since Francis' time, fully restored. He was praying in the presence of a representation of the crucified Jesus, not a crucifix, but a flat wooden cross, painted in red and gold. It is a large Romanesque or quasi-Byzantine rood cross, of a type sometimes called an icon cross because of the representations it contains around the central figure of Jesus of persons related to the crucifixion, or more commonly, called the cross of San Damiano. It was painted around the year 1100, about a century before the time of Francis's prayer, and Franciscans cherish this cross as the symbol of their mission. Interestingly, the ecumenical Community of Taizé in France also esteems and cherishes the San Damiano cross.

As Francis was praying, he "heard" Jesus speaking from the cross, and what he heard was this: "Francis, rebuild my church, which, as you see, is in ruins." At first, Francis thought Jesus meant the physical church of San Damiano itself; and so he gathered some friends, and they began to repair the ruined building. But very soon he realized that Jesus meant something more than this: that when he spoke of "my church," he meant not the building but the community, not the structure that shelters the community at worship but the community itself; and not simply the local or parish community, but the entire community, i.e., the universal church, then afflicted, as now, alas, with divisions and corruption of many kinds. (But here let me immediately say that I am enormously encouraged by the present pope, who indeed shares his name with the saint of Assisi, a very significant choice on his part.) Francis began to speak of this new understanding to his friends, and very quickly he was joined by many young men who wanted to be his brothers; and so was born the Franciscan movement of love and the simple life. Not long after this, Chiara Offreduccio (1194-1253), a young woman of high birth, came to him asking to be a sister in his movement; and so began the community later known as the Poor Clares, women of spirit committed to holy poverty and to joy, as were the brothers. Chiara, now known to us as St. Clare, and the other women who joined her, took

up residence in a building adjacent to the now-repaired San Damiano; and for many years, they lived there and prayed in the presence of the painted cross from which Francis had heard Jesus speak. After Clare's death, the great basilica which now bears her name was built in her honour, and the cross was moved there, where it still remains, in a side-chapel. A copy of it has been made, however; and it this copy that visitors to San Damiano see when they go there.

I visited Assisi not only as a tourist, but also as a pilgrim; so I prayed in San Damiano in the presence of the copy of the iconic cross, and later in the chapel in St. Clare's Basilica in which hangs the original. I confess that I did ask Jesus to speak to me, that I wanted to hear a personal word from him; but I heard no particular word such as Francis had heard. It's not hard to understand why, of course. Francis *heard what he needed to hear from Jesus in his time*; and I had *already* heard what I needed to hear in my own time, from the figure in my painting, not to mention what I have heard over the years from the gospels, words available to all of us. To be honest, I have already heard much more than I have acted upon. Arguably, I ought not to ask for another word until I have responded to the words I have already heard. (Surely the Desert Fathers must have asked those who came to them a second time if they had dealt responsibly with the first "word" they had been given before they were given a new one.) I think this is something of what Jesus was getting at in a more substantial way when he has Abraham, in the parable of the rich man and Lazarus, say to the rich man in hell, when the rich man asks him to warn his five brothers about their possible fate, "They have Moses and the prophets; they should listen to them" (Luke 16:29)—exactly. Or, as my wife once said, a comment painful to hear because of how true it was, "Why are you going to another workshop when you haven't integrated anything from the last workshop you went to?" Ouch.

But this brought me to this question: *who is it that is speaking to me from and through the painting in relation to how Francis heard Jesus speaking to him from the cross?* Is it Jesus? I didn't think so. Is it God in some traditional sense? Again I didn't think so. While I was pondering this question, I met a very engaging Dutch artist, Jos Solberg. Because he was an artist, and as both of us were visitors to Assisi with all the time in the world to sit in the piazza, drink espresso, and gab, I told him about my painting, and

how the holy man in it had spoken to me. As an agnostic, however, and as someone scornful of institutional religion, Jos dismissed any transpersonal or mystical interpretations of my experience as, not to put too fine a point on it, auto-suggestion. In other words, I was being sentimental, fooling myself into thinking that "someone" had spoken to me through the painting, or that God (because, surely, we can know nothing about God, if indeed there is a God) was somehow involved in this.

I liked Jos, and I acknowledged what he said as his own opinion, without getting into an argument with him. But his challenge remained with me for a number of weeks, by which time I had come home to Vancouver. For some years, as I have said, I have been in the habit of acknowledging the painting every morning on rising; and when I do this, I say "Thou, O God." I am not attributing divinity to the painting or to the figure, but I am relating to it as the Christians of the Eastern Church have for centuries related to God as they have prayed with icons, something I will discuss in Chapter 12. I can only physically acknowledge the painting itself, of course, when I am at home, where it hangs on the north wall of my bedroom. However, I developed the habit, when away from home, of trying to figure out which direction was north, and then at the day's beginning, to bow in that direction, in recollection of my practice at home. (There is an analogy here with the way Muslims away from home try to figure out the direction of Mecca, and then pray in that direction.) More recently, I have had printed a card bearing a photograph of the painting on the front, with the details of its origin on the back; and this I use as a correspondence card. I now take one of these cards with me when I travel, so that I can connect in a simple way with the painting and its archetypal complex of meanings. In the summer of 2010, at a Jubilee residency, I showed the card, without comment, to my friend Genjo Marinello, a Zen abbot from Seattle. With no prompting whatsoever, and without my telling him anything about the figure in the painting speaking to me, he quietly said, "It's your True Self." This was an acknowledgement of its archetypal character which in an informational sense was not new; but I accepted it gratefully as a statement supportive of my own understanding.

These thoughts about the True Self take me back to a Saturday afternoon in the spring of 1961 when a seminary friend at Mirfield, Martin, and I went to the movies in Leeds. Our only free time all week was the time between

lunch and Compline (8:40 pm) on Saturdays, and so we were restricted in our film choices to whatever might be showing on a Saturday afternoon. This particular afternoon, the only film on view was Disney's "Pinocchio," and so in we went. At the moment in the film when the wooden puppet becomes "a real boy," I burst into tears, suddenly and even violently, tears as much of a surprise to me as they were to Martin, who I think was somewhat alarmed about my mental stability. I filed the experience away, and have only thought of it occasionally in the decades since. I now realize that it was a movement of the spirit which pointed forward to the word I was to receive from the holy man, calling me to be my True Self, a "real boy," a mature man.

<div align="center">★</div>

One day, then, in the spring of 2006, somewhere in the middle of England, during the Big Walk I had decided to undertake to draw a line between my teaching career and my third adulthood (more on this below), I rose, bowed in a northern direction, and said my first prayer of the day, a simple acknowledgement: "Thou, O God." On this particular day, however, I heard for the first time a reply: "Thou, Donald." I know, of course, that I am hearing/saying "Thou, Donald," just as intentionally as I am saying, "Thou, O God"; and as I write this I can hear Jos Solberg snorting a little, and saying "More autosuggestion!" However, on the strength of my first "hearing" of the words—"Thou, Donald"—as something which I was not expecting, and at least did not *consciously* plan to say, I can today say both phrases in turn with a clear conscience.

Which brings me to my hypothesis about who it is who is speaking to me in the painting. I believe it is, as my Zen friend recognized, the voice of the True Self, of the deep self which lies beneath the ego, that deep self or soul which we discover and embrace through meditation and other ways of psychospiritual integration, and which we shape by our actions and decisions; and it was my experience in Assisi which brought me to that thought. It was Francis's own deepest self, I concluded, what Jung calls the capital-S Self, which spoke to him through the figure of Jesus, the True Human Self of God; and he responded in obedience from his surface self, from the ego, the primary executive dimension of the personality, the small-s self.

Similarly, it was my own True Self, my own deepest self, which spoke to me out of the painting, and to which I have attempted to respond in my outer life. Again, it was my own deepest self which pronounced my own name to me—"Thou, Donald" (cf. John 20:16)—in response to my word of acknowledgement in the direction of the painting, "Thou, O God."

Does this mean, then, that Jesus did *not* speak to Francis? I certainly don't want to say this. If anyone asks me if I believe Jesus spoke to Francis, I will say that of course he did, understanding this as a first-naïveté question to which a simple first-naïveté answer is the appropriate one. I mean it for myself, however, in a second-naïveté or mystical sense. In other words, in Francis's archetypal encounter with the Jesus of San Damiano, his True Self—the organ or vehicle of our participation in the divine nature (cf. 2 Peter 1:4)—was speaking to him *and* God was speaking to him, speaking as our "other and True Self," as Merton says.

Another way of saying this. *God speaks to us in the soul and through the soul.* So when the figure in my painting speaks to me (and of course I still sometimes wonder if he will speak again, even hope that he will), it is my own deep self which speaks to me; and to that extent I am indeed talking to myself; *and* it is God who is speaking to me, because it is God who speaks to us in and through our own deepest selves, as St. Augustine, Thomas Merton and others affirm.

"Thou, O God."

"Thou, Donald."

And so, beyond even Martin Buber's "I-thou" paradigm, my relationship with God can be framed as "Thou-Thou," an expression of divine and mutual indwelling: I in God, God in me. I can also tilt in the manner of Zen to the consideration that what I have heard both is and is not the voice of God.

I was once flatly asked the question, "Do you love God?"—and found it hard to respond to it the way it was so starkly asked. I now see that the way the question was asked implied a view of God as primarily outside the self. Were I to be asked the question again, I would now respond, "Yes: and my love of God and God's love of me are one reality," God in me and I in God. I see a parallel here to the oft-quoted line from non-dual teacher Meister Eckhart (c. 1260 – c. 1328): "The eye with which I see God is the same eye with which God sees me. My eye and God's eye are one eye, and

one sight, and one knowledge, and one love." The parallel is: the voice with which God speaks to me is the voice with which my inner self speaks to my outer self, True Self/God to ego.

Thank you, St Francis. Thank you, Carl Jung. Thank you, Genjo. Thank you, Richard Rohr.

CHAPTER TEN

THE PAINTING AND
MY PARENTS

When my parents brought me home from the Vancouver General Hospital, where I was born, they brought me to their apartment at 3335 Sophia Street, about three blocks from where I now live. My mother often mentioned that address over the years; but it was not until the time of my undergraduate education that I learned that *sophia* is the Greek word for wisdom. It is also the word used in the Hebrew Bible's Greek version, the Septuagint, for what in Hebrew is called *Hokmah*, sometimes understood as the feminine face of God, which is also called, in the rabbinic tradition, *Shekinah*. So I was brought home from the hospital to Wisdom Street! And have I lived up to the name of that street ever since? Sometimes yes, sometimes no. The name of my birth-street continues to challenge me. (Rabbi Dr Laura Duhan Kaplan, now teaching Jewish Studies at the Vancouver School of Theology, and who currently lives on that street, riffs on the same idea when she calls her blog sophiastreet.com.)

A childhood memory that remains vivid for me. I remember standing in the kitchen with my mother, aged five or six, and asking her this question: "I know what mommies are for—what are daddies for?" This was not a biological question—that came later. Some context: my father was "away at the war" between the time I was three and the time I was six. So it was at a time of my father's absence that I wondered what in fact daddies were for.

Robert Bly, in *Iron John*, tells the story of a boy with golden hair—a golden-haired boy. That boy I was, at least in my mother's eyes. She loved and admired me more than, I now believe, was healthy. I was the prince, the carrier of the family name—important to the family if my father didn't come home from the war. This recognition of my princely status takes me to a curious moment when I was ten. We had moved the previous summer to our new home on 39th Avenue in the Dunbar neighborhood, and I had started at a new school, Kerrisdale School, in Grade Six. In those stable times, the kids in my class, I discovered, had mostly been together in the same class since Grade One. The class was a very tight one, and I was very much the outsider—until one day in class, in the early stages of the flu, I vomited on the classroom floor. Not long afterward, I beat the teacher in a spelling bee—the word I gave her, really quite a simple word if you sound it out, was antidisestablishmentarianism. On the strength of these two happenings I was given admission to the class in a probationary sense, something fully realized when in December I was invited to Terry Raikes's "mixer"—i.e., a party for both boys and girls, after which I was accepted as a full-fledged member of the class. (I still remember being entranced at that party by Patsy Gopsill, in her blue taffeta dress: the hormones were beginning to do their holy work!)

But between September and December, when I was feeling isolated in the class, I undertook a project which I now see as an exercise in some kind of sympathetic magic, a project which would enable me to break into the class. On the west side of our living room, there was a small room, with windows taking up most of the walls on its three exterior sides, which we called "the sun room." I decided that I would take this as representative of my princely, indeed imperial, self-understanding. I made a sign—I know many children make similar signs—saying "Keep Out!" What few children add to this, however, was "By order, Emperor Theodosius I." I had run across the name Theodosius ("gift of God") in some book, and appropriated it for myself, not troubling myself that there was already a historical personage by that name, or knowing the meaning of the name. A quick google search will tell you that he was Roman emperor from 379 to 395, the last emperor to rule over both halves of the empire, East and West, and the ruler who made Nicene Christianity the official religion of the empire. None of this was germane, of course, to my use of the name. I just wanted a name and title that would

raise me up from the low place which I occupied in my class, and in my own self-esteem, a term which at that time I had not heard. I followed up this self-designation with the invention of an entire planet, which I named Apollonia, the planet of Apollo, god of the sun—I knew that—and of the intellect: I didn't know that. (I thought I had invented the name "Apollonia." Later, teaching at SFU, I met a woman of Italian heritage with that name; and recently I noticed that there is a Greek restaurant in Vancouver by that name. So much for my copyright.) And I was doing all this in the "sun room" of our house. The collective unconscious with its archetypal and mythological contents was manifestly *en plein essor*, as the French say, booming along. (Speaking of Theodosius: he had a brief revival during the 2016 US presidential election. Disgusted by the Republican candidate, with whom I shared a name, I sent out a note on Facebook that for the duration of the campaign I would be changing my name to Theodosius.)

And why was this planet, Apollonia, unknown to scientific astronomy? Ah, because it was the same size as planet Earth, exactly on the opposite side of the sun, and therefore invisible to earthlings as it moved around the sun at the same speed as our own planet. I drew maps of its continents, each of which had its own name; and I divided these continents into kingdoms and grand duchies (I had a special liking for grand duchies, having as a stamp collector encountered the last of the sovereign grand duchies, Luxembourg), appointing my classmates to royal positions in these imaginary jurisdictions. My rationale, I now realize, was something like this. If they knew how I was honoring them by giving them these exalted positions they would welcome me into the class. I made coins with the names and heads (to the best of my very limited artistic ability) of my classmates; of course I knew enough not to show these to anyone. Kids in Grade Six have a very low tolerance for weirdness! After the party in December, I no longer needed the archetypal compensation which my sun-room project had given me in those bleak months of the fall of 1949. So I carefully destroyed all the evidence, and retired Theodosius I from his place on the sun-room door.

<center>★</center>

My sweet father, peace be with him. Where to begin with him? At the beginning, of course. Edward Walter Grayston was born in Vancouver on

July 31, 1913, the second of his mother's five children and the eighth of his father's eleven children. His father's first wife had died of diabetes, leaving three living children, the other three having died, as had their mother, from diabetes—this was long before insulin was medically available, in the early twenties of the last century. His parents were English, and in my perception both as a child and from what family members say, English in that formal way which does not warm the hearts of the non-English. In 1915, his father lost all his money in an economic downturn, had some kind of breakdown in response, and never worked again. Nowadays we would have some understanding and compassion for someone in this situation; but in those days, my grandfather was regarded by my grandmother as "unmanly." To make ends meet, she had to take in boarders, which she found humiliating, although her situation was somewhat relieved when she took in her widowed sister and her sister's four children. Soon after the breakdown, my grandparents had begun sleeping apart, and my grandmother in various other ways communicated to her children that she was contemptuous of her husband. Years later my mother told me that my grandmother had never loved her husband; she had just married him to get off the farm and because she wanted children.

One day when my father was about ten years old, his mother gave him the family's last dime (this is sounding like Jack and the Beanstalk, I recognize, but the story is true), and sent him to the store to buy a quart of milk, then always contained in glass bottles. On the way home, he dropped it, and was afraid to come home, waiting until after dark to do so. I believe that he was strongly marked by this and other money-related incidents; and when he was fifteen, he had to leave school and go to work full-time to help support the family, his older sister Kathleen already having at the age of twelve done the same by "going into service" in a wealthy household. On payday he would hand over his entire pay packet to his mother. He worked in ship chandleries, purveyors of various kinds of supplies for deep sea ships. He enjoyed his work as a ship chandler enormously, right up to the time of his retirement at the age of sixty-four. But there was an underside to this, to which I have already alluded. Already affected by the difficult financial situation of his family of origin, he was traumatized, I am convinced, by his work situation during the Depression. I remember a story about how in those years he and his workmates were told by the boss, Mr. O'Brien, that if

they weren't grateful for what they were being paid, or if they complained about their work, there was a long line of men waiting at the door to take their jobs. I can't remember if Dad told us this story himself, or if my mother repeated it to me; my sister doesn't remember hearing it. This, of course, contributed to his workaholism, and, in the next generation, to mine as well.

He enlisted in the Royal Canadian Air Force in 1942, and during the remaining years of World War II served in Canada, the UK, the Netherlands and Germany, before returning to us in January 1946. I can remember saying years ago to friends that Dad came home from the war, said hello, and then went away again for thirty years. I remember one stretch of time when I was in Grade 10 when I noticed that although he had not gone away, I hadn't seen him for some days. He was leaving for work before I got up for school, and coming home from work after I was asleep. This lasted twenty-one days before I saw him again. To be fair, I don't remember missing him or wanting to spend time with him, or asking him to spend time with me. I was perfectly happy as a younger child staying home and reading, with my mother meeting all my material needs, and then as a teenager, living a full and enjoyable life with my friends.

Writing this memoir has moved me to collect up the few memories I have of "hang out" time with my father. When I was about eleven, I pestered him to take me to a movie—"Kind Hearts and Coronets"—in which Alec Guinness played a dozen roles, including one woman (Lady Agatha Ascoyne D'Ascoyne, as I recall—they all had names like that), characters all of whom were bumped off by the protagonist because they stood between him and his inheritance of a dukedom. At about the same time, he took me to a hockey game and a baseball game, at both of which I experienced painful boredom. Again around that time we spent half an hour in the back yard playing catch: you can tell that I am scraping here for memories. JJ Lee tells a wonderful and painful story about how on the last occasion he saw his father alive, they played catch (*The Measure of a Man*, pp.264-67). He makes the playing of catch into the metaphorical conversation he had never had in the fraught and fractured relationship he had had with his father. Is there something archetypal about playing catch with one's father?

My other great memory is of a fishing trip to the Cariboo country in the interior of British Columbia. There must have been a strike or work stoppage of some kind for him to have enough free time to take me and

a friend there. I remember the names of the two lakes we fished: Loon Lake, and Lac la Hache. The catch limit was twenty-five; and each day we reached that limit *before breakfast*. Every meal during the trip consisted of trout in butter, which in spite of its sameness, meal after meal, was the farthest possible thing from monotony of diet. Recently I have read Richard Wagamese's novel *Medicine Walk*. In that book Wagamese recounts how the very neglectful father of the main character, an indigenous sixteen-year-old boy also in search of the father, in reality already himself a young man, gives him a fishing rod for his birthday.

"You know how to fly-fish?" his father asked.

"No," the kid said.

"Well, ya will by the end of today. There's some big trout where we're goin'. The rig is all set up with line in the reel. All's ya gotta do is learn to throw it out there."

"You know how?"

"Well, I ain't exactly the best fisher but I can toss a fly out, yeah."

"Thanks. "Hey, I figure every kid should fish with his old man" (pp.125-26).

Our fishing trip to the Cariboo is one of the great memories of my childhood; and yes, every boy should fish in some way or other with his old man. At the same time, recording it here, I am sad to think of how few such memories I can pull together. At least I can match it with a fishing trip on which I took my son Jonathan, when he was eleven. It was the summer of 1989, about two weeks after my marital separation, a tender time. I was teaching a two-week summer school course at Iliff, a Methodist seminary in Denver; and on the free weekend between the two teaching weeks, we went to a river near Aspen, and fished. We didn't catch anything. But the shining moment that comes back to me as I think of that trip was Jonathan's comment: "Dad, it's just like that book we read—*Just Me and My Dad*." And yes it was. That book, by Mercer Mayer, tells the story of a furry father who takes his furry son fishing. Didn't catch anything? Who cares? It was prime hang-out time.

Beyond these few precious moments, however, there was not much sense of connection between my father and me, although I always enjoyed meeting the captains from different countries that he would sometimes bring home for dinner. Athletic in his youth, he continued to be interested

in commercial sports, something in which I had absolutely no interest. I did notice, when I was ten or so, that other boys my age wanted to talk about cars and sports. For a while I asked my father to help me identify different kinds of cars; but the point of this knowledge escaped me, and I soon gave it up. Probably this was the first of the moments in which I realized that all boys, all men, are not the same, and that I was in some kind of minority among young males.

My interests, as I got older, were intellectual, religious and political, and in these matters he had little interest. I think I was always something of a mystery to him, although I don't think of him as a mystery to me. I do believe I understand him reasonably well in relation to his family of origin and the effects on him of the historical moment in which he lived the first decades of his life—the unacknowledged and unprocessed breakdown of his parents' marriage, the depression, and the Great War. In writing this memoir, it has become clear to me that, like myself, he was his mother's son. His mother had sent his father into internal exile in the house, and alienated her children from him. As Dad grew, she made him into "the man of the house": and my mother told me that my grandmother in fact resented his getting married and leaving the home where had lived until his wedding day. Certainly the loss of his pay was a major factor in her resentment. He was a dutiful man, dutiful to his mother in the first instance, someone who would have responded to Nelson's dictum at the Battle of Trafalgar that "England expects that every man will do his duty." By the 1940s, Canada had begun to take its place as "our home and native land" beside England in the patriotic feelings of its citizens of British origin; but again my hunch is that it was the English connection that would have been a prime motivator for his enlisting. When he went to England, he met his grandmother, aunts and uncles and many cousins, among them young men of his own age and interests. He had, as some say, a good war.

I think of him now as the classic "absent father" of the post-war generation, men who saw themselves as in the first instance providers rather than mentors or guides. Certainly he would have taken in his mother's contempt for his non-providing father. I think if I had ever tried to discuss this with him, he would have found my perspectives hard to comprehend. He had probably never had what I think of as a real conversation with his own father, whose breakdown occurred when he was only two or three years old; and

I don't think it ever occurred to him that there were conversations that one could have with one's children (or at least with me: my sister was closer to him) in which feelings, relationships, political views or personal aspirations were discussed. What I was looking for from him, and did not receive, was "father" as Robert Bly speaks of it: a kind of spiritual substance, analogous to salt, without which food lacks flavor. "The contemporary mind," he says,

> might want to describe the exchange between father and son as a likening of attitude, a miming, but I think a physical exchange takes place, as if some substance was passing directly to the cells. The son's body—not his mind—receives and the father gives this food at a level far below consciousness. The son does not receive a hands-on healing, but a body-on healing. His cells receive some knowledge of what an adult masculine body is. The younger body learns at what frequency the masculine body vibrates. It begins to grasp the song that adult male cells sing (*Iron John* pp.92-93).

This, sadly, makes a lot of sense to me. It starts with the father rolling around on the floor with his little son, and as the son gets older, hanging out with him in various ways, spending time with him, so that the "father" substance can be almost alchemically transmitted. This is what didn't happen for me. I did try, when he was in his seventies, to start such conversations with him; but I soon stopped, because I came to the conclusion that I was being cruel, in asking from him what he was not so much unwilling as, by that time, unable to give. Robert Bly names this kind of attempt as classic for sons of absent fathers. "Somewhere around forty or forty-five a movement toward the father takes place naturally—a desire to see him more clearly and to draw closer to him" (*Iron John* p.25). In my case it was in my late forties; but the point is still well taken.

A foreshadowing of this impulse occurred at my daughter Rebekah's fourth birthday party, in March 1979, at my aunt Kathleen's house. Not long after the party began, I heard Dad say "Gotta go to a ship." This was a phrase I had heard hundreds of times as I was growing up. If a ship was coming in, it needed to be met by the ship chandler, and Dad would leave whatever he was doing to meet the ship. I have a faint memory that he got

up from Christmas dinner one year to do this—or am I imagining it? It's not impossible that he did that. So when he said those words at Bekah's party, all the resentment I had been unconsciously accumulating about his prioritizing of his work over his family boiled over, and I shouted at him that he was *not* going to go to the ship, that he was going to stay at his granddaughter's birthday party as he never had at my birthday parties. I was furious; Auntie Kay told me to control myself. "I will not control myself!" I shouted back and banged on the wall. Dad said nothing; and after a few minutes, when I went into the kitchen to cool down, he slipped away to the ship. Doing the math as I write, I now realize that I was thirty-nine—another of those "nine-end" years when life intensifies. We never talked about this, just as we never talked about another emblematic incident. In 1989, very soon after my fiftieth birthday, my father was in the hospital with pneumonia. One day I was visiting him when, out of the blue, he asked me, "Donald, how old are you?" I went on red alert. If I had been 46 or 54, this question might have been an innocent one; but people remember round numbers. "Fifty, Dad—I thought you might have remembered that." "Well, if you are fifty, why don't you have a house, or a car or some decent clothes?" (Ouch: decent clothes!) "Dad, you'll be home soon, and let's talk about it then"—but we never did. I didn't initiate the conversation, nor did he—an opportunity missed. But the subtext of his question is obvious: why don't you have the same normal male goals that I have had?

I've asked myself how this came about. Why did I find it easier to talk with women than with men? (I quickly affirm here, *bien sur*, that not all women are the same any more than all men are the same.) It came to me suddenly about fifteen years ago that the probable origin of this was the entirely female household in which I spent my first formative years. When Dad went to the war, my mother and sister and I moved in with my grandparents, who lived in a large apartment in Vancouver's West End. My grandfather died very soon after; and so I found myself the only male in the household, its other members being my mother and sister, my grandmother, my great-aunt (my grandmother's sister) and my aunt (my mother's sister)—five females and one little boy. I was, *de facto*, the prince, in a society in which the patriarchal tradition was unquestioned, the only likely bearer of the family name.

The child is father of the teen, to misquote Wordsworth: and when I was thirteen my mother got very concerned about the fact that I read all the time and didn't have any close friends. (There was one kid who lived around the corner who would call me to play if he absolutely couldn't find anyone else; without him saying so, this was very clear to me. But I swallowed my pride, because I liked going to his place to play Monopoly—I didn't have a set and he did.) My mother had heard about Camp Artaban, the camp of the Anglican diocese, and signed me up for a two-week session at senior boys (ages 13-16). As was my practice, I took a stack of books with me, instantly thereby identifying myself to my hut-mates as weird. At thirteen, I was one of the youngest boys there, and was unmercifully bullied by my fellow Christians, chiefly those in my own hut. Day after day at bedtime I found various offerings in my sleeping bag: lemon halves saved from the lemonade at noon; slugs from the forest; other slugs, cut in pieces; and on one occasion a live snake, held inside my sleeping bag by rocks carefully placed around its edges. I didn't react to any of this: I now realize that reaction is what they wanted and were waiting for. The low point of this misery came the day that they woke me up before the wake-up call, and carried me down to the swimming tank in my under-shorts with crabs on my stomach, one of my hut-mates having thoughtfully gone down early to the beach to bring the crabs back for this well-planned scenario. When we got to the swimming tank, they threw me in, but not far enough. I came down right beside the mussel-encrusted float, and received mussel-shell cuts all down the left hand side of my body.

As I crawled back to the hut, thoughts such as "I am doomed," or "they won't stop until they kill me!" ran across my consciousness. However, not wanting to die, I searched my mental files for a strategy for survival—and from the wisdom of the ages, it came to me: if you can't beat'em, join'em. I was saved! I put aside the stack of books I had brought up with me, and hurled myself into athletic activity. I took the word conformity to a new, deep, personal, performative, urgent, committed and indeed life-saving level; and when I did, my tormentors instantly lost all interest in me. At the end of camp—I mention this not to boast, but to provide evidence of the effectiveness of my strategy—I received the award for most improved camper, or some such designation. I note here that all of my being bullied took place under the radar of the camp staff, a thought sobering to me some

years later when I was on camp staff myself. Then many years later still, perhaps 2003 or so, I read an article in *The Globe and Mail* by restaurant critic Joanne Kates, who in the summer runs or ran a children's camp in Algonquin Park, in Ontario. In this article she asserts that every first-time kid at camp comes with an existential question: can I survive without my parents? Lights flashed and bells rang for me as I read this article. At Camp Artaban, aged thirteen, I had found my own way to give an affirmative response to that question. In its own way, my time there was a rite of passage.

Meanwhile, together with all the other campers, I was going, twice a day, to chapel. This consisted of the quasi-monastic offices of Morning and Evening Prayer from the old *Book of Common Prayer*. The 120 campers sat on the plank pews of the outdoor chapel, respectful, silent, backs straight, uncomplaining—this was 1953, I should mention—as the prayer wheel turned, morning and evening. Did the chaplain attempt to make the offices "interesting" or "relevant to young people"? No. This was a time when young people were expected and themselves expected to be much as their elders when they were older. The generation gap, advertising-fuelled rock-and-roll-stimulated and consumerist, had not yet appeared, although there were cracks in the cultural infrastructure which presaged its appearance in all its seductive and destructive power.

Morning and Evening Prayer, then: each office of prayer included two chapters of the Bible, one from the Hebrew Bible/Old Testament, the other from the New Testament, a total of fifty-six chapters of the Bible during the fourteen days of camp. This was the most substantial exposure to the Bible that I had ever experienced. Up to this point, my attendance at Sunday School had been spotty, and my attendance at church almost nil. I had encountered Moses in the bulrushes three or four times, and perhaps the feeding of the five thousand once or twice—and oh yes, Noah and the Ark; but the rest of the Bible was unfamiliar to me.

In the two weeks I was at camp, however, this changed. Perhaps it was the second to last day of camp: I was in chapel, and a scripture lesson was being read. Suddenly a rectangle appeared before my eyes (I was wide awake: perhaps I should say the eyes of my imagination, or my inner eyes, or, why not, my third eye). Not at thirteen knowing the Chomskian term "deep structure," I nonetheless intuited that this rectangle was a framework

for what I am ready today to call the deep structure of the Bible. See if you can visualize it: the top line of the rectangle I called "Creation"; the right-hand vertical line, "Fall"; the lower horizontal line "Redemption"; and the left-hand vertical line, "Consummation," with the energy starting at the top left-hand corner, and moving to the right around the rectangle until it returned to its starting-point. Of course it was only later that these thoughts came to me. In the moment, I thought of it more graphically: God created everything; we screwed it up; Jesus came to put it right; and God will wrap it all up at the end of history. I still think this is a reasonable summary of what the biblical theologians call *heilsgeschichte*: salvation-history, the essential mythos or base-narrative of the Bible, although I recognize that many other paradigms are possible, and indeed a developmental view of scripture is necessarily combined with any of these paradigms.

As I continued to look at the rectangle, suddenly its interior was filled in with the Mercator map of the world (with Canada very big at the top: I had always liked that). Yes, I get it: the biblical narrative connects with *everything in the world*. There is nothing in the world which does not have something to do with God. Then it changed again. The rectangle was now the frame of a jigsaw puzzle, and in my hand was a clear plastic bag, in which I could see a great many jigsaw puzzle pieces. Once again, the image did its work. The frame, I knew, represented my life up to that point, its empty centre my potentiality, my future (cf. what I said about the scroll). Each as-yet-unplaced puzzle piece represented a specific experience (e.g., my writing of this book, and, unknown to me, your reading of it) within that future. As I lived each experience, I would, in effect, place a puzzle piece in its place inside the frame. Then, I knew, the day would come when I would look in the bag, see that it was empty, look back at the puzzle and see that only one space remained for a piece to be put in place, in the very centre. This was my death, and God had kept that piece for himself, since the timing of anyone's death is God's responsibility—or has been, until the recent authorization of physician-assisted death. When the time came, God would put that final piece in its place, and I would be, as it were, complete; and my life, no longer a puzzle to me or anyone else, would come to an end.

<p style="text-align:center">★</p>

On reflection, after MAID (Medical Assistance In Dying) became legal in Canada I felt the need to revisit the meaning of the last piece in the puzzle. If I or anyone else were to decide to take advantage of MAID, would we not be usurping God's role, God's task, God's prerogative? Thinking this through, I realized that my idea of God when I was thirteen and had the epiphany was of a God "out there," essentially transcendent. My concept of God now is one which is co-inherent: I am in God and God is in me, just as I am in the world and the world is in me. Or, as the old poem says, "God has no hands but our hands, to do [God's] work today" On this basis, and if God is part of my decision-making, and I decide to take advantage of MAID, there is no contradiction between the two views. God has entrusted us with the power of decision-making. When the True Self acts, God acts. So no: we are not usurping the divine prerogative if we choose to die in this way (something I have not decided to do).

★

Back to my epiphanies. When many years later I shared the story of the rectangles with an architect friend, also a spiritual seeker, he told me that in architectural theory, the rectangles as I described them represented what the Greeks called the Golden Mean, a form seen as perfectly balanced and pleasing to the eye. What the internet tells us about this mathematically is beyond me; but in a general sense, I take it that the mean represents a relation of two to three, which is why so many national flags show this proportion in their dimensions. Another parallel is found in the Kabbalistic tradition of Judaism. In the *Zohar*, the classic text of Jewish mysticism, there is a description of an Israelite wilderness camp in which the twelve tribes are organized into four groups which form a rectangle around the *mishkan*, the tabernacle or "dwelling place" for the Ark of the Covenant (cf. Exodus 25) which contained the tablets of the Ten Commandments (cf. Exodus 20) and a pot of the manna (cf. Exodus 16) which sustained the Israelites at a certain point in their wilderness sojourn. In a blogpost of May 23, 2015 (sophiastreet.com), Rabbi Dr Laura Kaplan comments on this as follows.

We might ask: why a rectangle, a four-sided figure? Why not a 12-sided dodecagon, with a section for each of the twelve

tribes? Or a circle with no sides, expressing national unity? Because, says the *Zohar*, numbers link worlds. In the Israelite camp, the number four shapes the traffic flow of daily life. And the flow of daily life points us to the flow of divine life.

In the *Zohar*'s view, the division into four camps is not a matter of convenience, not a clever system for keeping track of troops. Instead, it expresses a deep structure of the universe. And it gives humans insight into divinity.

So there we are: "deep structure" again of a four-fold kind, or what Jung would call a certain kind of mandala. When I saw the three rectangles, the collective unconscious was offering to my consciousness an archetypal form, something which presaged my recognition of the personal archetypes in my great painting.

I didn't share these visions—epiphanies would be a better word—with anyone for years—I was already weird enough for my friends. But, like Mary, I did ponder them in my heart (cf. Luke 2:19). At the same time, I found these images inspiring; *and* I was sure that if I told any of my friends—for after my time of socialization at camp, I quickly acquired dozens: my mother's socialization plan had worked—they would say I was crazy. I later realized that I had been given or, had put together for myself, a *weltanschauung*, a worldview, which was in fact a classical Christian worldview. I don't deny that if my mother had sent me to Communist camp or Buddhist camp something similar would have occurred. My adolescent mind was expanding, and I was ready to take on and start living out of a coherent and all-embracing worldview.

The chaplain who conducted the chapel services was of course a priest, as was the camp director: two very friendly and pleasant men addressed as "Father," not a title I had previously encountered in the very Protestant Anglicanism of my earlier years. Never having had any difficulty conversing with adults, I had a number of conversations with them, and found them responsive and, apparently, interested in me as a person. Later that summer, I returned to the camp as a leader for junior boys ages 8-12 (what were they thinking? I was only a year older than the twelve-year-olds in that camp), and met its director, Ian Dingwall, peace be with him. He was nineteen, and planning to be ordained. Having realized that you could

do this deep structure stuff, alias Christianity, for a living, I asked him if he thought I could be a priest. His reply was something less than wildly affirmative ("Sure—why not?"), but it was all I needed, i.e., he didn't say no. Later I would realize that this is true for many if not most teenagers, impressionable as they are: one positive word or negative word can turn them decisively in one direction or another.

Another important moment at camp requires a mention. It was at a senior boys' camp the following year; the time of day, after lunch. I was standing in the horseshoe with other boys, not far from where the chaplain (the priest with whom I would work immediately after my ordination) was talking with one of my confrères. I wasn't exactly eavesdropping, but I was close enough to them to hear the priest say, "No, Adam and Eve are not historical figures; they are symbolic or mythological figures representing the beginnings of humanity." Hearing this, I had a brief attack of vertigo, and I had to sit down on the step of the nearest hut. Through my mind raced the thought, "Then the Bible isn't true." I decided to talk to the chaplain about this; and very quickly it became clear to me that the Bible contained many genres: myth, history, poetry, parables, letters and so on. This was the moment, then, in which my understanding of scripture moved from the literal—i.e., the fundamentalist—to the critical, in which reason can ask any question of scripture which it wants to ask. It would be some years before I would find myself moving on to the personal or mystical reading of scripture, a way of reading which does not reject the critical or rational, but which includes and transcends it. This conversation was my introduction to biblical literacy, and the first instalment of my theological education.

So camp launched me on the path that a little more than ten years later saw me kneeling in front of the bishop at my ordination, on September 8, 1963, the feast of the Nativity of the Blessed Virgin Mary, at St Mary's Church in Kerrisdale, Vancouver, the same church in which I had been baptized in 1939.

★

Now we come to the place where the archetypes leap into action, the moment which justifies my including these stories in this chapter about my parents. It was when I read the gospel story of the prodigal son that

Sunday in church some thirty-five years later that the connection between my decision at fourteen to be a priest and my expression of gratitude to God that I had lived long enough to become the prodigal son became clear to me. I realized then that when I decided to be ordained *I had opened myself psychically to the archetype of the Father.* In a normal developmental sequence, a male is first a son, prodigal or otherwise; then, if so be, a father. But I had somehow reversed that order psychically, turned it backwards. In the way I had decided to be a priest, an archetypal occupation if ever there was one, and of course I acknowledge that there are other less psychically fraught ways of doing so, I had unconsciously and prematurely become (as in the parable), the loving father, years before reaching the age when young men (and young women, for that matter) exercise their prodigality. I was only fourteen years old, but interiorly, I was the loving father, a boy priest; and one who had given very little of his attention or energy to the ways in which other boys of his age and time lived out their boyhood.

I can only think that this had a strong inhibitory effect on my psychological development. "A man may . . . pursue spirituality too early in his life," says Robert Bly (*Iron John* p.102), and this to some extent was true of me. About fifteen years ago, I found myself one afternoon walking on the sidewalk twenty metres behind three boys of perhaps eleven or twelve, just released from school. As they walked, they bumped into each other and casually hit each other in a non-hostile way. I confess to a pang of regret as I watched their easy sense of physical connection, regretting that I had missed out on what their body language represented. It wasn't until I had the moment of truth in church, with the parable of the prodigal son, that, at forty-nine, I could see myself *again for the first time* as the son, a psychic role which had not been sufficiently nourished when I was a child. I yearned to hear from a father-figure, if not my own father, the beautiful words that the father in the parable says, not to the prodigal son, but to the dutiful elder brother: "Son, you are always with me, and all that is mine is yours" (Luke 15:31), a word to which when I hear it in church I have often responded with tears. Another biblical word is equally powerful—the word of God to Jesus on the day of his baptism: "You are my Son, the Beloved: with you I am well pleased" (Mark 1:11). I find it important to note that Jesus hears this word *before* the time of his public ministry. He has *done* nothing specific to warrant this word from God—no teaching, no miracles: God is

"pleased" with him because of who he is, not because of anything he has done. Samuel Osherson, in his *Finding Our Fathers,* tells of a book of poetry written by men in which in one poem the poet says that he is "still waiting for you [his father] to say my son, the beloved son" (p.21). I hungered, without being able to name it, to hear this from my father, but never did. I hungered for Robert Bly's alchemical father-substance, for fathering, for *being fathered.* Gail Sheehy, somewhere in *Understanding Men's Passages,* asks men to ask themselves what cues they got from their fathers about how to be a man. Alas, in my case, very few. Save 10% of your income. Always take the second newspaper from the pile, not the top one, which may have been thumbed through and put back. Arrive fifteen minutes early for any appointment. All good ideas, but not enough for mature masculinity. Samuel Osherson confirms this: "most men know little of their fathers' inner lives, what they thought and felt as men" (p.20).

So let me try to pull together the factors that brought about what I have described as my dislocation of the archetypal life phases: the substantial absence of my father from my life; meeting some kind men called "Father" at camp; acquiring a Christian worldview; and deciding to become an authorized proponent of this worldview, a priest, a vocation in my church in those days, not incidentally, restricted to men. In the absence of my father, I had become at fourteen, archetypally and interiorly, my own father—not at that age a good idea. However, after the end of the marriage, I acknowl-edged that I was in a position—*for the first time*—to welcome consciously in myself the presence of the father archetype at an age-appropriate time. I told myself that I felt ready *for the first time* to be a son, to be a father, to be a partner, to be a priest. I even concluded that if I were to die in the immediate future, that I could do so without major regret, having once again found my right place in the developmental journey, having come home to myself (cf. Luke 15:17).

I hope now that the meaning of my wife's question to me about the letter from the bishop will be clear: "Why are you trying to force the bishop to be your father?" In the Anglican tradition, the bishop, at certain liturgical moments, is addressed, significantly, as "Father-in-God." But it was only in January 2010, when I was at Malahat Park, on Vancouver Island, a beautiful retreat house presided over by Jane Shapley, retired United Church minister

and Jubilee alum, a place to which for many years I went on retreat for the inside of a week, that I realized how profoundly the painting and my father are linked. I had brought with me the card of the painting, and had put it on the mantelpiece of the living room of the retreat house. Glancing at it casually one day as I passed the fireplace, suddenly it clicked: it *is* my father after all! The friends who had asked about the figure in the painting the question "Is it your father?" had spoken more truly than they knew, and more insightfully than I had been ready or able to acknowledge. One of the many archetypes which the holy man carries is manifestly that of the Father; and it took me until I was seventy to see what my friends had seen years before. It was that recognition, in fact, that told me that it was time for me to write this book. In effect, I saw my father's face in the face of the holy man.

<div align="center">★</div>

I know I would have benefited at various moments in my journey from an opportunity to connect with other men at a deep level, and to reflect with them on the meaning of the life stages. Recently, a friend of mine, Scott Swanson, a United Church minister, spiritual director and Jubilee alum, has launched a program he calls Manifest (manifestonline.org). Here is how he describes the mission of this program.

> Our mission is to shape better men for a better world. Our vision is for a society in which more men are engaged in doing their own soul work and participating in their own healing. More self-aware and emotionally available to themselves and others, such men will be better capable of navigating an increasingly complex world and less likely to let their own woundedness slip out in the form of violence toward women, other men, the planet, and themselves. These men will be in better positions to act generatively and to perform the much-needed functions of elders. Critically, they will be better equipped to become elders who teach boys—their children and grandchildren— how to be better men themselves.

He is absolutely correct when he says that we live

> in a time that is increasingly difficult for boys and men. Men
> are still socialized to be providers for our families and it is
> increasingly difficult for most of them to do that. Many of us
> have not received what we needed from the generations ahead
> of us in order to navigate manhood and the world as well. It's
> not the previous generations' fault—they often didn't receive
> it from their fathers either and so didn't have it to give to us.

I resonate very strongly with this. My father did not receive what he needed from his father, and so didn't have it to give to me. I was shortchanged by my father, as he had been by his father—and how far back does that go, I wonder. Scott Swanson's comment about men as providers is also very significant. How many young men have thought to themselves that they may never, in our skewed economic culture, be able to buy a house or in other ways provide for a family? Thoughts of this kind can lead to hopelessness and drift.

Perhaps the most significant statement on his website is what he says about rites of passage. Alone in the history of the planet, we live in a culture that has no society-wide rite of passage. Teaching at Simon Fraser University, I regularly encountered in my classes adolescent men in their twenties, thirties, even forties. The paradigm that came to me then was this: boys, guys, men. All boys become guys, but not all guys become men in the sense in which Scott Swanson would use the world. He characterizes this as "the ambiguous passage from adolescence into adulthood." Women are ahead of men here, given that the beginning of menstruation tells a girl in the very fabric of her body that she has passed into a new phase of womanhood. Religious rites such as Bar or Bat Mitzvah or Confirmation have meaning only within their own religious communities (although Confirmation is almost dead in many of the mainline churches in Canada), and not in the culture in general. This being so, young folk create their own rites of passage: first smoke, first sex, first getting drunk, first use of drugs, getting a driver's license, graduating from high school—some of which are clearly more creative than others. Some years ago I discussed this with a First Nations woman, now an Anglican priest. Her comment was that with the

collapse of traditional rites of passage in the First Nations communities, their young folk were very often creating their own rites of passage through violence. I can only see a way forward in this regard through intentional groups such as Manifest or Illuman, the program begun by Richard Rohr (illuman.org). When enough men have experienced themselves consciously as having passed from guyhood into manhood, adolescence into adulthood, I would hope for a ripple effect that would benefit our entire society, however long this may take. The development of these rites of passage stands out as a major challenge to anyone concerned about men's issues, and I applaud Scott Swanson and his colleagues who have taken on this challenge. He also highlights the "passage from career-focused adulthood into the senior years." There is a big difference between old people and elders in the true sense. In the next chapter I share what has come to me in my reflections about "the beautiful old men," every one of them a true elder.

<div align="center">★</div>

A concluding word about my father. He retired at the age of sixty-four, but regularly worked part-time after that for other ship chandlers. Not long after he retired, he was diagnosed with myeloproliferative blood disorder, a form of leukemia, with which he lived uncomplainingly for fourteen years. I never found (or made) the occasion to tell him about what this book narrates; and he died May 15, 1992, two months before his seventy-ninth birthday, the age at which his own father had died. Our relationship was in its final years affectionate and inarticulate; but even as inarticulate, it was light-years beyond his very formal relationship with his father—he addressed his father as "Sir." We did, in fact, the night before the hip operation from which he never fully recovered manage to tell each other that we loved each other. In writing this book, I have tried to build on this, and do what Osherson calls "naming the father."

> Until a man "names his father," sees him clearly, and accepts
> him for who he is and was, it is that much more difficult for
> him to grow up himself and become a father to his children,
> a husband to a wife, or a mentor to the younger generation

. . . . That is every man's task of healing the wounded father within (*Finding Our Fathers* p.51).

This writing has been another part of this process, a way of letting go of any residual anger, of accepting that my father was who he was, even that in his way of being a father he was doing his best. So I have come to peace over the unrealized character of our relationship; and I am glad to say that it is with a peaceful and indeed grateful heart as I write these words that I can say, peace be with him—or, better, peace be with both of us.

<div align="center">★</div>

My mother, then: Marion Houston Macdonald Grayston, peace be with her as well. She was born in Vancouver on November 21, 1912; so she was eight months older than my father. She was the middle child in her family, the third of five, with two older brothers and a younger sister and brother. She was sickly as an infant and small child: but this didn't prevent her from living until she was ninety-two. Her parents, William Livingstone Macdonald (a Presbyterian at his birth, his middle name coming from the famous missionary) and Helen Marion Houston were born in Ontario, married in Winnipeg in 1905 and came to Vancouver in 1910.

Like my father, my mother had to leave school at the age of fourteen to go to work to help support her family. She worked as a secretary—in those days secretaries who typed were called stenographers—until shortly before I was born in 1939, when she was twenty-six. My parents married in 1935—and, something different from today's pre-marital patterns, they both lived at home until the day of the wedding. (I can always quickly figure out how old the Dalai Lama is, because he was born the same day as my parents' wedding—July 6, 1935.) Once I arrived, her work became home management and child care; my amazing sister, Helen, joined us in 1943.

I've already mentioned that a large portion of my earliest and thereby formative years were spent as the only male in a five-female household. This resulted, as I realized in my fifties, that I had had a feminine formation, rather than a masculine one, or even a balanced one. "If the son learns feeling primarily from the mother," says Robert Bly, "then he will probably see his own masculinity from the feminine point of view as well" (*Iron John*

p.25); or, as Samuel Osherson says, men "learn about their fathers through their mothers" (*Finding Our Fathers* p.37)—as I did and as my father had. By the time my father returned from the war, in January of 1946, the family routines and perspectives had been well-established by my mother, and my father, acknowledging this, moved uncomplainingly into a secondary parental role. It never occurred to me, all the time I was at home (until not quite twenty-one), to challenge my mother's authority in the family. I had incorporated so many of her interpersonal perspectives, as had my sister, that our family life was almost entirely peaceful. I should say, though, that when I was in my early teens, my mother involved my sister and me in a tacit contract in regard to my father. "I wish your father would take me out more," she would often say. This moved us, loyal children, to lean on Dad. "Dad! Take Mom out dancing or something. She doesn't want to stay home all the time." I don't recall that this had any particular effect on Dad, who was, to be frank, more wedded to his job than he was to Mom.

I come now to perhaps the most painful recognition in my story, more painful even than the account of the end of my marriage. Brought up by my mother, with minimal influence from my father or any other father-figure, I ingested, as I have said, her feminine perspectives on masculinity, which she gave to me entirely unconsciously. I grew into what Bly calls "the soft male" (*Iron John* p.2). And who is the soft male? According to Bly, he is a kind and valuable person, more thoughtful and gentle than most of the men of the previous generation. At the same time, he lacks vitality of a virile kind. Although this manifested itself notably in the sixties and since, it is not a new phenomenon. "My brother Esau is a hairy man," says the Israelite patriarch Jacob, a comment from some 3800 years ago, "and I am a smooth man" (Genesis 27:11). (In Bly's book, Iron John is a hairy man.) In contemporary terms: my brother Esau is a strong male and I am a soft male—which is why Jacob, according to the story, had to resort to deception rather than physical or psychic strength to get his own way. I have a friend who told me once that she was looking for a husband with "bite." I didn't have to ask her what she meant. The soft male, like Jacob, lacks "bite." He lacks the ability to be fierce when fierceness is needed—non-dominating fierceness, but fierceness nonetheless: as Bly says, "In every relationship something *fierce* is needed once in a while" (*Iron John* p.4). And here is another comment from Bly. The soft male, he says,

is often more in touch with women's pain than with his own, and he will offer to carry a woman's pain before he checks in with his own heart to see if this labor is proper in the situation. . . . I don't mean that men shouldn't listen. But hearing a woman's pain and carrying it are two different things (*Iron John* p.64).

I am not blaming my mother for how she brought me up: blaming is pointless. She did the best she could according to her lights. But her upbringing of me was in the last analysis less than I needed to be a whole man.

The day I turned twenty-one, I was on a Norwegian ship sailing from BC to the UK. My father had obtained free passage for me on one of the ships that he serviced. At breakfast on my birthday, I went to the dining room feeling sorry for myself, thinking of the party that I would have had had I been at home. No-one on the ship, I reflected, would know it was my birthday, and I didn't plan to tell anyone. But when I sat down at my place, the steward brought a box, placed it in front of me, and said, "Happy birthday." "How did you know?" "Your mother told me, and gave me this box to give to you." So what was in the box? The *pièce de résistance* was my favourite cake—pineapple Christmas cake. And there was also a flat box, containing a birthday card which cost, I noted from the back, a whole dollar (!). I opened the box, and out fell two long pieces of green material, perhaps three inches wide, perhaps thirty inches long, pointed at one end, sewn in a flat seam at the other end. What were they? I had no idea. I held them up, waved them around, lay them down—and then it hit: they were my mother's apron-strings. Years later I asked her where she got the idea: it wasn't in character for her to do something so symbolic. "From an article in *The Reader's Digest*," she told me.

I give her a lot of credit for this. She recognized that at twenty-one I needed to cut my mother's apron-strings and take responsibility for myself. However, although the symbolic gesture was well-intentioned, it didn't come with a lot of commitment to its meaning, as I was to discover. In the *Iron John* story, the parallel to such a moment is found in what the Wild Man, Iron John himself, tells the boy-protagonist. If he wants to take possession of his own soul, represented by the golden ball that has rolled into Iron John's cage, and which he will not give the boy until the boy obtains the

key to the cage and frees him, he must obtain the key to the cage, which is under his mother's pillow. In giving me her apron-strings, my mother, in effect, was *giving* me the key, but it had an elastic cord attached to it, and it quickly snapped back under her pillow. Bly tells us that it is important to distinguish between the conscious mother and the unconscious mother. In his terms, my mother was unconscious; and so it was unconsciously that she had attached the elastic cord to the key. But the story tells us that in any case the boy cannot receive the key directly from his mother or even ask her for it: he has to steal it, and if he doesn't, he isn't ready to have it.

The next moment of truth with my mother came when I was thirty. I had been working hard at Sorrento Centre all fall; and when I came to Vancouver with my wife to spend the Christmas holiday with my parents, I was very tired. My mother had arranged some tea-dates for herself and me with some female relatives, to which I declined to go. I told her that I was tired, and needed to rest; and if these dear women wanted to see me, they could come to see me at my parents' place. I could see she was upset by this, but she didn't say anything. I went back to Sorrento after Christmas, and the day after my return, my mother phoned me. I should mention here that long-distance phone calls were not common in those days, being far more expensive then than they are now, and this one lasted for forty-five minutes. My mother wanted to know why I had changed, why I was being, in her view, uncooperative. Did it have something to do with my wife? No, it didn't. What I had told her was the flat truth: I was tired, and I wanted to rest and relax. The conversation ended without a meeting of minds. This was a moment when I made a kind of grab for the key; but again, it whistled back under her pillow.

Looking back, I now see that the moment when, aged forty-nine, I finally did what I needed to do to move out of my soft-male identity, i.e., to steal the key under the pillow once and for all, was when I entered into the relationship with my lover. In doing that, I was doing something of which I knew my mother would not approve. So did I tell her (or my father) about this? No: let's give people information on a need-to-know basis. They didn't need to know about it, and I didn't need to tell them. But I now know that in initiating the relationship with my lover, I had finally stolen the key from under her pillow. Again there was a shift, which she noticed. As I moved into my fifties, I now felt free to say yes to her, not automatically, but in

a way which balanced her needs and mine, meaning that from time to time I would also say no. Again she asked me why I had changed. "Why have you become harsh?" she asked. By this she meant, "Why do you not do exactly what I ask you to do every time?" I realize now that this presaged my choice, a dozen years later, of the most important thing (for me) that Jesus ever said, his word in Matthew 5:37 about yes and no.

In "stealing the key," then, I had moved from being the soft male to being, not a hard male, but the strong male. This was the moment when the reason why I had bought the painting leapt into reality, although I was not able to articulate it until my very recent re-reading of *Iron John*. If I look at the face of the holy man now, what I see is not the soft male, nor the hard male, but the strong male. There is no doubt that the holy man is in possession of his own soul. So now we come to a major reason why I had to buy the painting. The holy man, who later was to tell me that he was the image of my True Self, was calling to me in the first moment of my seeing him to transcend my soft-male identity and to become, as he is, the strong male. When I use the phrase "strong male," let the reader understand that I am not claiming some kind of absolute strength, psychic or otherwise. I *am* saying that I have moved along the masculine spectrum from the soft-male end toward the strong-male end, recognizing that I have "promises to keep, and miles to go before I sleep" (Robert Frost, "Stopping by woods on a snowy evening") as I explore the many dimensions of strong-male identity.

A moment of truth in this context came about a week before the day in July 1989 on which I separated both from my wife and my lover. My lover's previous *inamorato* (I'll call him Bill: interestingly, like myself, an Anglican priest of comparable age and interests: was there a pattern there?) had come to town, and she had slept with him. When she told me this, I was still in soft-male mode, and empathetic beyond reason, found myself unable to be angry with her. Yet this would seem to be a moment, if ever there was one, when the fierceness of which Bly speaks was needed. Ought I not to have told her that I was offended and unhappy and demanded an apology? I didn't. I never will now, of course: but I am glad to have been given the opportunity by Bly to get a handle on this significant moment. But there's more. I wasn't able to be fierce, but I still wanted something of an explanation. I said to her, "All this past year, have I just been a substitute for Bill?" "No," she replied: "you were both substitutes for God." Hmm:

perhaps fierceness, if it had deflected this question and its amazing reply, would not have been the right response after all.

<p style="text-align:center">★</p>

My father died on May 15, 1992, and my mother on March 1, 2004. I am convinced that if I had said to her after Dad died, "Mom, you're on your own, and so am I: why don't we live together and save a few bucks?," she would have cheerfully agreed, with no sense that we were living very different lives. So of course I didn't; and she did beautifully, on her own without my father, continuing in her young-at-heart way to make new friends into her nineties, many from her hospital stays, and sustained by my sister's loving care and attention. "Your mother," said one friend, "is a trip"—and so she was. Peace be with us both.

<p style="text-align:center">★</p>

Early in 2016, a friend invited me to a workshop on "green burial"—the increasingly popular practice in which nothing non-biodegradable is put into the ground at the time of a funeral. This led to me speaking to the manager of Mountain View Cemetery here in Vancouver, where my parents are buried. The manager checked on the status of my father's grave, and told me that if I wished to have a green burial, there would be room for me in my father's grave; and this I have decided to do. And my father was buried in *his* father's grave! So there we will be, three generations of Grayston men, at peace in the earth and with one another—in a very symbolic way, the end of my "search for the Father."

**Marie–Bernard Nielly. Photo credit:
the Dominicans of France**

**Trevor Huddleston. With the permission of the
Community of the Resurrection, Mirfield, UK**

Daniel Berrigan, SJ.
Photo credit: Jim Forest

**William Shannon. With the permission of
the Sisters of St. Joseph of Rochester.**

Tilden Edwards.
With the permission of Shalem, Washington DC.

CHAPTER ELEVEN

THE PAINTING AND
THE BEAUTIFUL OLD MEN

Further indications of the importance of the reality of fathering/non-fathering in my life: I met as time went by a number of men, older than myself, father-figures, men who like myself had committed themselves to a sacred role in their respective religious communities; and with many of whom or in regard to whom at some point in my relationship with them I would find myself in tears.

One of these was Père Marie-Bernard Nielly, OP (*Ordo Praedicatorum*, the Order of Preachers, the Dominicans: 1902-1991), whom I had met when during my studies at the Ecumenical Institute at Bossey in Switzerland (1968-69) I was given a three-month field placement (a *stage*, as the French say) at the Centre St-Dominique, a Dominican centre in an old chateau, La Tourette, near L'Arbresle, a town near Lyon. (One of Le Corbusier's famous buildings is there at La Tourette, the Dominican convent. The Dominicans, I was told, hated it: it's not built on the human scale.) Born in the Breton city of Brest, Marie-Bernard was professed as a Dominican in 1933, and ordained in 1934. In his late sixties when I met him, he had been deeply involved in the French worker-priest movement during World War II, as a result of which he was removed by the Vatican from his position as prior and provincial of his Dominican community. The Vatican of Pius XII thought the movement was dangerous, when in fact it was innovative and creative.

In the years just before I met him, he had been rehabilitated, and appointed as prior of the Dominican Province of Lyon. He was a warm, peaceful, humorous, insightful, accepting, brilliant old man. He was a beautiful old man, and when I received a letter from him in 1976, just a newsy epistle, I was moved to tears to think that he remembered me. Being remembered: very moving. It was in 1991 that I learned from his Dominican brother Jean-Pierre Lintanf that he had died, and again I wept for a long time.

A second was Archbishop Trevor Huddleston, CR (i.e., a member of the Community of the Resurrection, an Anglican religious order), successively bishop of Masasi, in Tanzania, of Stepney, in East London, and finally, based in the Seychelles, Archbishop of the Province of the Indian Ocean. Born into an upper-class family in 1913, after ordination he joined the Community of the Resurrection in 1939. Having worked in South Africa for many years, he wrote *Naught for Your Comfort,* a book about apartheid, which my sister gave me for my seventeenth birthday. After reading the book, I wrote to him, and to my astonishment received a reply three weeks later (I still have the letter). Our correspondence eventually led to my going to the theological college maintained by his community, the College of the Resurrection at Mirfield, West Yorkshire, for the first two years of my theological studies. The first time I saw him, at Mirfield, in 1961, aged twenty-one, I was too shy to speak with him. Then in 1967 I encountered him in London, when he was preaching at the Royal Chapel of St. Peter-in-Chains, the very appropriately-named chapel in the Tower of London (the dedication comes from Peter in prison: Acts 12:1-17). When I spoke to him afterward, he appeared to remember our correspondence, which moved me greatly. Later again, in 1984, when I was on sabbatical in Cambridge, Massachusetts, and he preached in the University Church at Harvard, I spoke to him again; and once again, he remembered me: "Yes, from Vancouver!"—this from a man who met thousands of people. I am moved to this day to believe that he did remember me. ("Jesus, remember me, when you come into your kingdom!" Luke 23:42.) Frankly, I *want* to believe that he remembered me. We *want* to be remembered rather than forgotten, do we not?

My final encounter and my only real visit with him took place, back at Mirfield, in 1996. I had just finished a Merton pilgrimage in France, and I found myself at the end of it with a few unplanned days. Realizing

that it had been forty years since I had read his book in 1956, I decided spontaneously to go to Mirfield on a retreat of repentance for how limited had been my response during those four decades to the call of God that had come through that book: "Forty years long was I grieved with that generation " (Psalm 95:10, the daily morning psalm, the Venite). The word "forty" in the psalm connected with my recognition that I had read his book forty years before, and off I went. At my first evening meal there, he was pointed out to me, sitting on the other side of the refectory in his wheelchair, aged eighty-three. Once again I was too shy, at first, to speak with him; in fact, I was overcome with emotion arising from the thoughts of my own mortality suggested to me by the recognition that forty years had passed since I had read his book. The next day I saw him out on the lawn, sitting in his wheelchair, reading. I carefully stood out of his line of vision, weeping, until I had gained control of myself and could go up to him and speak to him. Again to my astonishment, there was a flash of remembrance, and we settled in for a long and delightful conversation. He had just returned from a sojourn at Buckingham Palace, to which, together with other personal friends of Nelson Mandela, he had been invited by Queen Elizabeth for some personal time with the great Madiba. ("She didn't want him to have to run around the country seeing all his friends; so she gave him a wing of the palace for a week.") Just before that he had taken part in a private invitational event for religious leaders called by the Dalai Lama to discuss the possibilities of world peace ("What a fine young man he is.") Well, everything is relative: in 1996, he was eighty-three, and the Dalai Lama a mere sixty-one.) As our conversation proceeded, I realized that my perspectives on social justice as part of ministry, and an essential dimension of the life of the church, had their root in his book, something strongly reinforced by the ethos of the College of the Resurrection. (I remember the principal exulting when South Africa was expelled from the Commonwealth in 1961.)

As the afternoon ended, he asked me to sit beside him at dinner, which I did. There he told me some stories about his tussles with Margaret Thatcher about South Africa, and the wonderful story of how Desmond Tutu became a priest. ("This is really Desmond's story, but he's not here; so I'll tell you.") My memory being imperfect, let Desmond Tutu tell his own story, which

he told in *Trevor Huddleston: Essays on his Life and Work,* about what happened when he was eight or nine.

> We were standing with my mother on the balcony of the women's hostel where she was cook when this white man in a big black hat and a white flowing cassock swept past You could have knocked me down with a feather, young as I was at the time, when this man doffed his hat to my mother; I couldn't understand a white man doffing his hat to a black woman, an uneducated woman. it made . . . a very deep impression on me and said a great deal about the person who had done this.

I recall saying to him at dinner (and he agreed) that it was wonderful, almost providential, that in those days men wore hats: perhaps in a hot country like South Africa they still do. Later Desmond Tutu stayed at a student hostel run by Trevor Huddleston's community, where he came to know him well, and where he discovered his own calling as a priest. Arguably it was this act of old-fashioned courtesy that through the later leadership of Desmond Tutu helped to save South Africa from a bloodbath in the tumultuous declining years of the apartheid system.

I had somehow lost my copy of Trevor Huddleston's book, perhaps in a box misplaced during a move; certainly I know I would never have let go of it intentionally. When I got home from this trip, I told my sister about the encounter, and that I no longer had the book she had given me. Now my sister, like the serpent in the garden of Eden, is more *subtil* (King James spelling, Genesis 3:1) than all the beasts of the field: and lest you think I am being disrespectful to my sister, let me say that contemporary biblical scholars see the serpent of Genesis as the symbol of the goddess—who was, understandably, not popular in the patriarchal Judaism of the time when Genesis was edited. Her response to my account of my meeting with Trevor Huddleston was low-key, on the level of "uh-huh." I later realized that, as usual, the wheels had already begun to turn. She bought a copy of the book from an antiquarian bookstore, sent it to Mirfield for his autograph, provided packaging and postage for its return, and gave it to me for Christmas. Tears again. The book remains one of my great treasures.

Then in 1998, my daughter Megan went to New York for a holiday, and brought me back a copy of *The New York Times*, because she knows I am a newspaper junkie. In that issue I found his obituary, covering more than half a page. He died on April 20, 1998.

A friend had given me a signed photograph of him on the occasion in 1961 of his ordination as bishop of Masasi. I have treasured it ever since; but it was only after another friend pointed out to me the likeness between the photograph and the figure in my painting, that I recognized that once again I had been drawn to an iconic holy man, indeed a beautiful old man. When the photograph was taken, he was only forty-nine, the age of my spiritual awakening; but his face in the photo tells me that he was already well on his way to becoming the holy man who moved me so deeply when we met and spoke.

Another beautiful old man: Daniel Berrigan, SJ (Society of Jesus, the Jesuits, the same order to which Pope Francis belongs). Born in 1921, Dan Berrigan was a priest, a poet and a peace activist. An opponent of the Vietnam war from its beginning, he traveled to Hanoi in January 1968 with historian Howard Zinn to receive from the North Vietnamese three American POWs, the first such to be released since the beginning of the American bombing of Vietnam. Later in the same year, with eight fellow activists, he destroyed draft files belonging to the Catonsville, MD, draft board—his group became known as "the Catonsville Nine." He was sentenced to three years in prison, but went into hiding for a time in order to draw attention to the group's cause. Soon re-arrested, he went to jail until 1972. Then in 1980, with his brother Philip, and six others ("the Plowshares Eight"), he was a participant in an action in which nuclear warhead nose-cones were damaged, and in which the Eight poured their own blood onto documents and files at the nuclear base in King of Prussia, PA. After ten years of appeals, he and the others were re-sentenced and then paroled. I shudder to think what would be the punishment if he or anyone else performed such an action today (think Edward Snowden or Chelsea Manning) given the current paranoia of the US administration, or, more accurately, of the national security establishment which in the view of many is the *de facto* government of the United States. Since his release, while continuing to protest the war-related actions of his government,

he lived in New York, devoting himself to his poetry and to teaching at Fordham University.

In 2004, the Thomas Merton Society of Canada undertook a pilgrimage/study tour to New York: "Thomas Merton's New York." Judith Hardcastle and I went to New York in 2003 to do the advance work on it, as we would later do for "Thomas Merton in Rome." Knowing that Dan Berrigan, who had been a close friend of Merton, now lived in New York, and would be an ideal person to offer the keynote address for the tour, we called him and arranged to meet him at his apartment. We came to the apartment and knocked. The door was opened by a short, slight man of eighty-two, wearing jeans and a striped sailing shirt: Dan Berrigan in the flesh. Once again, tears. Once again I was in the presence of a beautiful old man, whose shining presence moved me very deeply. I don't think he noticed my tears; and we talked in practical terms about what we hoped he would do for our project. He agreed, and the following year gave an outstanding keynote address, drawing on his personal knowledge of Merton as a prophet of peace. He died on April 30, 2016, and his death released a flood of appreciations and encomia. He was both sage and prophet.

Next, Monsignor William Shannon (1917-2012). Bill Shannon was also a Roman Catholic priest, a longtime professor at Nazareth College, in Rochester, New York, the father-founder of the International Thomas Merton Society (merton.org), and the first dean of Merton scholars, a position currently held by Patrick O'Connell. In June 2009, the ITMS held its biennial general meeting/conference at Nazareth, and Bill (whom I had admired since I met him in 1978 at the first international Merton conference, in Vancouver) was to preach at the concluding liturgy on Sunday morning. I wasn't prepared for the fact that, now aged ninety-two, he would be entering with the procession in his wheelchair; and as he passed where I was sitting, once again the tears came. His homily was wonderful; a barn-burner, a powerful preachment. He was indeed a beautiful old man: may he rest in peace and rise in glory.

By this time you must have noticed how these encounters were regularly marked: with tears—not with crying, but with weeping, with tears that came from a deep well of grief the nature of which was until after my trip to Asia hidden from me—because I had not known what was in front of my face.

Tears, idle tears; I know not what they mean:
Tears from the depth of some divine despair
Rise in the heart and gather to the eyes
 (Tennyson, "Song," ll.1-3).

The deep meaning of my tears—until after my meeting with Chatral Rinpoche—was obscure to me. I had wept when I heard about the death of Père Marie-Bernard in 1991 and when I met Trevor Huddleston in 1996. Then came my meeting with Chatral in the year 2000, and the conversation with my friend some months later in which I realized that the tears were for myself and that they were connected to the unrealized character of my relationship with my father. ("Margaret, are you grieving / Over Goldengrove unleaving? / It is the blight man was born for, / It is Margaret you mourn for."—Gerard Manley Hopkins.) Later came my tears in the presence of Dan Berrigan (2004) and Bill Shannon (2009); but by this time I knew something of the meaning of my tears. In any case, as Rumi says, "Let the tears come: they water the soul," the truth of which I have proved to myself many times over.

More recently, however, I have come to understand that there is another level of meaning in regard to the tears. Each of the beautiful old men I have just named was a designated holy man, as am I: a Buddhist high lama, an Anglican bishop and member of a religious community, and three Roman Catholic priests. All of them had walked on the path of personal consecration as representatives of their respective religious traditions. In a Christian framing, they had put their hand to the plough and not looked back (cf. Luke 9:51, 62). As I consider the name of the painting, I recognize that these men realized in their own persons both of its terms: they were holy, both by profession and in the living out of that commitment; and they were men, bearers of the classic dimensions of masculinity—strength, courage, wisdom. I now realize that I had been groping for both realities: that in what happened with my lover at the time of the end of my marriage I was, paradoxically some may say, attempting to reclaim both my priestly vocation as well as my masculinity. These men, in other words, had fulfilled whatever vows they had made in a far fuller way than I ever had, have or will as an Anglican priest. I had talked the talk, and stumbled on the walk, or strayed from it. They had, so far as I and others can see, walked the walk—although

of course I recognize from my own experience that in everyone's life there is some element of darkness, hiddenness or woundedness. That is something which in regard to all of them I am happy to leave to God. As I look back on the years since my ordination in 1963, I see a pattern in my life of a partial, "reasonable," self-preserving living out of my vows, rather than the pattern of full-hearted surrender which I intuited, first unconsciously, later consciously, in the lives of these beautiful holy men. This is why I experienced them as beautiful: they were single-minded, pure in heart, men who, whatever their tradition, lived out the reality of the Beatitudes (Matthew 5:1-11). They had developed spines of steel; my own spine . . . I shrink from offering a contrasting image. This of course, still mostly unconscious, was why when I finally decided what for me was the most important thing that Jesus ever said, my heart and mind turned to Matthew 5:37, and to his challenging word: "Let your yes be yes, and your no be no." For most of my life—I am a Canadian, after all, and an Anglican; and moderation—even, heaven forfend, niceness—has so often in both those communities functioned as our highest operative cultural value. My "Yes" too often had been "maybe," or "if at all possible," or, frankly, "if it won't cost too much": and my "No" had been equally bendable. (Some of you will remember the contest organized by Peter Gzowski on "Morningside," his longtime CBC program, in which he asked his listeners to come up with a Canadian equivalent to the simile, "As American as apple pie." The winning entry? "As Canadian as possible under the circumstances.") In the seventeenth century, in England, I would very likely have been a fellow-traveller of the Vicar of Bray, who changed his religious allegiance to accord with whichever government was in power at any particular time in order to keep his position.

> And this is law, I will maintain
> Unto my Dying Day, Sir.
> That whatsoever King may reign,
> I'll be the Vicar of Bray, Sir!

My tears, so many of which were generated by my meetings with these authentically holy men, were shed in part for my imperfect response to my own call to authenticity and holiness, as well as in regard to my father.

I wanted to hear from them what I have already quoted and what I had never heard from my birth-father: "You are my Son, the Beloved: with you I am well pleased" (Mark 1:11). At this point in my life, of course, I had been weeping about the death of the marriage, and about my own physical mortality, my sense of which had moved from abstract assumption to felt reality at the age of forty-nine.

I want to add to these thoughts two more stories about tears, which seem to point forward beyond the need to continue to weep for these reasons. In 2006, to draw a kind of line between my teaching career, and my retirement/third age, I decided to go for the Big Walk in the UK which I have already mentioned. At first, I thought I would walk all the way from south to north, from Land's End to John O'Groats. However, for a number of reasons, the chief one being how expensive the UK was, I ended up just walking about 400 miles (one pair of boots, no blisters!), the largest portion of this being from Land's End to Newcastle, with a number of later, shorter walks, some south-north, some east-west, in Northumberland and Scotland. A number of friends came to walk with me, one of them being Douglas Christie, a Roman Catholic theologian from Los Angeles, one of my closest friends, a true *mensch*. We met at Hebden Bridge, in Yorkshire, and spent the next seven or eight days walking the Pennine Way, with Doug from time to time blasting out from his iPod Sibelius's "Finlandia" played on the bagpipes to the very attentive sheep who were our chief mammalian companions on this trek. We found a bed-and-breakfast in the delightfully-named town of Haltwhistle, in Northumberland, which claims to be the exact geographical centre of the island of Great Britain, a claim which is disputed by the community of Dunsop Bridge in Lancashire, 114 km to the south (!). At this point Doug suggested that we take a break from walking. He wanted to visit the cathedral in Carlisle, in which are to be found some 14th-century painted panels of the life of St. Anthony the Great, the first of the Desert Fathers (251-356), on whom Doug is one of the world's great experts. This meant that we had to go first to Newcastle, and then change trains.

We had about an hour and a half there between trains, and so decided to walk out into the city. Newcastle Cathedral is just a few metres from the train station, and so we entered the cathedral and began to explore it. Doug went one way in the building, and I another. A few minutes after

entering the cathedral, I was walking past its great organ when it suddenly began to play, or rather, to be played, in what seemed to me its deepest register—it may have been Bach. With no warning whatever (the usual way my tears came) I found myself silently weeping, startled into tears by the music I was hearing. As I began to weep, a memory and two images/visions came to me, all in the same split second of time. The memory concerned a sermon I had heard at a youth conference in 1957, forty-nine years earlier. It was a conference of the now long-departed Anglican Young People's Association, known familiarly by its initials: AYPA. The preacher, Bishop Ralph Dean, had given us a very effective mnemonic: All Your Past Absolved; All Your Present Accepted; All Your Potential Assured. What until that point had been an unutilized memory now named an affective experience. In the same moment, I saw myself fall through the floor of the cathedral and land on my feet in the crypt. Simultaneously, I experienced myself as a camera—the old-fashioned, pre-digital kind—which clicked into focus. A memory, two visual moments, and some tears.

Recently, I re-read part of Merton's *The Inner Experience*. There Merton describes *satori,* the experience of life-resolution to which Zen practitioners aspire, as

> a revolutionary spiritual experience in which . . . the [adept] experiences a kind of inner explosion that blasts his false exterior self to pieces and leaves nothing but "his original face," . . . or, more technically, his "Buddha nature" (p.8).

He then goes on to illustrate this by telling the story of Chao-pien, an official of the Sung dynasty of China (960-1279 CE). He was sitting quietly in his office when he heard a clap of thunder which catapulted him into the experience of *satori*, which he recorded in this poem.

> Devoid of thought, I sat quietly by the desk in my official room,
> With my fountain-mind undisturbed, as serene as water;
> A sudden crash of thunder, the mind doors burst open,
> And lo, there sits the old man in all his homeliness (p.9).

At the moment of readiness, says Merton, any "fortuitous sound, word or happening is likely to set off the explosion of 'enlightenment'" (p.8). A crash of thunder, an unexpected bursting-forth of the great organ? I have previously called this an epiphany, but am now wondering if I have undervalued it. I see it now not as the kind of breakthrough I experienced at the time of the end of my marriage, but rather a kind of affirmation or re-affirmation from the very cells of my body that some real resolution had taken place at that earlier time. What more could I desire than to be "the old man in all his homeliness"?

I tell this story because I intuit that the earlier reasons for my tears—the unrealized relationship with my father; my inadequate response to my priestly vocation; and my felt sense of mortality—did not obtain in this instance. These tears in Newcastle were tears of absolution, of acceptance, and of assurance that I had a future awaiting realization—including, as I now understand, the writing of this book.

Then in November 2010 I experienced another epiphany, which provided me with a kind of coda to my previous encounters with beautiful old men. I was at a Jubilee gathering at the United Church of Canada conference and retreat centre in Tatamagouche, Nova Scotia. It began with a continuing education event at which Tilden Edwards was the resource person. Tilden, an American Episcopal priest, was the founding director, in 1973, of the Shalem Institute for Spiritual Formation, in Washington, DC. When Jack Gorsuch and I put together the initial offering of our new spiritual-direction program, we used Shalem as our template, Jack being a Shalem alum. I first met Tilden in Bethesda, MD, in January 1985, the week following my resignation as rector of All Saints, when I took part in a Shalem program called "The Spiritual Life of Spiritual Leaders." I met him again in the mid-90s, when with other Jubilee staff I went to Washington to consult with him and other Shalem staff members about the work we were doing in Jubilee. I have long respected his work and profited from a reading of his books. So it was with real anticipation that I went to Tatamagouche to sit at his feet in a weekend devoted to the place of the contemplative way in our programs and in our culture. The weekend ended with a contemplative Eucharist, minimal in its use of words and in its structure, yet very powerful in the way in which the contemplative explorations earlier in our days together grounded it. During the very brief Eucharistic prayer,

I recognized—and this was the epiphany—that I was *not* weeping in his presence. He is exactly the kind of beautiful and holy elder very worthy to be included in the company of the spiritual men my encounters with whom I have already described. Why then was I not weeping? I concluded that it was because my time of weeping in such encounters was finished, that I had sufficiently if not completely integrated the lessons that my encounters and my tears had to teach me. This of course was why in Toronto in 2013 I didn't weep when I met James George (b. 1918), another beautiful old man, interfaith seeker, at one time our ambassador to Iran, and in 1968, when he was High Commissioner in New Delhi, host there to Thomas Merton. Nor, in February 2016, when I had the privilege of a long visit with Charles Brandt (b.1923), a hermit, Roman Catholic priest, bookbinder and ecologist. He lives in his hermitage, "Merton House," deep in the forest in the tiny community of Black Creek, BC, north of the town of Courtenay, on Vancouver Island, on the banks of the Oyster River, which he has played a significant part in returning to ecological health. He is the last of a community of hermits which came to the area in 1965, the Hermits of St. John the Baptist, founded by Jacques Winandy, OSB, a friend and correspondent of Thomas Merton. Two friends came with me and immediately felt about him as I did, that he was an integrated, individuated man, at peace with himself, God and the world.

I no longer weep in encountering such men because I have come to accept my own calling to bring the kind of beauty I had seen in them to reality in myself, God help me. The energy around this is no longer directed outward; it is directed inward, to my own task of myself becoming a beautiful and holy elder of a similar ilk to those whose very presence had so affected me. Immediately I have to make it clear that I am not considering myself as an equal of these beautiful old men. Just as it would be ridiculous for me, as I have already said, to compare myself with Jesus or the Buddha or Thomas Merton, so it is ridiculous for me to consider myself the equal of Chatral Rinpoche, Trevor Huddleston, Dan Berrigan, Bill Shannon, Marie-Bernard Nielly, Tilden Edwards, James George or Charles Brandt. Rather, for me they are or have been living icons (in fact, one of the participants in the weekend event with Tilden hailed him spontaneously during the Eucharist as "a living icon"), men in whom spiritual beauty—in which I include joy, courage and transparency—shines forth. They are brothers in the

spirit with the holy man in my painting, and spiritual fathers to me in my journey. In them I recognize living examples of the spirit which reaches out to me, speaks to me, from my iconic painting. I doubt that any one of them spends any time thinking of himself as a beautiful old man. Surely it is part of the beauty of such men that they have moved beyond such an exercise of the ego.

In his book, *Living Icons: Persons of Faith in the Eastern Church,* American Orthodox priest and Merton scholar Michael Plekon sets forth the lives of ten Orthodox Christians who lived in the eighteenth, nineteenth and twentieth centuries, men (and one woman) whom Michael Plekon sees as "living icons"—in Russian, *zhivye ikony*—"in their personalities and work, in their struggle and joys, in all of their lives . . . images of the Lord and of his gospel and Kingdom" (p.4). So when the woman at Tatamagouche hailed Tilden Edwards as a living icon she was in fact tapping into an already existing tradition of recognition of personal holiness.

<p style="text-align:center">★</p>

In December 2004, three months after my retirement from Simon Fraser University, and two years before my Big Walk, I went on retreat at Malahat Park. During this retreat I addressed God as follows: "I know I won't live forever. So to what should I be paying attention in the years that remain to me?" The answers came almost more quickly than I could write them down. I have come to call them the seven imperatives:

(1) Create more open spaces in your life.
(2) Deepen and extend your spiritual practice.
(3) Continue to reflect on your commitment to say,
 "Yes" when you mean yes, and "No" when you mean no.
(4) Honour and embrace womankind.
(5) Honour your elders.
(6) Seek balance between acquisition and relinquishment.
(7) Act now to prepare for your end-of-life needs.

The fourth, of course, concerned the new perspectives I had on womankind as a result of my time with my lover. The fifth of these I first recorded as

above: honour your elders. A year later I returned to Malahat Park, and reviewed the imperatives. When I did so, I left the others as they had originally come to me, but revised imperative five as follows: honour your own eldership and that of your fellow-elders. This then was the moment, when, aged sixty-six, I first accepted myself as an elder. Having skipped Grade 2, I had been used for most of my early life to being the youngest member of any particular cohort. Now I had caught up with myself, and I was ready to accept myself as an elder.

Roger Lipsey's *Make Peace Before the Sun Goes Down: The Long Encounter of Thomas Merton and His Abbot, James Fox* includes an account of Merton's meeting in 1964 in New York with D. T. Suzuki, whom Lipsey describes as Zen's "foremost scholarly exponent" (p.197). Lipsey's account of the meeting is for me strongly evocative of my own experiences with the beautiful old men. Merton was forty-nine, Suzuki was ninety-four. Lipsey says that Merton "met in Dr Suzuki, at last, a living spiritual father, an abbot in all but name" (pp.199-200)—and the title of abbot, of course, comes from the Aramaic *abba*, meaning "father" (cf. Romans 8:14-15). Indeed, the Desert Fathers were addressed as "Abba." Merton says that meeting Suzuki "was like finally arriving at one's own home" (p.200). It was for Merton, whose father died when Merton was 16, *an experience of being fathered*, as I had had the sense of being fathered in my brief and powerful meeting with Chatral Rinpoche—but without the tears.

As I conclude this chapter, I salute the beautiful old men of whom I have written, and I challenge myself with this passage from Orthodox theologian Olivier Clément in his *La Prière du Coeur* (and offer my thanks here to Jean-Claude Bazinet, who passed the passage on to me). The analogies in this passage to the reality of icons in the Orthodox tradition, though not explicit, are clearly intrinsic to what he is saying: in short, that the beautiful old man himself becomes a living icon. Clément speaks of the monk as prototypical of this, but we need not restrict what he is saying to monks; it will nourish the heart of anyone who reads, marks, learns and inwardly digests its truth.

> In the Christian East—in fact, in the East in general—we love old age because we think that it is made for praying. When one is old, and feels the nearness of God across the increasingly transparent surface of biological life, one becomes

in consciousness a child, returned to the Father, made light in spirit by the proximity of death, transparent to another kind of light.

A civilization in which no-one any longer prays is a civilization in which old age has no meaning. One walks backward towards death, pretending to be young; it's an agonizing spectacle, because a wonderful possibility is offered, a journey towards ultimate relinquishment, and it is not taken advantage of.

We need old people who pray, who smile, who live with a disinterested love, who marvel; they alone can show young people that living is worth the effort, and that oblivion is not the last word. Every monk whose spiritual practice has born fruit is called in the East, whatever his age, "a beautiful old man." He is beautiful with the beauty that rises from the heart. In him all the periods of his life have come into harmony, as with a symphony, one might say. And especially the original child is found again: shining with a transfigured shining, the beautiful old man has the eyes of a child (*translated by DG*).

CHAPTER TWELVE

THE PAINTING AS ICON

Jim Forest is a writer, a member of the Orthodox Church, an author, former secretary-general of the International Fellowship of Reconciliation, currently active in the Orthodox Peace Fellowship, and a great human being. He was a friend and correspondent of Thomas Merton, and is warmly regarded in the larger Merton constituency. Some years ago I asked Jim to look at a photo of my great painting. I asked him if he could see it as an icon, analogous to the icons which are so central to Orthodox worship and identity. His answer was a very firm no. He holds to the traditional view that a real icon will be painted (Orthodox iconographers in fact use the word "written" rather than painted) by someone who has prepared for years, through apprenticeship, fasting, prayer and deep acquaintance with the iconographic tradition, to put brush to wood and only so to create an icon. Of course I didn't argue with him—then. But I will try to make my case in these pages that the painting is indeed an icon, that it has an iconic character. I begin by citing again part of what Lois Huey-Heck and I sent to the *Christian Century*—"icon" was her word, incidentally.

Since 1972, it has been an icon—a gateway to God—for its owner, Don Grayston. He recalls an instant recognition on first seeing *The Holy Man*—that he simply had to buy it. Decades later, it continues to offer him truth and insight. As with all icons, the image-viewer dialogue is very personal. Revelation

is rarely gained in a passing glance; rather it comes from time spent in prayerful communion . . . from *imaginatio divina*.

Yes, "a gateway to God", which is what a traditional icon is. Orthodox believers will often form a kind of personal relationship with one or more icons, and find, as they pray with an icon, that the icon will continue to offer them "truth and insight," or, more precisely, that God will offer them truth and insight in the course of their prayer. They spend time with the icon or icons "in prayerful communion," believing that the holy person pictured in the icon is *praying with them as they pray*—the prime "use" of icons being as companions in prayer, not simply as decoration in a church. Alive in God, the holy person in the icon is eternally in prayerful communion with God, and draws the praying believer into this divine and divinizing process. As Michael Plekon says, we are

> not objective spectators but [are] invited to participate in the reality of the icon. The icon calls through its inverse perspective, pulls us into its reality. [Thus we] find a seat open [for us] at the table of the three angels who visit Abraham and Sarah in Andrei Rublev's well-known icon, the "Hospitality of Abraham" (*Living Icons*, pp.2-3).

By using the phrase *imaginatio divina*, "sacred imagining", Lois and I meant to refer to this process, seeing it as a spiritual practice parallel to *lectio divina*, "sacred reading," in which the reader spends substantial time with a passage of scripture, savouring it, trying to move beyond intellectual understanding of the passage to spiritual appropriation of its deepest truth, which typically does not reveal itself on a first or cursory reading. All of this I find true and valuable for myself. As regards the painter, Velenka, given the name she gave the painting, and knowing of her devout Christian faith, I find it entirely believable that for her the creation of the painting could have been a matter of prayer, if not in the precise tradition of the Orthodox iconographers, then analogous to it.

Wanting to explore further the Orthodox understanding of icons, I consulted a beautiful book—*The Meaning of Icons*, by Leonid Ouspensky and Vladimir Lossky. The book opens with a foreword by art critic and historian

of religions Titus Burkhardt, a chapter on the iconic tradition by Lossky, then two chapters by Ouspensky on the meaning and language of icons, and on the technique of their production. The rest of the book consists of colour reproductions of the main types of icons, with a commentary of some pages on each. I resonate strongly with a comment of Burkhardt, that "the meaning of an icon touches a centre so near [a person's] essence that it governs all aspects of the work of art, from its didactic elements to the imponderables of artistic inspiration" (p.7). Certainly my relationship with my painting has touched me at my centre, as did my experience of pain and failure at the time of my marital separation, as did my time with my lover. I relate Burkhardt's word "didactic" to what Lois and I said, namely that the painting "sits at the threshold between the didactic/representative and the interpretive/imagined and felt." Yes, *didactic*—the holy man in the painting is my teacher; *representative*—the painting holds up to me a portrait of the category of which I have written, that of the "beautiful old men"; *interpretive*—the painting has had for me a hermeneutic function, interpreting to me so many of the cardinal events of my life; and *imagined and felt*—in that I have formed a personal relationship with the figure in the painting, and that my connection to it is a matter of deep feeling, and not simply, again, of intellectual understanding (which this chapter with its academic references might wrongly be taken to suggest).

In his theological reflection on the meaning of icons, Ouspensky begins with the affirmation that Jesus, the Incarnate Word, visible to his contemporaries on the plane of history, is the ur-justification for icons, being himself the "image [in the Greek text, *eikon*] of the invisible God" (Colossians 1:15); and that on this understanding it is appropriate to regard representations of Jesus and his saints as avenues to prayer. In the eighth and ninth centuries, there was a violent dispute about this. The original iconoclasts ("icon-breakers") objected to icons on the grounds of the prohibition of "graven images" in the Hebrew Bible (cf. Exodus 20:4), and the possibility that the use of icons might lead to idolatry. The defenders of icon-veneration insisted on the symbolic character of artistic images and on the dignity of the human person created in the image of God (cf. Genesis 1:26), and in particular, on the Incarnation (cf. John 1:14), that is, on the human reality of Christ in his historical time. The controversy came to a definitive end in the year 842, with the victory of the pro-iconic view. Ouspensky again:

> On the plane of human creative work, beauty is the crowning
> given by God, the seal of the conformity of the image to its
> prototype, of the symbol to what it represents The beauty
> of an icon is the beauty of the acquired likeness to God; and so
> its value lies not in its being beautiful in itself, in its appearance
> as a beautiful object, but in the fact that it depicts Beauty (p.35).

I take it by the fact that Ouspensky capitalizes "Beauty" that he is saying that it is the *divine* beauty that comes through the icon to the consciousness of the one praying, "the beauty of the [icon's] acquired likeness to God." I do regard my painting as beautiful in itself, as have many others, but I agree with Ouspensky that its prime value is that it points to God. I see the figure in the painting as having placed himself, as it were, in the acknowledged presence of God, or, a little less mystically, having been placed there by the artist. It came to me one day, in fact, some decades after I had bought the painting, that the holy man was *meditating or praying.* His gaze is turned inward rather than outward, and he emanates peace—as I have sometimes said, peace after pain, something which I see particularly in the representation of his mouth. An icon, Ouspensky says, is

> flesh transfigured, radiant with Divine light. It is Beauty and
> Glory, represented by material means and visible in the icon
> to physical eyes. . . . a temporal portrait of a saint cannot be an
> icon, precisely because it reflects not his transfigured but his
> ordinary, carnal state. It is indeed this peculiarity of the icon
> that sets it apart from all [other] forms of pictorial art (p.36).

In short, an icon is a "manifestation of man as a living icon of God, . . . an external expression of . . . transfiguration, the representation of a man filled with the grace of the Holy Spirit" (p.36). Given that many traditional icons portray women, notably the Theotokos, the Mother of God (as Mary is commonly referred to in the Orthodox Church), but also female saints, we may pause briefly on Ouspensky's pre-inclusive language and understand him to mean by "man," "human being." The phrase "living icon," of course, will take us back to that electric moment at Tatamagouche when the woman in the congregation called out that Tilden Edwards, then presiding at the

Eucharist, was himself, in this life, a "living icon," as indeed I would also describe Brother Roger Schütz (1915-2005), founder of the Community of Taizé. I saw Brother Roger a number of times at Taizé, and have wondered why I shed no tears there, although he was very much the kind of beautiful old man of whom I have written. I've concluded that it was because I had *personal* contact with the others, whereas at Taizé I was one of thousands, and never did have a personal conversation with him. Looking into each other's eyes seems to be a necessary aspect of this process, the generation of holy tears.

So I read enough of Ouspensky and Lossky to satisfy myself that the essential characteristics of the traditional icon are to be found in my painting. The painting points me to God. It is filled with divine light. Beautiful in itself, it points the viewer toward transcendent Beauty. When I pray with the painting, I am companioned by the praying figure in the painting. It moves me to think that the painting has *become* an icon for me by the time and reflection I have given to it, thinking also that perhaps it would not have become an icon if purchased by someone else. A traditional icon would be recognized as such by anyone familiar with the Orthodox tradition, with no need to have it designated as such. If, for example, a newly-written traditional icon was placed in a warehouse which was then locked and not reopened for a hundred years, it would immediately be recognized as an icon. The case of my painting, however, is different. It would not necessarily be recognized as an icon by those who have not had with it the relationship that I have had. They might see it as a beautiful painting, perhaps, but nothing more. I am in fact unconcerned with whether anyone, dear Jim Forest or anyone else, recognizes it as an icon. For me it *is* an icon, and I rest in that recognition and relationship.

PRAYING WITH THE PAINTING

I've said that icons are for praying; and since I regard my painting as an icon, it is something I pray with. I've also said that the holy man in the painting appears to me to be meditating, something not so far from prayer. But who am I to deny that perhaps he is also praying, since prayer can lead to meditation and meditation to prayer?

It took me a number of years to recognize the iconic character of the painting, something beyond its archetypal character; and it is only in the last ten years or so that I have had a prayer-connection with it. Let me say right away that whatever you find as a focus for prayer is the right thing for you, as the painting has been for me. We pray as we can, not as we can't. We are beginners in prayer to the end of our lives. The question of the disciples to Jesus, "Lord, teach us to pray" (Luke 11:1), is itself a prayer, and one we can keep praying until we die. I have sometimes wondered whether I shouldn't rather, as a Christian, use a cross or crucifix as my focus for prayer. But then I decided that the holy man is also a Christian, indeed my prayer-companion, with both of us having responded in our different degrees to God's call to "throw off every encumbrance, every sin to which we cling, and run with resolution the race for which we are entered, our eyes fixed on Jesus, on whom faith depends from start to finish" (Hebrews 12:1-2, NEB). Ah, "start to finish," another racing image, and one which I had never noticed as such before starting to write this chapter. I do take it that the holy man has finished his earthly race already, and is companioning

me from the next life. Perhaps that is why he has a bouquet of marguerites on his lap, a recognition that he did finish the race and kept the faith (cf. 2 Timothy 4:7)—marguerites at the finish line instead of laurels! And his gaze is directed inward, the eyes of his spirit being "fixed on Jesus," present in his heart.

My prayer with him began wordlessly, with the simple bow that I began directing towards the painting in the first year after my marital separation at the beginning and end of my meditation time. The next stage came when I started to say "Thou, O God," in the presence of the painting; and when, some time later, I heard the matching phrase, "Thou, Donald." Sometimes this acknowledgement is a wordless moment. Very few people call me Donald, incidentally. My parents did, my sister and brother-in-law do, my former wife did: virtually everybody else calls me Don. It's my baptismal name, of course, and so it's entirely appropriate that in this context, I am called Donald, whether it is God naming me so, or (with a nod to Jos Solberg) simply auto-suggestion. Sorry, Jos, I just don't care. It works for me, as the kids say.

About five or six years ago, I started the practice of beginning the day with a time of prayer which is also a daily moment of accountability, in the immediate presence of the painting. In fact, because of where my bed is located, and where the painting hangs on the bedroom wall, it is usually the first thing I see when I wake up. I notice this especially when I have not set the alarm clock; and so when instead of leaping up to turn it off, I simply open my eyes and see the painting. It is a beautiful way to begin my day. I make a simple bow of acknowledgement, do my ablutions, and then, a little more awake, stand in front of the painting. During this past year I have noticed that as I start my prayer I will move to what seems to me the centre of the painting, and thereby place myself in front of the holy man in an aligned way. Often this will mean moving to the left or right only a couple of millimetres; but it seems right to seek the place of centering, of alignment. I don't begin to pray until I have a sense that I am standing, as I pray, in the right place. The old Shaker hymn speaks of "coming round right," and this is what I experience as I do this.

I begin with what is sometimes called Thomas Moore's prayer—Moore being a psychologist and author, and at one time a novice under Thomas Merton. This is a prayer I learned in the Jubilee Program from my friend

and colleague Dawn Kilarski. It is made up of a series of gestures, eight in all; sometimes, if I show it to someone, I will describe it as offering to its users the architecture of prayer—more on this below.

First gesture: with hands together in the prayer position, I bow—to the earth, from which I come, as do all other creatures. With this gesture I affirm and accept my place in the great world of sentience and mortality. By bringing my hands together, some commentators tell us, I am bringing together the right and left hemispheres of my brain. It is an ancient gesture which helps me to be more fully present.

Second gesture: I raise my arms to their full extent (eleven and one on the clock). At first, I thought of this as reaching for God; more often recently—since God is already here—I think of it as opening myself once again to God.

Third gesture: I make a circle in front of myself with my arms, touching the tips of my middle fingers to each other. This is the gesture of embrace, in which I embrace everything that God embraces, not *as* God embraces everything, for God's embrace is infinite and universal, but as a way of saying that I exclude or reject nothing that God accepts and includes in the divine mercy. So Hitler is in there, and so is Mother Teresa; the people who love and serve others are there, and so are the killers and rapists of ISIS who are as I write savaging their brothers and sisters in Iraq and Syria. It's all in there. God both rejoices and suffers with us; and this gesture takes us to a place where we too both rejoice and suffer with God. It also evokes the divine human connection that we see in the great painting of God the Father and Adam on the ceiling of the Sistine Chapel.

Fourth gesture: I cross my arms on my chest. This personalizes God's embrace, and tells me that God embraces me as well as everyone else and everything else. With every other part of creation, I am the beloved of God, and God is in principle well pleased with me (cf. Mark 1:11). Whatever I do or don't do doesn't budge God from the place of divine and foundational acceptance of the entire creation, including me.

Fifth gesture: I place my uplifted hands close to my shoulders, in the surrender position. Sooner or later, this is what it's all about. My real moment of surrender came at the time of the end of my marriage, which also involved the relinquishment of my respectable self-image. If your moment of surrender has come already, I rejoice with you. If not, I invite

you to open your heart to the possibility. We can't do it all, and never will; nor are we in charge of the universe, although at times we may have lived as if we were. It is a freeing, liberating, realistic gesture: I surrender. By making it daily, with all the other gestures, I acknowledge that although the deep reality of surrender may have come to us in a particular moment, it is something that needs daily reaffirmation and renewal.

Sixth gesture: leaving my arms in the same position, and turning my shoulders from side to side, I sweep what is in front of me, from left to right and back again, with my glance. It is a commitment to know what is in front of my face (cf. the Gospel of Thomas). If we do the prayer in a group, we look directly at the other people in the circle and smile at them, an acknowledgement that we are bound up with them in the bundle of life (cf. 1 Samuel 25:29), that we share with them the destiny of the entire human race as well as our own personal destiny. This has a particular meaning for me in this time of fear and apprehension around issues of climate change and global warming. We are all in this together, in the healing of the planet. The destiny of the planet as well as the human race needs to be front and centre in our prayer.

Seventh gesture: I clap, to wake myself up, and to wake up anyone else who may hear or encounter me as someone wanting to be an awakened or wakeful person. This is a gesture which we often associate with Buddhism, the path of those who follow the Buddha, "the awakened one," "the man who woke up." However, it is there in the Christian tradition as well: "Awake, sleeper, rise from the dead, and Christ will shine upon you" (Ephesians 5:14, NEB). In this regard, I look at what happened when I was forty-nine as the time when I awoke from the semi-sleep of my previous decades, indeed of my entire adult life. I said in the paradigm of the spiritual journey which came to me at that time that after becoming sane, I needed to work at staying sane. I could also have said that after I woke up, I needed to work at staying awake.

Eighth and concluding gesture: once again a bow, a little deeper than the opening bow. The first was a bow in honour of the earth, the mother of us all, the earth from which we come. This closing bow is also in honour of the earth, but in a different sense; it honours the earth to which we go. It is a daily *memento mori,* an acknowledgement of our mortality: in the midst of life, we are in death. Traditionally, in the refectories of Carmelite

monasteries, a skull would be placed on the high table in front of the prior or prioress as a *memento mori*. What I do, guided by Thomas Moore, is a less stark but no less necessary such acknowledgement.

I think of this prayer as offering a kind of "architecture" of prayer. In order, I can connect these eight meanings with the eight gestures: reverence, aspiration, embrace or love, knowing the self as beloved, surrender, inclusion, awakening, and acceptance of mortality. As we use the prayer over the years, we can add many other meanings, many other dimensions, to these basic ones, gradually *building*, as it were, the *house* of our prayer. Sometimes I stretch the time I give to each gesture by synchronizing the gesture with two, three or four breaths. It slows me down, and enables me to go deeper into the meaning of each gesture. And the prayer can be offered sitting down and at different energy levels. If you are tired, make the gestures smaller. If you are full of energy, pour that energy into each gesture.

After this, I offer **the three *rakus***, which I also learned from Dawn Kilarski, who told us that they come from the Sufi tradition. They consist of three bows, the second deeper than the first, the third deeper than the second. With the first, one says, "I bow to my own work." With the second, one says, "I bow to the work of others." With the third, one says, "I bow to the Great Work." The Great Work, yes—what is it? The phrase evokes what Jesus said about how he and his Father shared the divine "work"—"my Father worketh hitherto, and I work" (John 5:17, KJV); or in the NEB, "My Father has never yet ceased his work, and I am working too"—the work of universal redemption, the *anakephalaiosis* or bringing together of "all things in [Christ], things in heaven and things on earth" (Ephesians 1:10, NRSV). The line about Jesus "working too" occurs in a dispute about the keeping of the Sabbath, and is on the surface an apparent refutation of God's resting on the seventh day (Genesis 2:2). Or is Jesus saying simply that there are no gaps in the eternal outflow of God's love? I also think of geologian Thomas Berry's understanding of the Great Work as the healing of the planet—and his word *geocide* for what we are doing to the planet ecologically. As a workshop exercise, I have sometimes asked people to say what *for them* is the Great Work. The equivalent term in the Jewish tradition is *tikkun olam*, the healing of the world.

After the *rakus* come **the blessings**. In my bedroom I have photographs of my parents, my sister and my children, as well as of others whom I can

simply say that I love, who have touched my heart, my lover among them. As I turn to the photographs of my parents, I touch my hands to my heart, and then raise my arms to a ten to two position on the clock; they represent the generation above or before me. As I turn to the photograph of my sister, I touch my hands to my heart, and then lower my arms to a nine–three position; she and I belong to the same generation. As I turn to the photograph of my children, I touch my hands to my heart, and then lower my arms to an eight–four position; they belong to the generation which follows mine. I thereby locate myself in the family constellation—I am the child of my parents, the brother of my sister, the father of my children. Of all my relationships, these are the most fundamental and precious. Then as I look briefly at the photographs of the others, I simply touch my hand to my heart; a simple gesture of love. Every heart-beat is in fact a prayer. I complete this with a touching of my heart as I name the names of others in the same relation to me but for whom I have no photographs. I think of all these gestures as blessings, but they also have a dimension of intercession to them; and by touching my hands to my heart I mean to link the beating of my heart, the cultural symbol of love, with my love for others.

Which brings me to the next series of actions, **the intercessions**. First, with my arms by my sides, I name two special names, those of my two remaining directees. Then with my arms at the seven–five position, I name before God the names of those for whom I am particularly concerned at this time: people in difficulty, sick, in pain, in distress of some major kind. I know that God already knows their names and their situations, but at this moment I am giving to God some energy that God can use in the healing of the cosmos. ("What I can I give him—give my heart"—Christina Rossetti, "In the bleak midwinter").

My arms moving to the eight–four position, I pray in anticipation for those whom I expect to meet that day. It's a prayer for myself as well, that I may meet whomever I meet that day as a man of authenticity, honesty, encouragement and caring.

Then with my arms at the nine–three position, I pray for the world, for nations in crisis: these last days (as I write) I have been remembering the great wave of Syrian refugees, and the European countries receiving them with different degrees of welcome. I also remember on an ongoing basis Ukraine and Russia, Syria and Iraq, Iran and the United States, Israel and

Palestine, as well as my own country, Canada. Finally in this sequence, I lower my hands and touch them together in front of myself, then bring them up outstretched to trace a circle, touching my hands together above my head, and returning them to their starting place. This is the moment when I pray for our wounded planet, or as one of the Anglican Eucharistic prayers phrases it, "this fragile earth, our island home" (Eucharistic Prayer 4, *Book of Alternative Services,* p.201).

All of these are "locating" prayers, in one way or another. The Moore prayer locates me in the action of prayer itself, in the house of prayer which I am building by praying. The *rakus* locate me in my relation to the cardinal dimensions of God, self and others. The blessings locate me in my family constellation and in the community of my loved ones. The intercessions locate me in our world of need, the needs of individuals, nations and the planet. Thus centered, grounded and "located," I am ready to pray **the Lord's Prayer.**

Some years ago, I realized that there are two kinds of clauses in the Lord's Prayer: those which refer to the eternal realm, to life *sub specie aeternitatis* (life lived "in view of eternity"), and those which refer to time and history, to life lived in the present moment. To bring out this meaning, I have printed below the "eternal" clauses in Roman type, and the "temporal" clauses in italics. I have also added to every clause in which it does not occur in the original text the word "today," and bolded it, because it brings out the immediacy of the temporal clauses. I call this form of the prayer "the Lord's Prayer in *Time* and Eternity." The fifth clause, "*On earth* / as in heaven," unites and balances both dimensions, the temporal and the eternal. The final clause also brings together both dimensions, in the phrase "*now* [temporal] and forever [eternal]." As you see, I have also offered some alternatives for the opening address to God.

Our Father/Mother/Abba/Great Mystery in heaven,

> *Hallowed be your name* **today;**
> *Your kingdom come* **today;**
> *Your will be done* **today,**
> *On earth* / as in heaven.
> *Give us* **today** *our daily bread.*

*Forgive us our sins **today,***
*As **today** we forgive those who sin against us.*
*Save us from the time of trial **today,***
*And deliver us from evil **today**.*
For the kingdom/kindom, the power, and the glory are yours,
Now and forever. Amen.

I have also developed a series of simple actions to go with the emphasis on the word "today." It involves a slight raising of the arms at one's sides at each use of the word. Arms stay still for "Our Father in heaven" and "*On earth / as in heaven,*" in which "today" doesn't occur. Then when I say, "For the kingdom, the power, and the glory are yours," I hold my arms straight up, hands joined together at the limit of my reach. Finally comes "Now … NOW … **NOW**! … and forever. Amen." I repeat "now" three times, touching my heart, to reinforce what I am saying when I repeat "today" in the other lines of the prayer. I link this to what felt like a revelation to me some years ago when I was reading 2 Corinthians 6:2. I had always read it as "now is the day of ***salvation,***" but on that occasion I read it as "***now*** is the day of salvation." "Today" is the centrepoint of history, and "now" is the centrepoint of "today." (Cf. two books that make this point: Eckhart Tolle's *The Power of Now,* and Richard Rohr's *The Naked Now.*) In praying this way I am present both to human and planetary history and to myself, as together we move forward through time.

And then for the phrase "and forever. Amen," these actions:

- touch hands to opposite shoulders;
- touch hands to same-side shoulders;
- extend arms horizontally.

These actions bring together the two classic ways, East and West, of making the sign of the cross. In the West, the right hand goes first to the forehead, then to the heart, then to the left and right shoulders. In the East, the hand goes to the forehead, to the heart, and then to the right and left shoulders. In conflicts on the Latin-Greek language borders in the Middle Ages, unidentified captive soldiers were sometimes asked to make the sign of the cross to indicate their allegiance, and woe betide them if they made

it the "wrong" way. So to do it this way, using both arms, combines both traditions, and is thereby a sign of a fundamental if presently unrealized unity among Christians. Into my mind as I write comes a memory of a beautiful recent photograph of Pope Francis bowing to Ecumenical Patriarch Bartholomew (bowing to someone else not being an action we are used to associating with popes) and asking for his blessing; and more recently and even more boldly, a memory of his meeting in Cuba with Patriarch Kirill of the Russian Orthodox Church. I mean it to affirm a fundamental unity of faith among all Christians, East and West, North and South, and as a sign of hope for the coming unity of all Christians and the coming peace of the world.

This then is the format of my morning prayer in the presence of the painting. I know I have given you a lot of detail, but what I have described takes only a few minutes. If you take time to learn and practise any part of it that speaks to you, it will soon become very natural. I experience it as an anchor to my day, a time of prayer which launches me every morning into the day which shall be mine.

I have integrated my body into my prayer because to pray with the whole self is to pray body and soul, just as we undertake every other action of our day both with our body and our soul. I repeat my caution that this is simply a way that I have developed for myself. If any part of it comes to be useful to you as a model for part of your prayer, I will rejoice in this!

Once I have prayed my way through this morning routine, I turn to my dresser, and touch lightly a card bearing some words from Thomas Merton: "Every breath we draw is a gift; every moment of existence is a grace." I ran across this beautifully calligraphed card (thank you, Donna Kristoff!) in my files not long after going on oxygen in 2014, and immediately gave it a place in my morning prayer. Then I go out into my dining room and touch the rim of what I call my soul-bowl, a handcrafted piece of pottery which was a gift to me from the staff of the Jubilee Program. It contains stones from Jerusalem, Taizé, Naramata, BC (where we used to hold the Jubilee residencies), and a little olive-wood heart from Bethlehem. It used to hold a stone from Iona, but I gave this to a friend who was building a cairn in her garden as part of the blessing of her new home. And when I touch the bowl, I say to myself/to God/to the Universe, "The ground on which I stand is holy ground" (cf. Exodus 3:5); and by "ground" I mean

not only the floor of my apartment, but the planet on which we all stand and live and move.

There is another form of prayer that I am beginning to undertake with the painting, something entirely different from my morning ritual. It is a simple sitting with the painting, a contemplative time, a spacious time. At some time later in the day, usually after 5:00 p.m. and before supper, and after reading the New Testament lectionary reading for the day, I sit on the far side of the bedroom from the painting (I do the morning ritual on the near side, fairly close to the painting) and wordlessly drink in the peace and groundedness which God wants us all to have, in my case with the assistance of the holy man in my painting. This too is proving to be an anchor, one of a very different kind from the morning ritual, but still an anchor, a way of continuing to root and ground myself in the beauty and strength of my iconic painting.

CHAPTER FOURTEEN

L'ENVOI

Let me return now to the beginning of this narrative. I *had* to buy the painting. But *why* did I have to buy the painting? Here is what has come to me by way of answer in the forty-five years since. (For the sake of simplicity, I am ascribing agency to the man in the painting, the holy man.)

First, he wanted me to recognize the archetypal character of the painting, and through that, the presence and activity of the archetypes in my life.

Second, he wanted, at the right moment, the *kairos*, to call me into a new level of communion with my True Self, and to offer me the challenge of living with intentionality.

Third, in directing my attention to the beautiful old men, he was calling me into a teleological, i.e., goal-oriented valuing of myself, as someone with the capacity to join their number, certainly, of course, on a lower level.

Fourth, as a strong male, he was calling me out of the captivity and powerlessness of my soft-male identity into a more whole masculinity.

Fifth, as someone deeply engaged in meditation and prayer, he was challenging me to deepen my own spiritual practice.

★

So where am I now in my journey with the painting? Here's another take on it. The archetypes, which first I saw as only belonging to the painting,

I now recognize in myself. To various degrees, I *am* the stranger, my own True Self, my own father, my own teacher, the wise/beautiful old man, the partaker of the divine nature—and if that last descriptor seems excessive, let me say that I simply understand it as medieval Cistercian William of St.-Thierry did, as "not God, but that which God is" (cf. 2 Peter 1:4).

I am now in fact, God help me, the holy man myself. I am called to be a living icon to others. I am even called to be an icon to myself! Should that be so impossible? After all, Merton, when he had his epiphany at the corner of Fourth and Walnut in Louisville in 1958, said that he saw all the people on the street "shining like the sun" (*Conjectures of a Guilty Bystander*, p.157). The holy man in my painting spoke to me very directly, even sternly, when I was fifty, and set me on the path to become what we are all called to become, our true selves and children of God. I am ready, as I have said, to be accountable; but I do not mean this in a final sense, rather in an ongoing sense. I want to keep moving in the direction of what Iranian psychiatrist Reza Arasteh calls "final integration." Here, in "Final Integration: Toward a 'Monastic Therapy,'" is how Thomas Merton summarizes what Arasteh means by this phrase.

> Final integration is a state of transcultural maturity far beyond mere social adjustment, which always implies partiality and compromise. The man [*sic*] who is "fully born" has an entirely "inner experience of life." He apprehends his life fully and wholly from an inner ground that is at once more universal than the empirical ego and yet entirely his own. He is in a certain sense "cosmic" and "universal man." He has attained a deeper, fuller identity than that of his limited ego-self which is only a fragment of his being. He is in a certain sense identified with everybody; or in the familiar language of the New Testament . . . he is "all things to all men" [1 Corinthians 9:22]. He is able to experience their joys and sufferings as his own, without however becoming dominated by them. He has attained to a deep inner freedom—the Freedom of the Spirit we read of in the New Testament (p.225).

This is a statement which I find inspiring, particularly now in my later years (I read it first forty years ago), as a template for aspiration but in no complete way a self-description. However, many Merton scholars have noted how, although Merton here was summarizing Arasteh's views in a theoretical way, he was also offering a description of spiritual maturity which many readers have been ready to apply to Merton himself—which perhaps justifies its use of masculinist language. It indeed can simply be read, as I do read it, as offering a checklist for signs of growth in ourselves and others—so long as we leave the judgment of self and others to God. It is a remarkable and beautiful statement. So I send this book off to you, with the prayer that it may offer some assistance in your own walk with yourself and with God, conscious that it is always a risk to open one's heart in the way that I have done, our hearts being as tender as they are.

And, hey, while my heart is open, why not take another risk? David Chang is a friend of mine mentioned already in this book, a former student, for many years a high school English teacher, a Zen practitioner and Ph.D. candidate, and the son of an absent father. Let it be said: I love Dave. I officiated at his wedding to the lovely Pam, and have increasingly enjoyed our conversations as the years of our friendship have proceeded. More recently, he has kindly driven me to Seattle to do a book launch, and to Black Creek, where together we interviewed the hermit, Charles Brandt. In 2014, Dave sent me a poem he had written in which he says something very beautiful about me, however undeserved. It tells me that I am moving, in my own view far too slowly, but in his view, at whatever pace, in the direction of being a beautiful old man. Yes, I confess it: some years ago I did tell Dave that I wanted to be a beautiful old man. However, to forestall any suspicion on the reader's part that this is just one more ego trip on my part, let me say that I am glad to be associated in the poem with the rain, the scent of moist soil, Dave's morning cup of coffee, his bowel movement, his toast and peanut butter, and the cherry blossoms of the Vancouver spring. Here's the poem, "Gratitude."

I woke up this morning
Grateful.

A few thoughts drifting over glazed eyes . . .
But the memory of my professor,
75 years old
drawing oxygen from a tank,
exhaling love
into the world,
stirs me from my bed.
I too have something to live for

Grateful for the rain
Seeping up from the saturated lawn
A hearty gust of wind
Sweeping the grass
Lifting the scent of moist soil
and fragrant spring air to my nose

Grateful for coffee
A fine layer of amber foam on top
The cream that I pour
Swirls and twists inside the mug
Rising up like clouds against a black sky

Grateful for this bowel movement
I'm told the plumbing will not always work
At least it's working today

Grateful for toast and peanut butter
Each tasty morsel
A sweet, savoury mass
Loping around tongue and teeth
Crumbs falling on the table
I lick the knife clean
While the dog watches in envy

Grateful for pleasures
Too trivial to name
Too common to proclaim
I know furious fires burn at the world's edge
But now as the cherry blossoms fall to the earth
Each tiny petal
Dancing deliriously in its descent
Quells every flame

You can imagine how moved I was to receive this poem from Dave. I wrote back to him immediately, telling him that he was a prize and a prince, which he is, and that I would always treasure the poem, which I will.

So the moment of solemn accountability, my seventy-fifth birthday, the day when I became as old as Abraham when he was called, has come and gone. I know now that I need not have had any apprehension about what the holy man and I would say to each other on that occasion. When I was fifty, he pointed me in the right direction, and, however imperfectly, I have tried to move in that direction. As always, he accepts whatever I throw at him. At peace with the memory of my father and my mother, and attempting to live each day in love, authenticity and gratitude, I see whatever time remains to me as a time in which the holy man and I will continue to companion each other.

Lord, have mercy!

Thanks be to God!

BIBLIOGRAPHY

Arasteh, Reza. *Final Integration*. Leiden: Brill, 1968.

Burkeman, Oliver, *et al.* "Counting down to big birthdays," *Guardian Weekly*. December 12, 2014, 26-29.

Bly, Robert. *Iron John: A Book about Men*. New York: Random House, 1990.

Brotto, Lori. "Fairy-tale romance gets a reality check, *The Globe and Mail*

(December 14, 2015) L4.

Capetz, Paul. "Reformation Views on Celibacy," in *The Embrace of Eros*, ed. Margaret Kamitsuka. Minneapolis: Fortress Press, 2010.

Christie, Douglas E. *The Word in the Desert: Scripture and the Quest for Holiness in Early Christian Monasticism*. New York: Oxford University Press, 1993.

Clément, Olivier. *La Prière du cœur*, Paris: Ed. Bellefontaine, 1977.

Eliot, T. S. "Little Gidding," in *Four Quartets*. San Diego: HBJ, 1971, cop. 1943.

Grayston, Donald. *Thomas Merton and the Noonday Demon: The Camaldoli Correspondence*. Eugene, Oregon: Wipf and Stock, 2015.

Huddleston, Trevor. *Naught for Your Comfort*. London: Collins, 1956.

Lipsey, Roger. *Make Peace Before the Sun Goes Down: The Long Encounter of Thomas Merton and His Abbot, James Fox*. Boston and London: Shambala, 2015.

Lee, J J (James Jason). *The Measure of a Man: The Story of a Father, a Son and a Suit.* Toronto: McClelland and Stewart, 2011.

Lowry, Malcolm. *Under the Volcano.* Harmondsworth, UK: Penguin, 1947.

McVey, Kathleen E., trans. and ed. *Ephrem the Syrian: Hymns.* New York: Paulist, 1989. (*Classics of Western Spirituality.*)

Merton, Thomas. *The Asian Journal of Thomas Merton*, ed. James Laughlin et al. New York: New Directions, 1973.

Merton, Thomas. *Conjectures of a Guilty Bystander.* Garden City, NY: Doubleday, 1968.

Merton, Thomas. "Day of a Stranger," in *Thomas Merton, Spiritual Master*, ed. Lawrence S. Cunningham. New York: Paulist, 1992, 214-22.

Merton, Thomas. "Final Integration: Toward a 'Monastic Therapy,'" in *Contemplation in a World of Action.* Garden City, NY: Doubleday, 1973, 219–31.

Merton, Thomas. "From Pilgrimage to Crusade," in *Mystics and Zen Masters.* New York: Dell, 1967.

Merton, Thomas. "Hagia Sophia," in *The Collected Poems of Thomas Merton.* New York: New Directions, 1977, 363-71.

Merton, Thomas. *The Wisdom of the Desert: Sayings from the Desert Fathers of the Fourth Century.* New York: New Directions, 1960).

Mott, Michael. *The Seven Mountains of Thomas Merton.* Boston: Houghton Mifflin, 1984.

New York Times, The Week in Review, June 6, 2010, 4.

Nielly, Marie-Bernard, bio: *Biographical Dictionary of Preachers* [Online]. Posted August 23, 2014, accessed March 8, 2016: dominicains.revues.org/1907

Nouwen, Henri. *The Return of the Prodigal Son: A Story of Homecoming.* New York: Doubleday, 1992.

Osherson, Samuel. *Finding our Fathers: How a Man's Life is Shaped by His Relationship with His Father.* New York: Fawcett Columbine, 1986.

Ouspensky, Leonid, and Vladimir Lossky. *The Meaning of Icons*, rev. ed., trans. G. E, H. Palmer and E. Kadloubovsky, foreword Titus Burkhardt. Crestwood, NY: St Vladimir's Seminary Press, 1982.

Palmer, Parker. *The Active Life*. San Francisco: Harper and Row, 1990.

Peterson, Devorah. "The Stranger" (unpublished paper).

Pittman, Frank. *Private Lies: Infidelity and the Betrayal of Intimacy.* New York: Norton, 1989.

Plekon, Michael. *Living Icons: Persons of Faith in the Eastern Church*, foreword by Lawrence S. Cunningham. Notre Dame, IN: University of Notre Dame Press, 2002.

Rohr, Richard. Quotation in chapter 9 adapted from *The Art of Letting Go: Living the Wisdom of Saint Francis*, discs 1 and 5 (CDs).

Schweitzer, Albert. *The Quest of the Historical Jesus,* trans. W. Montgomery. London: A. and C. Black, 1936, cop.1910.

Tartt, Donna. The Goldfinch. New York and Boston: Little, Brown, 2013.

Tutu, Desmond. "An Appreciation of the Rt Revd Trevor Huddleston," in Deborah Duncan Honoré, ed., *Trevor Huddleston: Essays on his Life and Work*. Oxford: OUP, 1988, 1-2.

Wilde, Oscar. *The Picture of Dorian Gray* (1891, many editions since).